Thoughts of the Muses

ELIZA MERRY

Design, typesetting and publishing by UK Book Publishing

www.ukbookpublishing.com

ISBN: 978-1-915338-52-5

Cover photo: Maiden Gathering Flowers from the
Villa of Varano in Stabiae (c15BC-c60AD) – On
display at Museo Archaeologico Nazionale Naples

This book is dedicated to
Hilary Lewis
– with love and thanks

Contents

Prelude

For much of recorded history women have been a muted group: their stories untold, their lives deemed relevant only in relation to the men around them. Biologically equipped to be the bearers of children and the guarantors of the perpetuation of the species, women's intellectual capabilities were for centuries unexplored and unfulfilled.

Creative women have always existed, yet until comparatively recently their output - be it artistic, musical, poetic, literary - or indeed any other aptitude - has largely been considered insignificant. As late as the c19th women writers including the Brontë sisters and Mary Ann Evans (George Eliot) submitted their works under male names in order to be taken seriously by publishers. Gifted female composers like Clara Schumann and Fanny Mendelssohn were denied the public recognition afforded to their male relatives. These are well-known examples – behind them is a nameless multitude of creative, talented but disregarded women.

Undoubtedly there are exceptions to this assertion, but in general it's fair to say that the recording and interpretation of history is a story largely chronicled and controlled by men. Women

feature in the narrative merely as wives and consorts, both virtuous and wicked, as mothers and daughters, as objects of desire or opprobrium, as saints and temptresses, and, in the arts, as Muses.

I've been pondering on this, having spent much of my life immersed in the arts, and having made my living as a literature teacher and a lecturer specialising in literature and the arts.

The Nine Muses of ancient Greece, daughters of Zeus and Mnemosyne (memory) were each a personification of a different aspect of the arts according to the cultural priorities of the time: literature and poetry, music. dance, drama and science. They are female deities - equating the concept of creativity in the arts and sciences with the power of the life-force of the birth-giving female. The ancient Muses are:

* Calliope - the Muse of epic poetry.
* Clio - the Muse of history.
* Erato - the Muse of love poetry.
* Euterpe - the Muse of music.
* Melpomene - the Muse of tragedy.
* Polyhymnia - the Muse of sacred poetry.
* Terpsichore - the Muse of dance.
* Thalia - the Muse of comedy.
* Urania - the Muse of astronomy

I notice that there is no Muse of art or sculpture - possibly these were considered as craftsmanship - produced with the hands rather than through the Muse-infused meditations of the mind.

What, then, is a Muse? A creative inspiration? An unattainable ideal? A personification of physical beauty? A source of sexual obsession, overt or covert? There are many archetypes; and clearly the significance of the Muse to the male artist is as much about him as it is about her.

She may be an unknown but once seen, never forgotten person, who has then become part of the artist's fantasy. She may be known to the artist but have been idealised by him into a sort of private icon. Some Muses, as we shall see, were involved in love affairs with the artists; which often ended badly when reality got in the way. Sometimes tragedy intervened, leaving the memory of the Muse as an enduring vision. We will meet many different paradigms in the following pages.

In the centuries since the classical era the concept of a Muse as an inspiration to the creative male has inspired innumerable magnificent and memorable works. Still today beautiful and distinctive women continue to stimulate the imaginations and skills of men in all of the arts. But what we rarely, if ever, hear, are the thoughts and the voice of the Muse. If she does have a creative voice - and many Muses

did and do - it usually remains, often unjustifiably, a mere shadow of the accomplishments of the men she has inspired. Again, there are notable exceptions, but most of these date from the last hundred years or thereabouts as attitudes have begun to change and feminism has continued to develop.

I've wondered about the inner lives of these largely silent women, about their thoughts and ideas and opinions. The perception that their celebrity was a result of the visible inspiration they provided for those creative men, rather than what went on inside their own heads, got me thinking. Physical beauty has ever been and still is a stimulus for creative expression. There are indeed many professions - modelling for instance - where appearance is still the priority. This can result in manipulation and abuse.

Such exploitation still takes place - so much that in the view of many modern women, any profession where appearance is the most important factor is intrinsically offensive. But at least today people can speak out, and there are laws in place which aim to protect against abuse. There's still some way to go.

I want to explore what might have been the private thoughts of some of those who in the past became a literary, a poetic, a musical or an artistic Muse. There was no safety net for these women, no acknowledgement of any creative inner world

through which any of them might have found personal fulfilment and expression.

The story does become a bit more encouraging in recent times. Many modern women who started off as someone's Muse are now celebrated for their own creative and original work, their reputations sometimes eclipsing the person whose Muse they originally were. But my examples are just a few of the others, picked from the mass of those over the centuries who are remembered mainly in the context of their perceived rôle as Muse. The more recent ones have in some cases told their own story, so I can dip into their reminiscences, but many others remain silent. I am going to try and give each one a voice.

Every Episode in this book is divided into four movements, and is named after one of my chosen Muses. Each first movement opens with a portrayal of the historical background in which both Muse and artist lived. Next is an account of the lives of women during the period, with verbal sketches of some of the rare women who managed to make a mark on history. The third movement focuses on the man whose creativity was inspired by the Muse of the title, and each final movement is about the Muse herself, ending with an impressionistic conception of what some of her thoughts and feelings may have been.

I've identified nine Muses, not directly corresponding to the nine ancient Muses, but who

are remembered through literature, poetry, music and art. They are my own choices out of the many women who have fuelled creativity in gifted men - a personal selection manifested by my own particular preoccupations and preferences. Theirs are the lives and ideas I want to reawaken from the shadows of history.

My chosen Muses span two millennia. The first lived during in the late Roman republican period just before the Christian era, and the last died in the 19th century. There is uncertainty as to identity for some of these women - the four earliest chronologically in my list - but each has been named by several scholars as the most likely candidate. I have asterisked the four to whom this applies.. The woman in Episode 5 occupies a different position, which will be explained when I reach her part of the book. In Episode 7 the composer Hector Berlioz will be seen to have had two Muses as inspirations to his work.

My nine Muses are:

* Lesbia - Muse of Roman poet Caius Valerius Catullus
* Beatrice – Muse of poet and philosopher Dante Alighieri
* Laura – Muse of poet and humanist Francesco Petrarca (Petrarch)
* Emilia – Muse of poet and playwright William Shakespeare as his 'Dark Lady of the Sonnets'
* Catharina – Muse of artist Johannes Vermeer
* Fanny – Muse of poet John Keats
* Harriet and Estelle – Muses of composer Hector Berlioz
* Mary – Muse of author Charles Dickens

Episode 1

Lesbia

FIRST MOVEMENT: BACKDROP

We travel back to the city of Rome during the first half of the first century BC. These last decades of the Republic were ones of fractious political turmoil. Power struggles between influential and ambitious men took place against a background of ongoing friction between the common people - the Plebeians, and the aristocracy - the Patricians. In a scenario recognisable in today's politics, opportunist populists like Julius Caesar - although a member of an old and influential patrician family - courted the plebeians. When this incurred the anger of the dictator Sulla, Caesar made himself scarce, spending several years away from Rome and becoming a successful and talented military commander.

Obviously most of the soldiers he commanded were not 'officer class'. The Roman legions, in common with armed forces throughout history, consisted overwhelmingly of commoners, plebeian troopers who had left their farms, families and livelihoods to fight for their country and do their duty in ensuring the spread of Roman power across the known world. They were staunchly loyal to Caesar and were to prove a valuable supporting factor in his populist ambitions.

Caesar eventually returned to Rome in triumph and became the darling of the common people, rising quickly up the political ladder after Sulla's death. In due course he overcame all political opposition and emerged in 60BC to rule the country as one of a trio of influential men - the first Triumvirate (the other Triumvirs being Crassus and Pompey). This at times uneasy oligarchy worked quite well for some years, many of which Caesar spent on campaign abroad with the Roman army in Gaul. This time his return as war hero and conqueror of Gaul was not enough to sustain the increasing ideological differences between himself and his fellow Triumvirs. The death of Crassus in 53 left Caesar and Pompey facing one another in opposition. Both had distinguished military reputations, but their power bases had become implacably divided. Neither was prepared to yield.

Pompey emerged as the champion of the old order, known as the Optimates – the conservative faction which represented the traditional patrician class. Caesar, always a populist, supported the people, the faction described as the Populares. In a scenario not unlike the verbal warfare which goes on in today's House of Commons, they argued repeatedly in the Senate. Caesar refused to compromise; he returned to his army and invaded his own country, crossing the Rubicon river between Gaul and Italy and, with this violation, initiating civil war. Pompey was routed; he escaped to Egypt, but was murdered there by order of the Pharaoh. Caesar emerged all powerful; by 44 he had been proclaimed Dictator for Life. But politics and ambition are a dangerous game, which ended for Caesar with his assassination that same year.

This is just a glimpse into the political instability and discord which dominated the lives of those living in late republican Rome. Among them was the poet Catullus and his adored Lesbia, the Muse for his love poetry. This story so far has been one of men - men vying for political supremacy, men leading armies and fighting battles. The chroniclers of this story were also men - contemporary writings from the time include the works of Marcus Tullius Cicero (106-43BC) and Caesar himself (100-44BC) - blowing his own trumpet with panache and erudition.

During the next two centuries further versions of these events were written - all varying in content and emphasis according to the preconceptions and subjectivity of each historian. Among others Plutarch, Appian and Suetonius all had a go. But very scanty indeed is the reference in any of these accounts to the lives of the women of the times. Of plebeian women there is rarely a mention. For a patrician woman, in order to merit a mention, she had either to be rich but wicked or to have a very high profile indeed - Cleopatra for example. Plutarch's evocative description in his *Life of Antony* of Cleopatra's arrival by barge on the river Cydnus was to inspire one of Shakespeare's most enchanting and rhapsodic pieces in *'Antony and Cleopatra'*. But if you weren't a queen or one of Roman history's handful of Noble Women (who incidentally were all noblewomen!) – or didn't have a reputation for extreme iniquity or concupiscence - it's very unlikely that anything about you would have made it into any chronicle of the period.

Time, then, for me to move on and try to piece together some of the aspects of life for women in the late Republic, and what was expected of them.

SECOND MOVEMENT: WOMEN

Upper-class women are the only ones visible in records of events in this period. The ideal image for a Roman matron invokes Lucretia, dating from over five hundred years earlier; a virtuous and devoted wife who was raped by lascivious and drunken prince Tarquinius. In order to preserve her husband's honour, she stabbed herself to death. Widespread outrage at this atrocity was said to have been a key reason for the overthrow of the monarchy and the establishment of the Republic. Lucretia was thereafter extolled as the very essence of the virtuous woman and as such has featured as a tragic heroine over the centuries in music and art.

Then there is the story of patrician lady Cornelia, living in the second century BC. Lauded in her time and thereafter for her devotion to her elderly husband while he was alive, and for her loyalty after his death, she refused several prestigious marriage proposals including one from the king of Egypt. She devoted the rest of her life to studying Latin, Greek and philosophy and overseeing the education of her surviving children. Cornelia is famed in Roman history as the mother of the Gracchi, brothers Tiberius and Gaius. When they grew up to become significant politicians she counselled them with

morality and wisdom, often in opposition to the brutal opportunistic policies of the ruling élite. As a child reading my 'Tales of Greece and Rome' I was stirred by the account of 'Cornelia and her Jewels', those jewels being not the riches displayed by the elegant and gem-bedecked noblewomen who visited her, but her two little boys.

Another virtuous Roman matron emerges round about the time that Catullus was writing his verses. Caesar's final wife Calpurnia; modest, uncontroversial and faithful, was everything a good wife was expected to be. She married him in 59BC, and was the last of at least two, possibly three previous wives.

Those wives who preceded Calpurnia deserve a brief mention. Choice of consort for powerful men was always a matter of political expediency; and certainly Caesar's celebrity and achievements made him a desirable and attractive prospect for these women. His first marriage took place when still a teenager to Cornelia Cinnae, who was herself only about 15. This was an arranged political marriage. Cornelia's father Lucius Cornelius Cinna was a prominent and powerful politician and had just finished a four-year term as consul. Caesar, though young, was already ambitious and single- minded; a well-connected wife was just what an aspiring politician needed. His only legitimate child, his

much-loved daughter Julia, was the result of this marriage.

Two years after Cornelia's death in 69 he remarried - once more into a renowned political family.

His next wife, Pompeia; only lasted a few years. This time it wasn't death which ended the marriage, but scandal. And in a bizarre coincidence, it was Publius Clodius Pulcher - the rackety younger brother of Catullus' beloved Lesbia who was the cause of it. (We shall hear more of this young man later). Caesar, by now a very high flier indeed, had in 63 BC been elected Pontifex Maximus (the chief priest of the state religion) - a rôle which carried with it a range of important ritual duties as well as an official residence and the responsibility for hosting various religious festivals. There was one particular festival - that of Bona Dea (a fertility goddess) - whose rituals were strictly limited to women; so the festival had to be hosted not by Caesar but by his wife. It was this event that Clodius, disguised as a woman, gate-crashed; rumour has it that he intended to seduce Pompeia. The whole thing was a massive scandal and, although innocent, poor Pompeia paid the price; Caesar's reputation couldn't be tainted by such an outrage, so she had to go. He divorced her forthwith.

This early example demonstrates the double standard which has affected womens' reputations

for centuries. Adultery, actual or, as in this case, assumed, was considered a woman's crime. Men, married or not, were free to couple with women of all ranks without censure. As well as his wives, Caesar had a plethora of mistresses, the most enduring of whom, Servilia, outlived him. He also indulged in strategic love affairs with well-connected women at home and abroad including Queen Eunöe of Mauretania and, more famously, Cleopatra of Egypt. But as Pontifex Maximus, Imperator, and finally Dictator for life, the great man needed a wife beyond reproach. Enter Calpurnia - a contemporary of the first of my Muses, Lesbia, - but a very different type of woman.

Again, this was a political marriage; Calpurnia's patrician lineage was impeccable. Her father Lucius Calpurnius Piso became Consul in 58; her brother would later be appointed into the same office. She was about seventeen when she and 41-year-old Julius Caesar married in 59 BC. Calpurnia is one of those shadowy figures who have left the palest of imprints on history. She is mainly remembered for an account by Suetonius of the prophetic dream she is said to have had the night before Caesar's assassination. Centuries later this episode was to be effectively dramatised by Shakespeare in *Julius Caesar*: '*Thrice hath Calpurnia in her sleep cried out: 'Help, Ho! They murder Caesar'...* She has described seeing his statue

'*...like a fountain with an hundred spouts, did run pure blood, and many lusty Romans came smiling, and did bathe their hands in it...*' This, however, is almost the sum of what is known about Calpurnia - a model wife, faithful and loyal, her behaviour exemplary. There were no children, and unlike many of her noble contemporaries, including Catullus's Lesbia, she had no extra-marital affairs.

THIRD MOVEMENT: CAIUS VALERIUS CATULLUS

I was introduced to Catullus when I was about thirteen by my school Latin teacher. She took us through the tender love-poem he wrote after hearing that his beloved's pet sparrow had died. '*Passer mortuus est meae puellae*'- (My girl's sparrow is dead); '*Passer deliciae meae puellae*' he says (my darling girl's sparrow) and goes on to implore all the Gods of love to mourn with her. Addressing the sparrow in another poem he fondles it, hoping that if he plays with it gently she'll soften her heart to him; however it nips him sharply, perhaps a metaphor for the volatile nature of their relationship.

Catullus is thought to have been born in 84 BC, but by 54 he disappears from the records. This doesn't necessarily mean that he died young, but until any

indication to the contrary is found, the assumption has to be that he did. Insofar as his poetry can be dated (through references to contemporaries) there doesn't appear to be any evidence of anything written later than early 54.

What we do know is that he came from a well-off family who lived in Verona - north of Rome, then part of the area which was known as Cisalpine Gaul (Gaul this side of the Alps). His wasn't one of the great noble families which wielded huge influence over politics and power, but still a patrician household wealthy enough to ensure a comfortable home and a good education for the young Catullus and his brother.

Rome was the magnet for all young men of talent, and it seems that Catullus left the family villa and headed for Rome when he reached maturity. It's probable that his arrival in the city when he was sixteen or seventeen was so he could participate in what was for many Roman men the high point in their lives - the donning of the Toga Virilis. This important ritual and celebration took place in Rome annually in the middle of March during the Festival of Bacchus. Surrounded by his family, young Catullus would be ceremonially presented with the Toga Virilis, which he would put on while the gods were invoked to bless the occasion, He would then have joined in a procession to the Capitol, en-route

possibly visiting a temple for prayers and sacrifice. During this festival the streets of Rome around the Forum would be teeming with celebrants and well-wishers; there would have been music, dancing and rejoicing, while elderly priestesses of Bacchus bustled around selling sacred honey cakes in honour of the god. The occasion was both solemn and joyful – a rite of passage from one stage of life into the next - as significant and momentous for the Roman youth as a Bar Mitzvah ceremony is for a Jewish boy.

Catullus was now a man, a citizen of Rome, where he would remain for most of the rest of his life. He probably spent his first few years there in the care of an older man, who mentored and watched over the youth while he found his feet in the city. In some of his early poems Catullus addresses the writer and biographer Cornelius Nepos as his friend and foster father; Nepos is also the dedicatee of the volume. It seems likely therefore that it was into his care that Catullus was first consigned.

It must have been a heady and exciting life for the new citizen; Rome, busy and vibrant, was the capital of the known world. Catullus was able to enter a society which was cosmopolitan, sophisticated and cultured. With few money worries and no need to find employment, the young poet would have been swept into the tide of fashionable Roman society. He would have had little interaction with the city's

squalid and poverty-ridden underbelly - the poor in their crowded tenements, the thousands of slaves from all over the empire servicing the needs of the wealthy, the struggling shopkeepers and the ragged beggar children in the city's slums. His own family's prosperous household would have included several house and garden slaves, both male and female. Catullus would have accepted their presence and purpose without question; inequality in power, freedom and the control of resources was part of life. Indeed it was upon the foundation of this forced servitude that the entire structure of the Roman state and its society was maintained.

Catullus was not, however, one of the super-rich. He didn't come from one of those ancient patrician dynasties which had supplied members of the ruling classes for generations. In fact, albeit revelling in the excitement of his life in the great city, I think he must have felt a bit insecure in this hedonistic, fashionable high-society world. Outwardly cultivating a 'cool', modish image, his poetry explores his inner doubts and emotions in a style very different to the grand elegiac tradition of the ancient Roman poets.

He had a villa near the town of Tibur (present day Tivoli) in Lazio, not in Rome but about 18 miles east of the capital, near the Sabine hills. Renowned today as the site of the 1st century AD emperor Hadrian's magnificent villa, in Catullus's time it

was becoming popular as a resort for fashionable Romans seeking a break. Catullus's villa was in an outlying and less fashionable neighbourhood and there are hints in one of his poems that the villa was mortgaged to the hilt. Again, we get a picture of a young man striving to keep up with the smart set but without the unlimited resources which would have secured him a villa in a stylish part of Rome. He was beginning by now to make a name for himself as an appealing and original poetic voice.

There are mentions of his poetry in the works of later writers including Ovid, Horace, Martial and the historian Suetonius. For several centuries Catullus was only known through these references, which included occasional quotations from his works, because his poetry had passed out of circulation by the 2nd century AD. Perhaps it wasn't considered suitable for educational purposes, dealing as it did not so much with the great events of history or stories of Gods and heroes, but more domestic concerns. His subject matter encompasses human relationships - love, jealousy and betrayal - and vents emotions ranging from supreme ecstasy to anger and misery. There are also several ribald and scatological poems - some of them denigrating notables of the day, including the mighty Caesar himself. Even by today's standards many of these are pretty strong stuff; certainly, my school Latin teacher didn't give

us any idea of the graphic obscenities in this part of the canon!

The story of the rediscovery of Catullus's poetry is a thrilling one, the more so because the survival of these works was so precarious. In about 1305 AD a single original manuscript was discovered in Verona, the town of his birth. Two copies were made before the original was lost again. Two more copies were then made - one of which was also lost. So now just three copies of the lost original remain. One is at the Vatican Library in Rome, another in the Bibliothèque Nationale in Paris, and the third in the Bodleian Library in Oxford. From these, and with the aid of fragments transcribed in previous times, an archetype has been produced. Only 113 or 114 poems survive, some incomplete; the collection also includes fragments, some probably parts of lost longer poems – but the shortest poem of all *'Odi et amo'* is thought to be complete. Here it is:

OdI et amo, quare id faciam, fortasse requires
nescio, sed fieri sentio et excrucior.

(I hate and love. Why I do so, perhaps you ask. I don't know, but I feel, and I am in torment)

This brings us on to the subject of these conflicting emotions – the *femme fatale* he addresses in his verse as Lesbia. She is the subject of twenty-five of the existing poems - and indeed probably of many more which have been lost. They record with vivid eloquence this love affair, which reveals a gamut of emotions ranging from rapture to despair.

FOURTH MOVEMENT: LESBIA (CLODIA METELLA CELER NÉE CLAUDIA PULCHRA)

Who was she, then, this woman who inspired some of Catullus's most passionate but also some of his most bitter and despairing poetry? Lesbia is his pseudonym for her, but she is, according to a consensus of most scholars, believed to have been Claudia Pulchra - a wealthy married noblewoman living in Rome at the time of Caesar. Her husband, the patrician Quintus Metellus Celer, was an active politician who became consul in 60BC but died the following year. In a brief but unhappy poem Catullus refers to Lesbia and her brother who he nicknames 'Lesbius' and calls a 'pretty boy' – using the family surname Pulcher (Latin for beautiful) as a synonym for his beloved's preference for her brother's company over

his. Cicero likewise uses the epithet 'pretty boy' in his invective against this brother - Publius Clodius Pulcher. We met him earlier in the Bona Dea Festival incident which put paid to Caesar's marriage to Pompeia. It was the 2nd century AD writer Apuleius who categorically identified Publius Clodius's sister Claudia as Catullus's Lesbia.

Unlike most of her less notorious female contemporaries, Claudia makes several appearances in accounts of the period, particularly by Cicero, who accuses her of drunkenness and adultery. She certainly had a colourful love-life. Catullus's pseudonym for her isn't considered to be any indication of a preference for women lovers, but rather a tribute to Sappho. Much admired for her poetry, Sappho, the archaic Greek poet who had lived on the island of Lesbos in the 7th century BC, wrote passionately and exquisitely about love and betrayal. In Catullus's time, more than seven centuries later, the tone of his poetry too is intimate and heartfelt, he moves away from the stately epics of some of his contemporaries and pays tribute to Sappho, notably here in a reworking of part of one of her poems in which he describes the rush of emotion which overcomes him when face to face with Lesbia:

> ……. *nam simul te, Lesbia,*
> *aspexi, nihil est super mi,*

Lesbia, vocis,
lingua sed torpet, tenuis sub artus
flamma demanat sonito suopte
tintinant aures,
gemina teguntor
lumina nocte

(…as soon as I look at you, Lesbia,
no voice remains in my mouth
But the tongue is paralysed,
a fine fire spreads down through my limbs,
the ears ring with their very own sound,
my eyes veiled in a double darkness.)

Claudia was a daughter of the influential and ancient Claudian dynasty - a family whose reputation was part of contemporary folklore; Claudians were reputed to be either out-and-out villains or patriotic heroes. This stereotype didn't help the assessments of Claudia by the writers of her time and of the future - she was labelled early on as one of the bad Claudians. But can we get behind this to come to some sort of evaluation of the sort of woman she really was?

She was one of several children, male and female, of the patrician Appius Claudius Pulcher and his wife Caecilia. Confusingly, all the daughters were called Claudia and all the sons Claudius – this was the *nomen* or family name. To identify each, he or she

might be known as the first, second, third - and so on - so the Claudia we are talking about is thought sometimes to have been known as Tertulla - third girl. As a young adult she transformed her name 'Claudia' into Clodia. Why?

This change was probably initiated by her brother Publius Clodius Pulcher, who was an ambitious young political hothead with radical sympathies, aspiring to be elected as a Tribune. These were representatives of the plebeians in the Roman assembly - the common people - so the office couldn't be held by a patrician. Pulcher therefore changed his name into the less posh 'Clodius' and managed (with Caesar's help) to get himself adopted into a plebeian family, becoming Tribune in 58. In an act of solidarity with their brother, Claudia and her sisters all also took on the name change. As a supporter of the Populares Pulcher was a close ally of Caesar but also had a less respectable persona as the boss of a thuggish gang - a mixture of discontented plebs and runaway slaves. He led this anarchic group in unruly and violent activities - causing street riots, trashing people's property and generally fomenting unrest. Earlier we saw his attempted violation of the Bona Dea festival. He actually survived a trial for this offence; rumour had it that the jury had been bribed to acquit him. All in all, he seems to have been a pretty unsavoury character.

Clodia too was not considered to be above reproach. Assertive and intelligent, she certainly didn't conform to the accepted stereotype of the virtuous Roman matron. She gets a particularly bad press from Cicero - lawyer and distinguished man of letters - who spent much of his life campaigning through rhetoric and action to uphold what he felt were the principles of the Republic. His perception was that old-established values and ideals were in decline - the age-old complaint of every generation looking at the behaviour of the young. The time was one of political upheaval; Cicero himself was in the end to be destroyed by the new order after Caesar's murder. But much of his writing - letters, speeches, political and philosophical essays - survives, and it is in some of these works that we get glimpses of Clodia.

Her destiny as a nobly-born Roman woman was to have a husband chosen for her by her father, to bear heirs and to focus her life on that husband, their children, and running their home. The husband chosen for her was the politician Quintus Metellus Celer; the marriage took place in 63 BC and was not a happy one. The two of them didn't get on at all; she was extrovert, sociable and flirtatious, already enjoying the attentions of admirers who by now probably included the young lovestruck Catullus. It has been suggested that she too wrote poetry -

certainly as a well-educated noblewoman she could been familiar with the poetic works of the most admired literati of the day. Her husband Celer was serious and ambitious, focused on his career.

Politically too they were on opposite sides of the spectrum. Clodia, like her reckless brother, was a supporter of Caesar and the Populares. Celer on the other hand was firmly allied to Pompey and the Optimates - the traditionalist faction dedicated to upholding the old conservative aristocracy. Furthermore, women were not supposed to involve themselves in politics - which was considered to be exclusively men's territory. Cicero indeed said women weren't capable of understanding the complexities of matters political. So Clodia, taking an interest in politics, having lovers and, after her husband's death, running her own household - in effect behaving like a man - was pilloried for her conduct.

Pretty soon after their marriage - during much of which Celer was on government business abroad - Clodia was looking elsewhere for love and companionship. The marriage in any case didn't last long; as Celer was dead by 59BC; rumour (unsubstantiated) accused Clodia of having had him murdered. Cicero, in a high-profile court case in 56BC (of which more later) referred to her as 'the Medea of the Palatine' (Medea was an enchantress and murderess depicted in the play of the same name

by the Greek dramatist Euripides). Such eloquent invective had no justification but did nothing for Clodia's reputation.

By this time she'd had several lovers, including Catullus. The relationship between the two of them probably started round about 63 BC, just after her marriage. Catullus, who would have been in his early twenties, was obviously dazzled by this sophisticated, glamorous woman of the world. She was nearly ten years his senior; history dates her birth to around 95BC. It seems that she was a beauty – described by Cicero as '*Bou-opis*' (Ox eyes) – the implication being that, like many Italian ladies, her eyes were large, dark and long-lashed. Rich, beautiful, clever and alluring - no wonder the youthful poet was smitten!

Let us then imagine her awaiting his arrival one early spring evening. She visualises him making his way up the Palatine Hill, as the pale sunshine casts faint shadows across the cobbled street and filters through the bright green leaves of the trees in the courtyards of houses on either side. Clodia's house, of which she has been the sole manager since she became a widow, is a spacious *domus* half way up the hill. She is in the atrium, reclining on a couch and holding a hand mirror; outwardly tranquil but inwardly nervous. In the mirror she gazes at her face, which has been bathed in donkey's milk by her slave before being made up with saffron tincture

to highlight her eyes, and crushed poppy flowers to redden her cheeks. The image stares back at her – pale and beautiful. Her [1]stola is of fine wool and decorated with gold and purple embroidery. She has jewelled bracelets on her wrists, a gold leaf pendant around her neck and wears gold earrings with amber drops. Her slave has curled and scented her hair and dressed it with strings of pearls. Even in her present agitated state of mind Clodia feels a fleeting flash of relief that her luxuriant dark hair is all her own, thick and glossy enough to be styled without need of the additional hairpieces used by many other women.

She is thinking about the meeting to come. Her situation is complicated. Catullus - that infatuated young lover of a few years ago, who begged her for kisses – *da mi basia mille, deinde centum, deinde mille altera…* (give me a thousand kisses, then a hundred, then another thousand) - as he had written in one of his passionate poems to her - was now angry. Initially she had been charmed by his devotion and delighted with his love-poetry. He was gentle, talented and handsome - and utterly besotted with her. He wept with her when her caged bird died, he wrote her poems describing the bright days of their love for one another and saying that he would never again love as he loved her. But after time, he realised that she

1. *A Stola was a long robe fastened by a clasp at the shoulder*

didn't love only him. In his poems, wistful Catullus became angry Catullus; he now wrote of his once beloved as a wicked girl, an adulteress. Clodia admits to herself that she did indeed get fed up with him. He is too serious, too earnest. Since his brother died, he seems to have lost his sense of humour, he's no fun any more.

But things are much more complicated than this, Catullus has never been her only lover. Clodia runs through some of her other affairs in her mind; was Catullus so blinded by love that he didn't realise he wasn't the only one? Now, she's in trouble. The most recent lover – the one who really put paid to the affair with Catullus - was Marcus Caelius Rufus, who, to add insult to injury, was a friend of Catullus. This had made the break-up all the more stressful. Indeed Catullus shortly afterwards dashed off a brief poem to Caelius Rufus rebuking him for his treachery. Clodia thinks however that this one poem is small stuff compared to the many bitter poems Catullus has produced about the end of his love for her. In fact, the Caelius Rufus love affair didn't last long - but Clodia is now thinking about the aftermath, and fervently wishing she could turn back time. She had been so infuriated by Caelius Rufus abruptly ending their affair that she decided to sue him. Finding out that he had possibly been inplicated in a murder she filed a prosecution against him. To augment the

charge, she also accused him of stealing poison and planning to use it on her. But now she is worried, because Caelius is a friend of the celebrated lawyer and advocate Marcus Tullius Cicero, and Cicero will act for Caelius in the trial. Cicero has no time for Clodia whose morals he deplores, and even less time for her brother Clodius.

Clodia does not yet know how skilfully Cicero will win the case for Caelius. She cannot see into the future to hear his brutal and witty character-assassination of her; how he will berate her for dishonouring her family, repeatedly committing adultery and indulging in a profligate lifestyle with affairs, orgies and other licentious behaviour in her villa at Baiae (a southern resort with a reputation for excess); how he will entertain the courtroom with his descriptions of beach parties, banquets, drinking bouts, songfests, musical ensembles and yachting parties.

She is scared, and has called Catullus back just in case there's a chance of patching things up with him, hopeful that his betrayal by Caelius Rufus might make him more sympathetic to her own plight.

She waits for him hour after hour until nightfall – but he never arrives.

CODA

After Cicero's brilliant 56BC oratorical demolition of Clodia's case, described verbatim in his treatise *Pro Caelio*, she pretty well fades out of the picture. She would only have been about 40 and there is no record of her death. Surprisingly, relations with Cicero seemed to improve; after the death of his daughter Tullia he wrote to Clodia asking if she would consider selling him a property she owned near the Tiber so he could create a shrine there dedicated to Tullia. There is no evidence of her reply. It has been suggested that her family, the lordly Claudians, arranged for her exile from Rome so she would cease to be an embarrassment to them.

Her brother Publius Clodius Pulcher - whose reputation is as tarnished as his sister's - did actually as Tribune initiate some much-needed social reforms for the common people. He ended the arbitrary closing down of public businesses on religious grounds - which had caused considerable financial hardship - and also put forward a series of laws forbidding the execution of a Roman citizen without trial. Much of his conduct was indeed unlawful and vicious, but he was trying to initiate social change. And as we still see in our own times, change is often preceded by violence.

Clodius was killed in a brawl with a rival gang leader in 52 BC.

Episode 2

Beatrice

FIRST MOVEMENT: BACKDROP

*I*n my last year at primary school I fell ill with what turned out to be rheumatic fever. I was first hospitalised, then in due course sent back home, where I spent what would have been my final term recovering and convalescing. I was given all sorts of presents to keep me entertained – books, games and puzzles among them (this was well before the days of electronic games and iPads). The one I remember most vividly was a thousand-piece jigsaw with a picture on the lid of a stern-looking man dressed in a red robe, holding in one hand an open book, and gesturing with the other towards a strange sort of tower behind him. On closer scrutiny I could see that this tower, wide at the bottom and narrowing in

concentric circles up to a pinnacle at the top, was full of running and writhing naked human creatures.

The title of the jigsaw was *Dante e sua Poema* – Dante and his Poem. I didn't know who Dante was, didn't understand what he was pointing at while holding what I took to be his poem, or the significance of those little figures circling round the tiers of the tower. But I was fascinated. The jigsaw proved to be both challenging and absorbing; and as I pored over it trying to link the pieces I discovered more detail, more enigmas.

To the left of the picture was another bizarre structure, a dark rock in front of a tall gateway with another throng of naked people behind it, gesticulating and seemingly in distress. In the shadows behind them was a horned and grotesque demonic figure chivvying them down the rocky slope into the ground. What was it about? What did it mean? My mother said it was a medieval representation of heaven and hell, but I saw no angels and no flames. In fact, it all seemed to be happening on the outskirts of a city whose walls and churches I could see to the right of the man in red. I got to know the picture very well as I worked on the jigsaw, and although I didn't understand it I became obsessed with it, even at times having weird vivid dreams about it.

It was a reproduction of Domenico Michelino's 1465 painting of Dante and his Work. Years later, when I visited Florence for the first time as a young adult, I saw the original in the Duomo (Florence's magnificent cathedral, begun in 1294 during Dante's lifetime and consecrated nearly 150 years later in 1436). Looking at the painting was a pretty mind-blowing experience - re-living the feelings of fascination and bemusement I experienced as a child; while standing entranced before this masterpiece of imagination and technique which depicted so memorably the imagery of Dante's *Commedia*.

So, leaving the world of late republican Rome behind us, we remain in Italy but have advanced more than 1200 years ahead in time into medieval Florence. There is still a link with Rome, as the city actually had Roman origins. It had been established by Julius Caesar as a *colonia* in 59BC (round about the time that Catullus was courting Clodia). It was originally laid out as a garrison for Roman army veterans; the Roman grid plan of the streets is still evident even today between the Duomo and the Piazza della Signoria - which became the political heart of the late medieval Florentine Republic. The Piazza della Repubblica, bisected by the Via del Corso, is halfway between these two locations and is the site of the original Roman forum.

From its very beginning then, Florence was a place of significance. It had been situated strategically - below the old Etruscan hilltop settlement of Fiesole and in the wide valley of the River Arno; enabling the city to control the only feasible crossing of the river. In the 2^{nd} and 3^{rd} centuries AD Florence - *Florentia* (the flourishing or flowering town) as the Romans had named it - became a busy trading centre and a prosperous commercial hub, one of the provincial capitals of the Roman Empire.

The decline of the Roman Empire in the c4^{th} and c5^{th} AD and the spread of Christianity brought big changes to Florence and its surroundings. Formerly under the perceived protection of Mars - the Roman god of war - by the end of the c3^{rd} he had been displaced by St John the Baptist who was proclaimed patron saint of the city. A sort of vernacular rivalry between these two patrons was sometimes expressed by the Florentines; and as late as Dante's time the remains of a statue of Mars still stood on the Ponte Vecchio. As we shall see shortly, the later history of Florence in the early medieval period had its own bitter rivalries. The vicious conflicts between Guelfs and Ghibellines, then between Black Guelfs versus White Guelfs were very much the troubled backdrop to Dante's young manhood. I can't help wondering whether this was a more modern version of that old conflict – in the Romano-Christian era the Pagan

God versus the Patron Saint; in the Middle Ages the supporters of the Holy Roman Emperor versus the supporters of the Pope and the Church.

The centuries between the fall of Rome and the Middle Ages were turbulent ones for Florence. Repeated assaults by Byzantines, Goths and Lombards took place over the next three centuries, culminating by the end of the c8[th] in a take-over by the Holy Roman Empire under Charlemagne. The town again began to revive and expand; increasingly heading towards a sort of autonomy by developing its own self-governing administration run by Tuscan Margraves (princes of the Holy Roman Empire) and powerful local bishops – which led to the establishment of the Tuscan League by the end of the c12[th]. Florence was now a powerful city state, well-fortified and pre-eminent among the cities of Tuscany. The city had extended over the Arno, more bridges were built. and enlarged city walls ensured Florence's impregnability to attack from outside.

This was an era of burgeoning Florentine prosperity. The city's wealth was by now mainly generated by trade in textiles. Raw materials - wool and silk - were imported; Florence had long been a busy commercial trading hub. Skilled Florentine workers would turn these raw materials into luxury goods which would then be exported, generating large profits. These profits then fed into Florence's

other important business – banking. Yes, banking! It all started here - the money management institution which was destined to sit at the heart of the global economy right up to the present day and presumably far into the foreseeable future! The golden Florin, first minted in the c13[th], was to make Florentine financiers the most powerful in Europe. Members of the city's powerful banking families provided financial advice and services all over Europe, including to the Pope and many of the continent's monarchs.

It was also the period when the architectural glories of Florence would expand and develop. Gifted architects like Arnolfo di Cambio began to lay the foundations of some of those stunning monuments which still characterise the city today: Santa Croce, the Duomo (the cathedral of Santa Maria di Fiore) and the Palazzo della Signoria are just three of the marvels of this time. Existing monuments too were embellished - for instance the ancient octagonal Baptistery (dedicated to the city's patron saint and probably originally a Roman building honouring Mars) was enlarged, faced in marble and an octagonal lantern added to the roof. Further magnificent additions such as the famous southern doors and the glittering mosaics in the vault of the Baptistery's dome would take place in subsequent centuries. It was, however, already

sufficiently exquisite in the c13th to have been described in canto 19 of *Inferno* by Dante (who had been baptised there), as *'Il mio bellissimo San Giovanni'* (my most beautiful St John).

This, then is where we are now, looking at Florence in the c13th – a wealthy and powerful commune or city-state, well defended, busy, vibrant and successful - very much the 'flourishing town' that it had been dubbed by the Romans. On the wall of the Bargello (once the seat of government, now a museum) there's an inscription, probably put there round about 1255, which testifies to the ambition and civic pride of the city: *.que mare, que terram, que totam possidet orbem* ('…which owns the sea, the land and the whole world'). But, rather like William Blake's sick rose, there was a canker at the heart of this mercantile powerhouse.

Earlier I referred to the Guelfs and the Ghibellines. Florence, by the c13th, was a self-governing city state or commune with a constitution that had been developed over several decades and was designed to establish a form of democratic government for the city. The system aimed to move power and influence away from the old landed nobility who had previously ruled with totalitarian authority, prioritising their own interests and the sustainment of their traditional hegemony over the needs of the people. This new system was an

innovative and progressive prototype at a time when in most places power was still firmly in the hands of the aristocracy. Instead, here, government would rest with those whose industrial and entrepreneurial skills had made the commune wealthy - the bankers and merchants, the textile workers and manufacturers. Idealistic and radical it might have been - but it didn't really work.

The new system established a Priorate based on members of the different Guilds; six Priors were appointed from these associations to form a sort of cabinet for government. Each Prior served for two months; this meant a large number of Guild members could in turn be appointed to the legislature, but the brief tenure of the post limited what could realistically be achieved. Dante himself served as a Prior and found the system not only unstable but open to corruption. Political rivalries arose between members of the citizen body; resulting in the banishment of Priors whenever a rival faction attained power. The most bitter and damaging conflicts arose between the Guelfs and the Ghibellines.

These two groups were named after warring German families which had fallen out over support for, or opposition to the Holy Roman Empire. In Italy these divisions developed into a vicious ideological battle. The Guelfs were the Papal faction, fiercely

resistant to attempts by the Empire to re-seize control of independent Italian city states which had, in the past, been part of it. The Ghibellines, pro-Empire, came to power in 1260 and promptly exiled all the Guelfs from government. It didn't last long; six years later the Guelfs made a comeback and stayed in charge for more than thirty years, now all influential Ghibellines were banished.

We've seen in our own times how splits can also develop between different blocs in the same political party, The Tory 'Wets' of the Thatcher years; the 'Momentum' movement which propelled Corbyn to Labour party leadership, and the right-wing populism of today are just a few recent examples. Florence had the same problems; the ruling Guelfs in the late c13th split into to two factions, labelled the Black Guelfs and the White Guelfs. The split originated in rivalry between two influential families – the Donatis (Black) and the Cercis (White). The wealthy and influential Donatis, an ancient aristocratic family, could have no rôle in government due to the democratic constitution. Their leader Corso Donati, charismatic but ruthless, was bent on controlling the city and reinstating the aristocracy - the *grandi* - as they were called, to power. On the other hand the Cercis, a moneyed mercantile family, took part in the legislature but were disliked and despised by the *grandi* because of their *nouveau riche*

origins. This mutual enmity split the Guelfs down the middle and led to a state of civil war.

Turmoil therefore was the backdrop to Dante's troubled political career. A supporter of the White Guelf faction, in mid-1300 he was appointed to the Priorate. But by 1302 he had been banished on trumped-up charges as the partisan struggle between Blacks and Whites continued to tear Florence apart. He spent the rest of his life in exile.

This brief outline of Florentine history and politics is again a story of power struggles between men. But what about that almost invisible half of the populace - the women of the time? A pioneering form of democracy might have been established, but as about 50% of the adult population had no say whatsoever in the running of the commune, it wasn't really a democracy at all. The idea of including women at any level in public life was unthinkable. In the next movement we go behind the curtain to explore the lives of women during the period.

SECOND MOVEMENT: WOMEN

The account in the early chapters of Genesis of God's creation of the world and his placing of Adam and Eve in the garden of Eden must be one of the best-known stories from the Old Testament. Adam was

made first, Eve was then fashioned out of Adam's rib, thus from her very inception subordinate - God creates her *'as an help meet'* for Adam. It is Eve who, tempted by the serpent, picks and eats the fruit of the forbidden tree, and encourages Adam to do the same. By doing so she unleashes the knowledge of Good and Evil on the world. The pair of them are expelled from Eden; God tells Eve that she will always suffer for this transgression; he will *'greatly multiply'* her sorrow, particularly in the bearing of children, and that her husband is to rule over her. Eve - and by implication the whole of womankind - is thus established as weak, untrustworthy, and subservient. The doctrine of Original Sin has been established.

In early Christianity this idea formed a key part of the teachings of St Paul in the c1st AD. He was the great evangeliser, bringing the word of God to much of the Graeco-Roman world. Paul's interpretations of the Old Testament and his accounts of the ministry of Christ on earth would become part of the New Testament Gospels. The Old Testament - the key text of Judaism - was intrinsic to Christianity; without the Old Testament there would have been no New Testament. As the new religion took hold, for millions of people the stories and events told in the books of the Bible were believed as historical truth.

By the middle ages Christianity had spread over much of Europe. With it came the inherent concept

of woman as subservient to man. A few examples from the Epistles of St Paul suffice to make the point: *'Wives, submit yourselves unto your own husbands, as unto the Lord, for the husband is head of the wife, even as Christ is head of the church….'* (Paul's Epistle to the Ephesians, ch5 vs 22-23) *'Let your women keep silence in the churches, for it is not permitted unto them to speak ..And if they will learn anything, let them ask their husbands at home.'* (Corinthians Ch 14 vs 34-35,) *'Even so must their wives be grave, not slanderers, sober, faithful in all things….Let the deacons be the husbands of one wife, ruling their children and their own houses well.'* (Timothy vs 11-12)

So what was life like for European women in the late 13th and early 14th centuries? In general, the only women from the Middle Ages who made it into the history books seem to have been either queens - often described in pejorative terms as they were considered to have overreached themselves conduct-wise - (Isabella of Castile, Margaret of Anjou, Eleanor of Aquitaine) - or Saints (Catherine of Siena, Hildegarde of Bingen, Joan of Arc). The fact is that for many young women from moneyed or noble families, choice was limited: either marriage to a husband chosen by the senior males of the family, or becoming a nun.

We know even less about the lives of lower-class women. But in Florence, this city which had made

itself rich through the creation and merchandising of fine textiles, some artisan women would certainly have been part of the workforce. They were paid much less than men so it could have made good economic sense to use their skills. And it's likely that they were competent needlewomen, as on the whole the clothes people wore were made by the women of the household.

But still the main function of a woman, whether she was lowly or well born, was to bear and care for children, to support and service her husband and to manage the household, whether it be humble or grand. Most artisan women would have been illiterate though their brothers might have been taught to read and write. Paolo da Certaldo, a Florentine merchant living in the early c14th, brought out a book called 'The Book of Good Morals' which is a sort of manual of advice on customs, management and morality, On the education of children he says '*If the child be a girl she should be put to sew and not to read, for it is not good that a woman should know how to read, unless you wish her to become a nun*'.

I can't help thinking that the destiny of women from upper class families was in some ways even more limited than that of their more humbly born sisters. Without the imperative of work - whether it be helping out with the family trade, growing and tending a plot of land, buying foodstuffs and supplies

to support the family, making clothes for them all as well as childcare and all its necessary obligations - what was the purpose of life for the high-class lady?

It was, quite simply, to make an advantageous marriage to ensure the production of children; boys to continue the male line and girls who in turn would be married to a chosen husband and therefore ensure the future of his lineage. Keeping the family wealth to pass on to future generations was implicit in these arrangements. Quite a bleak and empty sort of life it seems to us, 700 years later. Is wealth, comfort and status more acceptable than a life of unremitting toil? Time would hang heavy - how did these women occupy themselves? We presume that they would have had some education – Paolo da Cervado's advice in his book of morals was aimed at the commercial and trading classes rather than the aristocracy. But it's likely that many of these upper-class women too could have remained illiterate - bearing children, managing a household, creating fine embroidery and attending to a husband's needs could all be done without being able to read.

Marriage at this time was a civil contract and not a sacrament. Neither of the couple would have had any say in the choice of partner; betrothals were often contracted when both were children. Dante, for example, had his wife Gemma Donati chosen for

him by their parents when he was twelve and she was ten; the contract was drawn up by his and Gemma's father in 1277. The Donatis were wealthy Florentine landed gentry, so the match was considered a good one for Dante; his family, though also gentry, were not rich.

The next stage in the process would have been the couple's consent - required by canon and civil law. This was a mere formality, entirely controlled by the two families; it was highly unlikely that either of the betrothed couple would have dared to refuse. Then the male members of each family would meet to draw up the marriage contract and agree on a dowry - to be signed by both sides before witnesses. The wedding itself was a civil ceremony in which the couple exchanged vows - with a priest possibly though not always on hand to give a blessing. The final bit of the procedure was consummation; the main purpose of the marriage being the begetting of children. Love didn't come into it, although as we shall see later, the emotions and effects of being in love were intense preoccupations for a plethora of writers and poets during the period.

Childbirth was a dangerous business, Neonatal and infant mortality was common, as was the death of the mother during or post-delivery. Post-natal infections carried off a lot of wives - indeed puerperal fever was still rife centuries later. No wonder a fair

proportion of young girls opted for the nunnery rather than marriage; no such danger there.

The other way a woman could achieve some sort of independence and control over her own life was by outliving her husband. As a widow, there were privileges available not just to wealthy women, but also to some of the female working population. Many women worked alongside their husbands in Florence's Guilds. They were denied Guild membership but did form part of the workforce, which meant a working wife was able to continue earning money after her husband's death. Indeed, many of the Guilds offered support to widows and children and encouraged women to carry on running the family workshop.

For women from higher-class backgrounds there were also advantages in widowhood. The purpose of the dowry, fixed as part of the marriage contract, was to ensure solvency for the widow in the event of her husband's death. The bulk of family wealth and property was transferred to the male heir(s) in the next generation but Dower wealth, which could include land, meant some widows found themselves not just solvent but independent.

The playwright John Webster, a contemporary of Shakespeare, makes this the central theme of his play *The Duchess of Malfi*. Although probably written in the early c17[th], the play uses several earlier sources based on Italian works as well as English versions of

the story prior to Webster's time. It's a fascinating and horrific tale of a wealthy widow and the attempts by her unscrupulous brothers to keep her money in the family.

The young, beautiful Duchess has inherited a considerable fortune and large property holdings from her deceased husband, the Duke of Malfi. She has no children so all this belongs to her alone. Her two brothers, determined to keep the wealth in the family, warn their sister that she shouldn't consider remarrying. Not only would all the property be lost to whoever she chose to wed, but the noble blood of their family could be diluted if she married a social inferior. *'Shall our blood, the royal blood of Aragon and Castile, be thus attainted?'* asks the younger brother. (Act 2 Sc.5) As we've seen, women of the Middle Ages and indeed well into the early modern period were under the control of the men of their family; the Duchess's brothers are a grasping and ruthless pair who will stop at nothing to prevent their sister remarrying.

Despite assuring the two of them that she has no intention of marrying again, the Duchess is in love with her steward Antonio, a wise and humane man but very much her social inferior. As such he can't propose to her, but she can to him - which she does - and they marry in secret. It is only when she becomes pregnant and starts to bear children that

her brothers find out. Not only will all this property be lost to them but the heirs to her fortune will be the children of the non-nobly born Antonio. Between them they plan a murderous revenge.

The play lays bare many of the negative stereotypes of the qualities of womanhood that remained current. Women were considered be less in control of their sexual appetites than men - and because she is a widow with experience of sexual union, the brothers insist the Duchess must be kept under very strict control for her own good. Chastity is constantly invoked as an essential feminine virtue. Meanwhile one of the brothers, a Cardinal of the church, is regularly committing fornication with a courtesan. One rule for men, another rule for women - had much changed since Clodia's perceived transgressions over a thousand years earlier? I suppose it was the addition of Original Sin and the implied culpability of Eve which added sexual shame to the mix.

Webster actually presents the Duchess as an admirable person, with courage, integrity and a steadfast defence of her right to self-determination. It's a powerful and gripping piece of drama and I highly recommend it!!

THIRD MOVEMENT: DANTE ALIGHIERI

I hesitate about my ability to give an account of this towering figure of Western literature, this poet and philosopher whose writing is one of the cultural glories of human achievement. Not just for the people of the Middle Ages and the Renaissance - when his *Divine Comedy* became in effect a best-seller - but for all of us right up to the present-day, Dante's writing continues to influence and inspire poets, artists, musicians and thinkers. His originality of thought and the power of his imagination, together with his exquisite use of language, his elegant command of poetic form and the profundity of his ideas, created in the *Commedia* an epic which, though coming from a very different era, continues to challenge and enthral the modern reader. According to TS Eliot, Dante and Shakespeare *'divide the modern world between them. There is no third.'*

I marvel how this man who died over 700 years ago can still cast a spell on the imagination, awakening images and ideas so vivid and so profound that one is led into a dimension of understanding hitherto unknown. I'm writing this as the world continues to battle Covid 19. Many people are leading lives of isolation and solitude and are living with no

small measure of fear. There are riots, instability, war and conflict in much of the world, as well as global environmental destruction on a massive scale. Dante's dark wood has never seemed more relevant.

There are lots of gaps in the biographical details of his life, but a plethora of richness and intensity lies in his written accounts of his thoughts and ideas. He was born in Florence in May or June 1265, into a White Guelf family; the eldest child of a mother who died while he was a child, and a father who died when he was in his teens. The family was comfortably off, not rich, from minor nobility but would today, I suppose, be described as part of the well-educated upper middle classes. As stated earlier, he had been betrothed at the age of twelve to ten-year old Gemma Donati, who he probably married in 1285; the marriage led to the birth of at least three, possibly four children. One of these, his son Jacopo, himself a minor poet, was to put together the complete text of the *Commedia* after the death of his father. It was received with enthusiasm, became a best-seller, and has been regarded ever since with esteem and admiration. At this stage it became known as *The Divine Comedy* – the word Comedy /Commedia chosen because the journey has a happy ending.

We learn about various of the important figures of Dante's era when he meets them in his travels through the three canticles, or sections, of the

Commedia (*Inferno, Purgatorio* and *Paradiso*). They don't include his wife Gemma, his parents, his children or his siblings. Some but not all these would have still been alive when he makes his fictional journey into the realms of the dead, however the only member of his family who makes an appearance is his great-great grandfather Cacciaguida, who he meets in *Paradiso*.

But it was as a politician and activist, not as a poet, that Dante first made his mark on Florentine life. While he was in his infancy the Guelfs had defeated the incumbent Ghibellines. In his early twenties Dante himself fought with the Guelfs against the Ghibellines at the battle of Campaldino. For thirty-plus years from 1266, Florence under the Guelfs had established a period of relative political stability, and as a young, articulate and highly intelligent man Dante enthusiastically volunteered his talents and abilities in the service of his native city. During this time, he was also writing poetry, sharing ideas with other gifted young men, and studying philosophy. With the encouragement of his close friend and fellow poet Guido Cavalcanti, one of the most intellectually able of his contemporaries, he started to write in the Tuscan dialect rather than the more traditional Latin. *La Vita Nuova* – the intensely personal mixture of poetry and prose which he wrote in praise of Beatrice - is in Tuscan Italian, this dialect

would in time become the accepted Italian language. Dante's poetry too was a key development in what became known as the '*dolce stil nuovo*' (the sweet new style) which developed beyond the current popular southern French poetic tradition, by intellectualising the structure and content of love poetry and extolling the spirituality and dignity of women.

Politically too his career was taking off. In consequence of his philosophical studies Dante was able to become a Guild member. In 1295, when he was 30, he was accepted into the Guild of Physicians and Apothecaries, which admitted philosophers, and this meant that he could now take an active rôle in government. However, the long period of Guelf stability in Florence was beginning to crumble. Factional infighting between the Black and While Guelfs led to a highly volatile political situation. Florence once more became a divided city, and Dante, in the public arena, was in the thick of it. While the Whites were in still in charge in 1300, he had been appointed to the Priorate, but the tide turned when the exiled Blacks re-entered the city and caused mayhem, secretly backed by Pope Boniface VIII and the French prince Charles de Valois. Meanwhile Dante, who had been sent to Rome as an emissary to the Pope, was detained there and not allowed to return. By early 1302 he had been exiled on fabricated charges and a couple

of months later he and a group of other Whites were condemned to be burnt to death. He never returned to Florence.

Dante's years of exile from his beloved Florence were to prove the very opposite of the arid desert initially he felt he had been consigned to, banned from his native and much-loved city. He never saw his wife again. Beatrice was long dead, and his political career was over. He tried at first to plan for a return to Florence, joining up with other exiled Whites, but soon became disillusioned. He had also become disenchanted with the papal cause which had underpinned so much of the Guelf ideology; finding in Boniface VIII a pope with unacceptable territorial ambitions and devoid of morality. So he turned back to his writing.

Planning a political and philosophical examination of human systems he started to write *Il Convivio* (The Banquet). This unfinished work, among many other ideas, promotes the idea of a non-church dominated culture, using the language of the people, rather than the traditional Latin which only the educated elite could understand. Dante expresses his ideas about innate human desire and how it can become corrupted by worldly aims, and suggests that philosophical understanding can act as a sort of referee in reaching religious truth. The idea is that understanding the desire for knowledge

from its origin, as an innate quality of the human condition, can help people to avoid following the wrong path and committing destructive acts. It's very idealistic, very intellectual - and by no means anti-religious - but alert to the damage which can ensue when religious leaders direct their desires to worldly power. The ideal, he says, to reach a position where the love of wisdom is synonymous with the love of God.

All this seems to be leading toward the extraordinary literary creation which will become the *Commedia*. It's written in triplets – *'terza rima'* – elegant three-line verses, each linked to its successor by a rhyming pattern: ABA; BCB; CDC and so on. It seems that Dante himself pioneered this verse form, which proves to be highly effective in his long narrative poem.

Dante's fictional journey into Hell (*Inferno*), *Purgatorio* and *Paradiso* starts when he awakes in a dark wood inhabited by wild beasts through which he can't find his way. He is confused and frightened. His real-life exile from Florence had given him an intense and searing understanding of rootlessness; as a homeless outlaw he had to find his way through and adapt to a new mode of living. Implicit in this first canto is the realisation by the fictional pilgrim Dante that he has to find another way out of the wood; metaphorically as well as actually. He is shown

that other way by the shade of the poet Virgil, his guide and mentor for most of the long journey ahead of him towards enlightenment. It starts with their passage into the horrors of the *Inferno*.

Virgil, the distinguished Roman poet who died in the late c1st AD, was the author of the epic poem *Aeneid*, also a story of exile. Aeneas escapes from the ravaged ruins of Troy with a small band of followers and has to find his way, dealing with travails, perils and challenges before he reaches the part of Italy where he will establish the city which becomes Rome. Like Dante in the *Commedia*, and like Homer's Odysseus before him, Aeneas visits the land of the dead. Here he meets with a succession of grotesque creatures as well as the souls of some of his own men, men who are condemned to eternal suffering because the requisite burial rituals were not enacted for them. Dante's *Inferno* is peopled with many of the same monsters as Aeneas's Underworld, but here there is no Land of Joy or Fortunate Woods for the souls of the Blest as there is for Aeneas. Guided by his father Anchises, Aeneas reaches Elysium through pleasant green meadows where the heroic and virtuous live. Dante however has to pass from the *Inferno* through *Purgatorio* before he reaches the *Paradiso* of the *Commedia*. Virgil can't accompany him there; having lived his life as a pagan his is a soul which can't be saved. I like to imagine Virgil

returning to spend his immortality in the Elysian Fields of Greek and Roman mythology rather than in Limbo!

Aeneas is introduced by his father to the soul of his as yet unborn son, together with several more yet to be mortal heroes of the future, figures who will feature in the glorious story of Rome still to come. Dante deals with the future in a different way.

He started to write the *Commedia* probably around 1307 and finished it more than a decade later, not long before his death in 1321. He sets it however a few years earlier in 1300 - around Easter - starting on Good Friday when the Dante of the poem goes down into the *Inferno* and emerges onto the shore of the *Purgatorio* three days later at dawn on Easter Sunday.

The poem begins *'At one point midway on our path in life...'* As the Bible deems the lifespan of mankind to be threescore years and ten, one assumes the fictional pilgrim Dante to be 35 years old, which indeed the real Dante had been in 1300. This means that Dante the writer has knowledge of the immediate future and is therefore able to direct the fates of his characters and the events of their times with precognition. In the course of the *Commedia* Dante the pilgrim meets several of his contemporaries - among them his old teacher, Brunetto Latini, and his friend Forese Donato, as well as political enemies such as the Ghibelline leader Farinata degli Uberti.

They are able to tell him what is going to happen to him in real life - including his own banishment.

As one journeys through the *Inferno* with Dante the pilgrim the impressions come thick and fast - with dramatic descriptions of stinking swamps, burning rain, vile monsters and apparitions - and the torment and bitterness of those desperate souls who've been abandoned there for all time. They include characters from the distant and more recent past and are classified according to the nature and severity of their vices in the nine concentric circles of Hell. But there's also a compelling undercurrent the reader is never unaware of - Dante's own history - the political power struggles and the internal strife which has corrupted and poisoned his native city. The final canto of the *Inferno* brings us to the very heart of Hell, presided over by Lucifer the fallen angel; no longer the bright Son of the Morning who had been cast out from heaven for the sin of Pride, but a hideous slavering giant with three faces and leathery bat-like wings. There are no flames of Hell here, this monstrosity is trapped in ice and is chewing on the bodies of the wicked.

With extraordinary skill and daring Virgil extricates the pair of them from the pit of Hell and brings them out the other side. To his surprise, Dante the pilgrim, having scrambled with Virgil up the back of the fiend, sees his guide with superhuman

effort swivel its head and body right round so it is now upside down, they then escape between its thighs through a cleft in the rock above them. He is amazed to see, when he looks back down, that the legs of the monster are now upended below him. The design of the *Inferno* is like the top half of an hour-glass, with the pit of hell in the narrowest bit in the middle. When the two of them get through that fissure in the rock, they have passed along the narrow stem of what was the bottom half of the hour glass until the Satanic figure was flipped over by Virgil. They are out of Hell and on their way to Purgatory.

Dante the writer then produces another ingenious and inventive conception by creating a mountain on the other side of the world. This was caused, Virgil tells the pilgrim Dante, by the land displaced by Lucifer when he fell from heaven into the pit. Dante obviously knew the world was round; here they are now in the southern hemisphere - on the antipodal axis through the globe from the holy city of Jerusalem - and are on the foothills of the mountain of the *Purgatorio*. As they walk on, Dante ends the first canticle of the *Commedia* with these evocative lines: *'We climbed, he going first and I behind, until through some small aperture I saw the lovely things the skies above us bear, now we came out, and once more saw the stars.'*

Purgatory – *Purgatorio* - is a completely different set-up from the hopeless eternal suffering and ghastly surroundings of all the sinners in Hell. Here there is hope. The sinners here - their transgressions deemed less grave than the mortal sins of the hapless inhabitants of Hell - have the chance to reflect on their wrongdoings and work on changing the pathological disposition which led them into sin. They undergo punishment in Purgatory - harsh and apposite to the offences they committed when alive. The proud, for example, are doubled up heaving huge boulders, a corrective to their hauteur. The avaricious have to lie face down on the ground, their hands and feet bound, so they can no longer grasp at riches. The souls of the envious are clad in penitential grey and their eyes have been stitched shut with wire, so they are unable to see and covet other people's possessions.

There are seven terraces in Purgatory, each corresponding to one of the seven deadly sins: Lust, Gluttony, Avarice, Sloth, Anger, Envy and Pride. But despite the punitive regime, this is a place of hope. These are souls who are in a process of change. The penitents welcome their punishments and the necessity to reflect on their faults, because these penances will lead to eventual absolution and the way to heaven. There is constant music and prayer, rock carvings of biblical and classical scenes illustrating

exemplars of the virtues, and instead of demons and monsters the place is run by angels. Before the first terrace is a sort of holding area for those who never got round to repenting when they were still alive - they must wait before being allowed to travel up the mountain. And above the top terrace is the Earthly Paradise, the Garden of Eden and the gateway to the heavens.

Dante the pilgrim is more proactive in *Purgatorio* than the horrified onlooker he was as he travelled through the *Inferno*. For him too it is a chance to reflect on his own errors. He learns as he ascends, realising through the encounters he has with other pilgrims, that it is only through acknowledging and working on past failings that he will be accepted into heaven. The significance of love above all other virtues will become clear to him when he reaches the Earthly Paradise. But that also means that Virgil must leave him; there is no place for the pagan Virgil in the Christian Paradise. Dante's main guide and mentor in *Paradiso* will be the divine Beatrice - the angelic spirit of the human girl he has loved since he first saw her when they were both children. So let us now turn to Beatrice: Muse and inspiration for so much of Dante's writing.

FOURTH MOVEMENT: BEATRICE (BEATRICE DE BARDI NÉE BEATRICE PORTINARI)

The identity of Dante's Beatrice is generally considered to be that of the daughter of Folco Portinari, from the noble Portinari family of Florence. The *Vita Nuova* (The New Life), Dante's prose and poetic chronicle written over a ten-year period from around 1283, describes his love for her from the first moment he saw her. It's a sort of autobiographical account of his developing ideas on the nature of love, illuminated and inspired by his feelings for her.

That life-changing first meeting took place when they were still children; he was nine years old and she a little younger. Was it in her home or his? Were they both at some sort of party - possibly a child's 'name day', the day commemorating his or her patron saint after whom he or she was christened? Giovanni Boccaccio, in his *'Life of Dante'*, suggests that it was a May Day party, which took place at the Portinari house; this implies that the Alighieris and the Portinaris were known to one another. They were certainly from a similar stratum of society; the Portinaris were richer, but the Alighieris, though not rich, were higher-class. As Boccaccio was born

during Dante's lifetime (living from 1313-1375), much of what is assumed about Dante's life derives from Boccaccio's narrative. These details include the identification of Beatrice and a lot of other information which has over the centuries served to fill in some of the missing aspects of Dante's biography. I should however add that there is, so far, no way of categorically validating all Boccaccio's assertions..

Dante himself gives us little information about the occasion other than the overwhelming impression this first meeting made on him. He must have been an unusually sensitive and ardent little boy, because he relates how the sight of Beatrice made him tremble. In the *Vita Nuova* he recalls every detail of that first encounter - the *'goodly crimson'* of her gown and her *'noble and praiseworthy'* demeanour, describing her as *'this youngest of the angels'*. Thereafter he kept the image of her in his mind and in his heart. Biographers have suggested that this childhood encounter could have taken on the crucial significance it did for him because of the untimely death of his mother when he was still a child - it seems that this happened sometime around 1270 when he would have been about five. His father appears to have remarried fairly soon afterwards.

According to the *Vita Nuova*, over the next few years Dante saw Beatrice again several times, but

whether these encounters led to the two getting to know one another he doesn't relate. Meantime of course, he had become betrothed to Gemma Donati. Presumably at some time in this period Beatrice too was betrothed, to the man who certainly by 1287 was her husband - the banker Simone de Bardi. We can date this because there's a bequest in her father's will of 1287 leaving her a legacy and naming her as his daughter, the wife of Simone de Bardi. Both father and husband came from comfortably off banking families.

Dante's next descriptive mention of her in the *Vita Nuova* comes nine years exactly after that momentous first meeting when they were both children. Dante describes it thus: '... *it happened that the same wonderful lady appeared to me dressed all in white, between two gentlewomen older than she. And, passing through a street, she turned her eyes towards me where I stood humbly, and thanks to her ineffable benevolence and grace, which now is rewarded in eternal life, she greeted me with such power that then and there I seemed to see into the very limits of blessedness*'. There's a famous late c19[th] painting by Henry Holiday of this encounter, in the Walker Art Gallery in Liverpool.

This meeting and the disturbing dream he had afterwards became the subject of a sonnet in which he tries to understand the meaning of the dream and the qualities and demands of Love.

During the early Middle Ages, much of European love poetry had followed what was known as the Provençal tradition, lyrical and courtly - as set out by the 12th century Frenchman Andreas Capellanus. His treatise '*De Amore*' ('On Love') comprised a sort of instruction manual for young men, defining the meaning of love, offering advice on courtship - which should be an ennobling experience for the lover - and looking at examples of love between selected couples. The manual was in general aimed at noble or upper-class youths. In line with the accepted practices of the time, this sort of courtship didn't need to have anything to do with marriage - which as we saw earlier was a business arrangement between two families. It became fashionable to have an inamorata, to give her love-tokens and write songs and poems to her, and if possible, to perform daring deeds on her behalf. The young man might also experience the physical effects of being in love - insomnia, loss of appetite, pallor and increased heartbeat. Capellanus is generally rather dismissive of the female half of any couple – he warns young men that women are untrustworthy, weak minded and vain - and inevitably he invokes Eve as an example of cupidity in womanhood.

For Dante and his fellow Tuscan poets, there was much more to the meaning of love poetry than this Provençal 'troubadour' style. Through his love for Beatrice and his idealised and spiritual view of

her he was able to examine both the physical effects this love had on him and to explore the changes it brought to his mind. It made him think not only of his feelings for her, but to ask himself how and why he felt as he did, and how it affected the way he conducted himself. Earlier I mentioned the '*dolce stil nuovo*' (sweet new style) of poetry which Dante and his friend Guido Cavalcanti were establishing; Dante's reverence and respect for Beatrice as an exemplar of holiness and grace was very much in the spirit of this new style.

The quality of loving is a universal human emotion, but it can be used to both good and evil purpose. One of the most powerful and emotional episodes in the *Inferno* is Dante's meeting with Francesca di Rimini - who with her lover Paolo has been condemned to eternal damnation for committing adultery. Such a judgement seems inconceivable in today's morally permissive society. Posterity has indeed been kind to Francesca; she has inspired paintings, opera, theatre and dance. Her explanation to Dante is poignant and eloquent - she is greatly distressed by the severity of their punishment. Today she would probably be viewed as a heroine and a victim, particularly as the pair were murdered by the cuckolded husband. But Dante points out that this immorality is compounded by more than the illicit love affair; there was a single-

minded self-centredness in the actions of the pair. They did what they knew was wrong, without regard for anyone else. The other factor, highly significant in Dante's time but of negligible import today, was that Paolo was her husband's brother and therefore her own brother-in-law. This was considered incest at the time and a mortal sin - if anything a worse transgression than their adulterous affair.

Dante continued chronicling his love for Beatrice in the prose and poetry of the *Vita Nuova*. He describes her appearances in his dreams and his reactions to events in her life - his sadness when she left town for a while, his hurt when one day she failed to respond to his greeting, and his anguish on her behalf when her father died. He literally became physically ill with love; in his delirium at one point, he dreamed that she had died. Tragically she did die not long afterwards, in 1290 aged only 24. Mortality among young women often as a result of pregnancy or childbirth was common at the time.

Dante read great significance into his premonitory dreams, so when, as he says in the *Vita Nuova* *'The Lord God of Justice called my most gracious lady unto himself'*, I think, looking at his writing during this sad time, that, broken-hearted though he was, he accepted that she was too good for this world. He says in one of the poems from this period, talking of God *(the Eternal Lord):* that…*a sweet desire entered*

him for that lovely excellence Counting this weary and most evil place Unworthy of one so full of grace.... It's very hard for us, in this modern and largely secular age, to imagine the state of mind and the religious fervour which occasioned these thoughts.

For Dante, Beatrice's death did not mean she was lost to him. The thought of her continued to uplift and inspire him throughout the travails and tribulations of his own life; she seems in effect to have become, for him, a guardian angel who was watching over him from Paradise. It is Beatrice who sends Virgil to guide Dante the pilgrim away from the crisis of his confusion and distress in the dark wood at the beginning of the *Commedia*. And it is Beatrice who is waiting for him in the Earthly Paradise when he has made it through the *Purgatorio;* she will be his guide as she leads him into heaven - *Paradiso.*

How then do I enter into Beatrice's world and try to envision some of her thoughts? I've talked about Dante the writer and Dante the pilgrim, the first being the real-life person who was alive in Italy in the late 13th and early 14th centuries; the second the fictional pilgrim who makes that compelling journey through the *Inferno* and the *Purgatorio* to *Paradiso.*

Perhaps I can try to do something of the same thing with [2]Beatrice.

Let us imagine her then, in the family chapel for the service of Vespers - evening prayer. Bice is a devout and dedicated disciple of the Virgin Mary and usually observes the holy offices several times a day. But today she is finding it difficult to concentrate on prayer. She is in pain. When she awoke this morning, it was just a nagging ache in her back, but despite her maid's gentle massage with unguent of herb-infused oil the pain is getting worse. She rested during the day but could not let the sun go down without an act of prayer, so here she is, her mantle wrapped around her, her head veiled, praying to the Holy Virgin for the life of her unborn child.

It is too much early for the baby to be born. Bice knows that the little one needs many more months inside the protection of her swelling body in order to live. She tries to distract herself by considering other possible reasons for her pain. Yesterday she ate some green lentil polenta with salsiccia - had the sausage been too strong flavoured - she remembered thinking it had tasted a bit pungent? Or was it the figs and grapes she had enjoyed afterwards - perhaps

2. *Bice as she was known; the Italian pronunciation of this*
 diminutive is 'Bee-chay'

her pain is a punishment for having over-indulged on those tempting delicacies.

Bice is longing to be a mother. She is often lonely. Her husband Simone is absorbed in his work in the family banking business and is not much of a companion. She imagines holding her child close in her arms and experiencing the love and tenderness she can see in paintings of the Blessed Virgin Mary cradling the infant Jesus. She thinks of her baby growing into childhood, perhaps a little girl dancing and playing, blithe and carefree as she herself had been at that wonderful May Day party when she was eight years old. How pretty she had felt in her new red gown! How delightful it had all been in the May sunshine, she and the other girls crowned with flower garlands to welcome the spring. She remembers a particular little boy, seemingly so excited too that he couldn't keep still, smiling tremulously, his body shaking as he watched her dancing.

He seemed repeatedly to crop up in her life after that. Although she knew who he was, he wasn't part of her close circle of friends, and sometimes, seeing him, she found his attention a little unnerving. But once, more recently, when she met him yet again, now a gangling, anxious-looking youth, she felt sorry for him and a little sad. That time she wasn't on her own, she had two companions with her; which gave

her the courage to smile at him and greet him, hoping it might ease his anxiety.

But these wandering thoughts don't work for long as a distraction. The pain is getting worse. Bice makes it back home, supported by her maids, kind and concerned. They all know that the baby isn't due yet, but the older ones among them are exchanging uneasy glances. They can see what is happening. The baby is on its way, far too early.

As the pains intensify Bice tosses and turns on her bed this way and that, semi-delirious now with grief and suffering. Images parade through her head - somehow wound up with the memory of that troubled young man of her childhood. She sees him in scenes of horror - her own agony creating visions of tortured people struggling in landscapes of fire and ice, monstrous beasts and demonic spirits whirling around them. Even in the midst of the torment of her own suffering she knows that he needs help too.

It is over. The baby, tiny, red, wrinkled, is born - too weak even to cry, its life finished before it has started. Bice is exhausted and bleeding. Her maids bustle round with cloths, their subdued voices a quiet murmur as she drifts towards unconsciousness. But gradually a strange feeling of peace begins to flow through her and a wonderful realisation dawns as everything becomes clear. She is no longer trapped in that aching, pain-racked body. Suddenly a great

splash of light illuminates the horizon over an endless garden full of flowers and trees. Tendrils from the rambling roses there stretch out to her and winged angels waft her in. And as she arrives in this holy place, she understands at last how she will be able to help that confused and unhappy young man.

CODA

It's not known why Beatrice died so young, but childbirth is a very possible reason. It is estimated that maternal mortality in the Middle Ages could have occurred in as many as a third of births, and that excludes premature births. If a woman delivered a still-born baby it was also highly likely that she too would die. One in four infants didn't survive their first year of life,

A commonly held belief was that a developing foetus had no soul until its brain had fully developed. But because of the theory that all human beings, when born, already possessed Original Sin, a dying newborn baby wouldn't be able to enter the Kingdom of Heaven unless it was quickly baptised. In the *Inferno* Dante places Limbo, the hinterland where pagans and the unbaptised are housed, in the First

Circle of Hell. This is not a place of punishment, but its inhabitants, including all those unbaptised babies, are denied entry into Paradise. My idea of making Beatrice's baby so premature was to spare her the anguish of her unbaptised child going to Limbo; as at only a few months gestation the baby might not have been considered yet to have a human soul.

In reality, it seems most likely that Beatrice left no children. Her widower, Simone de Bardo (generally known as Mone), remarried soon after her death and there's a record of his daughter Francesca getting married in 1313. Since Beatrice died in 1290 it's probable that Francesca was the daughter of Mone's second wife, Sibilla. There were also two other children; a son, Bartolo, and a daughter, Gemma, neither of whom are thought to have been Beatrice's.

Episode 3

Laura

FIRST MOVEMENT: BACKDROP

*O*nly a few decades divide the life of our next poet Francisco Petrarca from our previous one. Both Dante and Petrarch came from the same part of Italy. The political unrest which impacted so profoundly on Dante's life was also to have an overwhelming effect on Petrarch's family. At first glance then, it might seem that there is little more to add. But Petrarch's life was to develop in a very different direction.

Like Dante, Petrarch came from a Florentine family; Dante was actually still alive and coping with his permanent exile from the city in 1304 when Francisco Petrarca was born. Petrarch's family too

were forced into exile. His father [3]Ser Petracco, a notary or lawyer, had been ordered to leave Florence in 1302, the same year as Dante's own banishment - he was, again like Dante, a victim of the brutal Black Guelph takeover of the city.

Charged with malpractice by the authorities, ruthless penalties were imposed on Ser Petracco. His small property in Florence was confiscated and a huge fine imposed on him which he had no hope of being able to pay. The appalling and unacceptable alternative to the fine was to have his right hand chopped off; an atrocity which would render him unable to pursue his profession, involving as it did a lot of written work in drawing up contacts, producing reports of legal proceedings and other such duties.

Refusing to pay the fine and in order to save himself and his career, Petracco fled with his wife Eletta to Arrezzo, about 50 miles south-east of Florence, where he hoped he would again be able to practice. His son Francisco was born there in July 1304 followed (after another move) three years later by another son, Gherardo.

It was however to be France, not Italy, which would provide the backdrop for Petrarch's formative

3. *Ser was the commonly used abbreviation of the word of the word Messer, meaning 'gentleman'*

years. Once more the troubled and often violent relationship between papal and secular power was the reason behind the family's next new move,

To clarify this, I'll try to outline some of the circumstances which led to what was to become known as the Avignon Papacy.

In 1309 the incumbent Pope, Clement V, who had himself been born in France, made the unprecedented decision to move the papal court, the Curia, to Avignon. He had refused to come to Italy when elected Pope - his coronation in 1305 took place in Lyon in France. Clement was probably voted in by the conclave as a sort of compromise candidate - he had never been a cardinal and he was not an Italian. This may have been intended to establish a sort of much-needed neutrality after a period of stalemate - riven by acrimonious disputes and disagreements in Rome between French and Italian cardinals. Such squabbling had already caused a year's interregnum after the brief tenure of the previous Pope, Benedict X.

Turmoil and factionalism had been raging for much longer. It had become particularly vicious during the incumbency of Benedict's predecessor, the powerful but corrupt Boniface VIII - he who generated so much opprobrium in Dante's *Commedia*. Boniface had involved himself forcefully in matters temporal as well as spiritual, asserting the pre-

eminence of the church over secular heads of state. Those who opposed him got short shrift. In 1303 Boniface excommunicated the French king Philip IV. But this Pope in the end got his come-uppance; King Philip's army attacked him at his palace and demanded his abdication. After the short-lived papacy of Boniface's successor Benedict X, during which Philip consolidated the French interest, it was rumoured that Clement V, (Bertrand de Got as he was before his election to the papacy) had made a secret pact with the French king. If he became Pope, he would move the Curia and all the trappings of the Papacy to France. (Incidentally, Pope Clement too makes his appearance with other corrupt and dishonest popes in Circle 8 of Dante's *Inferno* as '*the lawless shepherd*'!)

By now, the French faction, under Philip, had the upper hand. The new Pope declared that, events in Rome having caused such violence and dissention, the city was no longer a fit location for God's earthly representative and his court. Clement set up his court first in Poitiers and then in Avignon. This was where the Petracco family arrived in 1312, where an experienced and able lawyer such as Ser Petracco might very reasonably find employment as a notary at the papal court.

Today Avignon is a charming Provençal city, situated at the confluence of the rivers Rhône and

Durance. An important trading post since well before the Roman era, it had been a valuable prize for Julius Caesar, who captured the city in c1BC and extended the port. Avignon retained its importance throughout the Imperial period, becoming a Colony under the emperor Claudius and a Roman City under Hadrian. The robust Roman city walls were able to withstand early raids by Vandals and Goths after the decline of the Roman Empire, however later invasions saw Avignon fall to a succession of attackers, culminating in the Arab takeover of Provence in the c8[th] AD. By the 11th century it was part of the Holy Roman Empire; the city and its surroundings forming part of the Kingdom of Arles, ruled by the house of Anjou. Still part of this kingdom when the Avignon papacy began, Avignon was now part of a territorial entity not unlike the Italian city states.

Philip IV (known as Philip the Fair) was a son of the royal Capet family, king of much of France, with influential family members strategically installed in many other European kingdoms. His lands in France surrounded the Kingdom of Arles on all sides, making him a powerful and dominant neighbour, able to exert his authority without serious challenge. Working with Clement V to secure Avignon as the home of the papacy was a huge win for him.

Avignon is still dominated by the monumental edifices of the medieval papacy, This endured in

the city till 1377, when Pope Gregory XI managed to return the Curia to Rome. The imposing papal buildings remain - the *Palais des Papes* being the most striking and memorable. In fact, two adjoining palaces were built, the first in 1334 (the *Palais Vieux*) is quite an austere looking building - well fortified and stark. Ten years later came the much more elaborate *Palais Nouveau,* decorated with architectural embellishments and very much in the high Gothic style.

The medieval city walls also date from this period, but the remains of the famous St Bénézet Bridge are older - built in the 12th century originally, with 22 arches and considered one of the wonders of the time. It was the only bridge over the Rhône - immortalised in the song '*Sur le Pont d'Avignon*' (familiar to generations of children both French and English) - and part of a pilgrims' route to Italy and Spain; another factor which probably influenced the choice of Avignon as the new home for the papacy. Sadly, the bridge couldn't hold out against swirling river currents of the Rhone in spate; it was repeatedly broken and eventually abandoned in the c17[th]. Four arches remain, with the exquisite Romanesque chapel of St Nicholas over one of the buttresses. Avignon is still a most fascinating and beautiful city which has played a significant part in western European history.

But for Petrarch, who grew up in the area, the place had few charms. He describes it in one of his letters as '*a sewer where all the muck of the universe collects*' an allusion as much to the violence of the Provençal mistral wind as to the decadence of the city. He continues '*There God is held in contempt; money alone is worshipped and the laws of God and men are trampled underfoot. Everything there breathes a lie...*' He was not alone in his condemnation. Italians at the papal court nicknamed the city Babylon - emblematic of the Babylon of the Bible which God destroyed in response to its idolatry and the worship of false gods, the wickedness and self-indulgence of its inhabitants and the general depravity and corruption of the place.

Certainly, medieval Avignon had its fair share of criminals and heretics, and like many other cities at the time there were brothels aplenty. There were also fraudsters and usurers plying their unsavoury trade, as well as gangs of soldiers of fortune ready to carry out acts of violence for money. All his life Petrarch yearned to return to Italy, which always seemed like a promised land to him, and which he glorified in elegiac fashion as a sort of Elysium in much of his poetry. However, the sad reality was that this sleazy nether-world was (and indeed in part still is) a feature of cities all over the world including in his beloved Italy. It was mainly the presence of the Papal

Court at Avignon and its perceived immorality which aroused Petrarch's condemnation; in a vituperative poem he accuses the Church there of being a *'nest of betrayals'* …and *'a slave of wine, of beds, of food'*… where *'throughout your rooms young girls and old men carry out their affairs'*. His innate veneration of Rome as the pre-eminent city of the known world made the very existence of the Avignon papacy an offence to him.

Interestingly, the above quotation is my first mention of girls in this movement. Let us now, then, delve a bit further into some of the lives of women in France in the Middle Ages.

SECOND MOVEMENT: WOMEN

In the last Episode I mentioned the Provençal writer Andreas Capellanus (in his native France known as André le Chapelain) - the c12[th] author of a four-part treatise on courtship known *as 'De Amore;,* a handbook of advice and instruction for young men on the art of courtly love.

Women don't come out too well in Capellanus' discourse. He suggests that in liaisons with a peasant woman the young man should 'puff her up' with lots of flattery, then embrace her by force - in effect rape her. I can't help being reminded of Thomas Hardy's *'Tess of the D'Urbervilles'* written about six centuries

later, and the episode in which Alec D'Urberville subjects poor Tess to precisely the same brutal treatment - sweet talk followed by rape.

Capellanus also adds that nuns are often ripe for seduction, though in all fairness he doesn't really advocate such couplings. With regard to prostitutes, he says they should be *'shunned absolutely'*, the main reason being that they always expected some sort of present or remuneration, as well as damaging the young man's good name.

On the whole, courtly love, he says, should be pursued between individuals of similar social classes. However even suitable women don't get a very good press. Quotes from the manual include such comments as: *'everything a woman says is said with the intention of deceiving'*; many women are *'slanderers filled with envy and hate'* and *'tortured by envy of all other women's beauty, even her daughter's'*. As previously stated, predictably the transgressions of Eve are also repeatedly invoked as evidence for these undesirable attributes.

With regard to the realities of womens' lives in the Middle Ages, much of what I have already said in the previous Episode about women in Italy would have been similar in France. Peasant women would work on the land alongside their husbands; sometimes both man and wife would effectively have been bonded serfs to the Lord or landowner.

Artisan women would likewise have been occupied in supporting whatever the family trade was; and as in Italy, might have continued managing the family business in the event of their husband predeceasing them. For upper-class women the practice of arranged marriage was a contract designed to perpetuate the husband's lineage and conserve the family wealth and property. And of course, the other traditional domestic duties for women including the bearing of children and the care of the home were all part of the package.

So instead of going over the same ground, I intend first to look at two contrasting examples of women's lives in medieval France, exploring the way in which they dealt with their subordinate status and coped with the patriarchal world they inhabited. I'll then end this movement by taking a look at the life and work of the remarkable medieval French woman writer, Christine de Pizan, who really did 'break the mould' in her life and work and is still highly acclaimed today.

Earlier I referred to brothels in medieval Avignon. The attitude of the Church to prostitution was a conflicted one - on the one hand it was a sin, because it involved repeated acts of fornication, condemned in scripture. But on the other hand, it was accepted by ecclesiastical authorities as being what might be described as a necessary evil. Young men would seek

out prostitutes to satisfy their sexual urges, thereby sparing respectable women from the danger of unacceptable lustful advances. Remarkably, in 1358 the Grand Council of Venice made a declaration asserting that prostitution was '*indispensable to the world*'. Certainly in later centuries Venice developed a reputation for a relaxed and libidinous lifestyle where adultery was institutionalised - Lord Byron, who loved the place, in the 1820's described it at Sea-Sodom!

The medieval Church, then, didn't fail *officially* to condemn prostitution - while simultaneously condoning it on the sly. Clergy urged prostitutes to reform - even suggesting that they might consider becoming nuns - and there were actually sanctuaries established for women who wanted to leave the profession. But covertly it was acknowledged it could never be eradicated; the demand was too great, not just from young single men, but also from married men. Even members of the clergy availed themselves of this service.

The municipal authorities in towns like Avignon tried to clamp down - either by expelling prostitutes from the area or confining them to a designated area in the city. This didn't really work however because it led to those areas becoming part of the anarchic criminal underworld, attracting all manner of villains

and malcontents to the vicinity and threatening civic stability.

The effects of sexual promiscuity often led to venereal disease (probably gonorrhoea; syphilis hadn't yet emerged) - categorised as the result of sin. Paradoxically, at the same time regular sexual intercourse was believed to be important to the health of a man's body. As for the prostitutes, they had to make a living. Euphemistically described later as 'City Tolerance Houses', brothels were run as businesses. They were usually managed by men, but some even in the Middle Ages had female proprietors. And as part of a municipal system, sometimes these establishments actually appear on the rent rolls of particular cities.

What we don't hear at all in this period is the voices of the prostitutes themselves. In the next two hundred years - as the Renaissance advanced - high-class courtesans such as Veronica Franco became public figures. She, well-educated and literate, published poetry, was an accomplished musician and a philanthropist, concerning herself with the plight of elderly and sick prostitutes. But we can only imagine the inner lives of those medieval women earning a living in the sex business; supporting one another emotionally, sharing experiences and maybe laughing together about some of their customers. Doubtless some of them were conflicted as to the

morality of what they were doing, but they needed like every other human being to be able to live, eat, and care for their children. And while there was concern about the health issues experienced by their clients, these women too would have been prey to sexually transmitted diseases. Who, I wonder, would have treated them?

My next example of active womanhood in the Middle Ages is at the opposite end of the spectrum. In the early c13th, a group of women in Bruges - not nuns or associated to any specific religious order but with devout and altruistic ideals - founded a semi-religious lay group to minister to the poor. They became known as the Béguines, and over the next hundred years communities of Béguines would become established in the Netherlands, Germany and France. These women weren't bound by permanent religious vows and came from all ranks and walks of life. They didn't live in convents, although as the movement spread some of the larger groups might form what became known as Béguinages - groups of dwellings on the outskirts of a town.

Their work was mainly aimed at helping the urban poor, but some of them also worked in local trades. The cloth trade in the Netherlands for example employed many Béguine labourers, and in Paris there were Béguine workers in the city's silk production industry. Some Béguines might plant

gardens and sell produce, others would work at spinning, weaving and other such occupations. At the same time they would be engaged in fund-raising and would accept donations to finance their good works. Wealthier women might contribute some their own resources to the work of the group, but there was no obligation to give up personal property or fortune.

Different groups of Béguines were able to develop in varied ways, because there was no overriding rule of practice as there was for members of a specific religious order. In short, all that was required of a Béguine was to have sincere religious faith, to be committed to helping the poor, and to spend part of each day in prayer and devotional activities. Entirely benevolent in intention, these women were really ahead of their time; today's philanthropic institutions and volunteer-run charities are in many ways a development of the same tradition.

The established Church, though, was ambivalent as to its view of them. A religious group which made its own rules did not fit well with the accepted ecclesiastical and patriarchal patterns of devotion to a holy life. While some individual clergy supported the Béguines and welcomed the help they were giving to the poor, others began to see the variety and fluidity of the different groups as heretical. Any rigid bureaucracy is threatened by liminality.

The Béguines - not members of any religious order (though many followed the rule of St Francis), not under the control of any ecclesiastical orthodoxy but instead managing their own lives and mission - could be seen to be transcending boundaries in an unacceptable way. The other troubling aspect of the Béguine movement - disquieting to both Church and Laity - was the commitment of many of these women to celibacy. Unless she was a nun, a woman's duty was to marry. All in all, the Béguines, living outside the cloister, seemed to be 'having their cake and eating it', as it were - hanging on to their own possessions, enjoying the freedom of life in the outside world and running their own lives without male authority.

By the beginning of the c14th this disquiet was growing. Marguerite Porete, a deeply spiritual Frenchwoman born probably around the middle of the c13th, was a Béguine and a mystic. Not much is known about her life but she was well educated so probably came from a well-off family. What she is remembered for is the book she wrote sometime during the 1290's, called '*The Mirror of Simple Souls*'. It's about the relationship between love of God and the human soul - she says that in the state of pure love for God, there is no need for ritual and prayer, because the soul becomes united with God so is at one with the Almighty. This, she says, is what human beings should strive for in their spiritual journey.

Unsurprisingly the Church wasn't impressed. No need for masses? No need for ritual? No need for prayer? To add insult to injury, the book was not written in Latin, the language of the Church, but in vernacular French. She was denounced as a heretic and the Bishop of Cambrai had copies of the book burned publicly in the square at Valenciennes. To plead the validity of her ideas, Porete then approached various theologians - a Franciscan friar, a Cistercian monk, and an academic from the University of Paris, asking them for their judgement on her book. All said it wasn't heretical - but the authorities didn't agree. Porete was ordered to withdraw the book, and when she refused, was tried by the Dominican Inquisitor and imprisoned. Refusing again to recant, she was burnt at the stake in Paris in June 1310.

This was early on in the period of the Avignon Papacy. The new Pope Clement V, under pressure from Philip IV, convened the Council of Vienne (15th Ecumenical Council of the Catholic Church) between 1311 and 1312. The king demanded, among other things, that unorthodox orders like the Knights Templar and the Béguines.be denounced as heretics. Following Marguerite Porete's recent trial and execution, the whole movement was declared heretical. - one of the decrees of the Council stated that the Béguines 'dispute and preach about the highest

Trinity and the divine essence and introduce opinions contrary to the Catholic faith concerning the articles of the faith and the sacraments of the church.'

After this the Béguines declined although that papal denouncement was revoked by Clément's successor Pope John XXII. Some Béguine orders did survive and were still around and doing their charitable work as late as the c16th. According to the *Economist* magazine, the very last of the Béguines, Marcella Pattyn, died in Belgium on 14th April 2013.

Finally we come to Christine de Pizan. Her story is an extraordinary one. Born in Venice in 1364, as a small child she moved with her family to Paris where her father, an astrologer and physician, had been offered the prestigious post of Court Astrologer to Charles V (the son of Philip IV). Christine therefore grew up in exalted court circles and received excellent schooling; her father ensured she was as well-educated as her two brothers. She was also encouraged to make use of the superb court library; undoubtedly her father recognised her literary talents and encouraged her to develop them. But despite this promising start her life's path was expected to be the usual one laid out for young women of her status; marriage to a suitable and sufficiently well-born man, the bearing of children, and the comfortable but restricted lifestyle of a lady of the French court.

At the age of fifteen then, she was married to Etienne du Castel, a notary and secretary to the king. And luckily for them both, this was a happy marriage. Etienne was a man of letters himself and it seems to have been a real love match - pretty unusual for the time. Three children were born to the couple over the next ten years, but when Christine was 25 Etienne died suddenly and unexpectedly of fever. This was devastating for her - both emotionally - she was broken-hearted at the loss of her much-loved partner - but also financially. Within the space of just one year both her father and her husband had died, leaving De Pizan with three small children and no money of her own. She was unable to access funds from her husband's estate despite initiating a lawsuit to claim what was due to her; the legal system wasn't geared to women who had no male protector. She was also defrauded out of a settlement owing to her.

Desperate times need desperate measures. De Pizan started writing. Her first productions were lyric poetry in the traditional style, mourning the loss of her husband and expressing the grief of her widowhood. She then started producing love ballads, and it was these, by about 1393, which brought her to the notice of wealthy potential patrons. Her own unique style was developing by now - original and diverse, it caught the imagination of nobles in many of the French courts including Burgundy, Orleans

and Berry. This remarkable woman was now earning her living and supporting her family as a professional writer, and was probably the first woman to achieve this milestone.

In recent times she has been 'rediscovered' and has become a bit of a feminist icon because of her challenges to the accepted views of womanhood. A very popular book at the time was the Romance of the Rose *(Roman de la Rose)*, a c13/14th poetic tale by Guillaume de Lorris and Jean de Meun. It's in the tradition of the idea of chivalry and courtly love - the same genre as in Capellanus's writing previously mentioned. The book is an allegorical story in which a young man dreams that he enters a walled garden and tries to pluck a rose, and, helped by spirit guides symbolising different human qualities, is advised on the art of courtship. In the second part of the book the allegory becomes real – the plucking of the rose is a metaphor for the conquest of his beloved. Christine de Pizan is critical of the different aspects of womanhood presented and the central message of the story, which is patently all about seduction. She found its misogynist and derogatory accounts of the attributes of womanhood unacceptable; they are still unacceptable today.

De Pizan's most famous book, repudiating the traditional medieval view of courtship and the perceived untrustworthiness of the female sex, is

'The Book of the City of Ladies' (*Le Livre de la Cité des Dames*). She completed it in 1405 and in it she presents a series of intelligent, wise and humane heroines. Each woman is a 'building block' for the city - which is in effect the book. It was beautifully illustrated with illuminated pictures created by a female manuscript illuminator, Anastasia, who De Pizan met in a manuscript workshop in Paris. It's a revisionist history of women, written for women by a woman and illustrated by a woman, and written in French, not the customary Latin. Remarkable stuff indeed! The book was so popular that it was translated into other European languages including English; Caxton printed an English edition in 1521.

Christine de Pizan wrote prolifically, producing many more extraordinary and unprecedented works of literature and poetry. Politically aware, she also involved herself in the issues of her time, much of which was dominated by the on/off hostilities of the Hundred Years War with England. She wrote a panegyric poem about Joan of Arc; '*The sun began to shine again in 1429*' she says in it, full of hope for the future of France when the siege of Orleans was lifted and the Dauphin was crowned, and expressing her optimism about the reformation of the body politic. Another of her causes was the education of women. Ahead of her time and a real trail-blazer from a long-

gone era, Christine de Pizan was herself a heroine to match any of those in her '*City of Ladies*'.

THIRD MOVEMENT: PETRARCH (FRANCISCO PETRARCA)

I'm ashamed to admit that in my youth I had no idea that Petrarch was a medieval poet. I had heard of him, but assumed he came from the classical period - contemporary perhaps with Virgil and Horace. Maybe it was his Latin-sounding name that made me think this; it was only when studying some of Shakespeare's sonnets that I realised where Petrarch fitted in historically and poetically. And what a revelation it has been - this complex and gifted man who, Janus-like, seemed to face the classical past with one side of his head and to look towards the coming ideas and inspirations of the Renaissance with the other.

From boyhood Petrarch was fascinated by the works of the writers and poets of ancient Rome. His early education was at a school in Carpentras near Avignon, where he learned the basics of Latin grammar. Latin continued as the universal written language of educated people throughout the Middle Ages long after it had ceased to be a *lingua franca* in everyday life in Italy. Indeed, the rôle of Latin

in education, literature and official business was widely employed all over western Europe well into the early modern period. For Petrarch's father, as a notary Latin was the language of his professional work. Latin was also the language of the Catholic Church, transcending national boundaries so that even in places which had never been part of the Roman Empire, such as Ireland, church services were in Latin.

It was therefore an essential part of education - not just as a religious language, but as the language of the great writers of the past such as Cicero, Virgil, Horace and Livy. Even in my schooldays in the last third of the 20th century, Latin was an important part of the curriculum. From childhood I had enjoyed the stories of Greece and Rome and I was excited to study the ancient languages in which they had been written. This all contributed enormously to my own lifelong fascination with the past.

For Petrarch, fluency in Latin came early. His father sent him aged twelve to law school in Montpelier, intending that he too should become a lawyer or notary. From there he progressed, together with his brother Gherardo, to the University of Bologna - the oldest university in the world and a place of great distinction. In his writings about that period, Petrarch praises the quality of the teaching and is excited by the '*great gathering of students*'. He

was delighted to be back in Italy; even though his home was in France he never considered himself anything other than Italian. There he threw himself into student life with great enthusiasm, making some good friends, and as he says '*a more passionate age arrived as I entered adolescence and was more daring than I should have been*'. - perhaps not all that different from student life today!

Much as he enjoyed his time at Bologna, Petrarch didn't want to follow his father into the legal profession. He had a passion for literature; when he was still a young boy he had started to collect all the manuscript books of Cicero's writings he could lay hands on, as well as works by a variety of Roman poets, the foremost of whom was Virgil. His father was also a lover of Virgil, and together they put together a compendium of poetry they called The Ambrosian Virgil, containing extracts from Virgil's Eclogues, Georgics and Aeneid, as well as works by other classical poets.

Bear in mind that that this was a time before the invention of printing, so the manuscripts Petrarch collected would have been in the main handwritten copies, of copies, of copies going all the way back to the original autograph. During the 1320's he collected as many texts as he could, starting to compare different copies of any given work, and annotating them himself when he found errors. The

scribes who had produced these copies often made mistakes, but by comparing several examples of any particular text Petrarch was able to work out logical amendments to many of these errors.

By 1329 he had managed to collect copies of thirty books by the historian Livy (Titus Livius - born around 60 BC, died 17 AD). Petrarch made transcriptions of these copies, correcting them one against the other, occasionally paying a professional copyist but doing most of the work himself, then had them bound in quires into one manuscript
which still exists today in the ancient manuscript collection at the British Library! Always in pursuit of fame, I think Petrarch would be absolutely thrilled to know what an extraordinary contribution to posterity he made with all this detailed work on Roman manuscripts.

The death of their father in 1326 while he was still at Bologna undoubtedly caused heartfelt grief for both Petrarch and his brother. Their mother had died some years earlier, commemorated by Petrarch while still a boy in an accomplished Latin poem where he addresses her as Electa – the chosen one. After their father's death he and Gherardo hurried back to Avignon, and, although sincerely grief-stricken, Petrarch nevertheless possibly felt a measure of emancipation, as almost immediately he gave up his legal studies. The following year another

momentous event was to occur which was to colour the whole of the rest of his life and inspire much of the exquisite vernacular poetry for which he is most admired today. He expresses it thus in one of those poems:

> *Mille-trento ventisette, a punto su l'ora prima*
> *il di sesto d'aprile, nel laberinto intrai*
> *Ne veggio ond'esca*

(One thousand three hundred and twenty-seven precisely at the first hour of the sixth day of April I entered into the labyrinth, and I see no way out)

This was the date when he says he first saw Laure, the French girl would become the Muse for his love poetry and, like Dante's Beatrice, would imbue him with an obsessive yearning for much of the rest of his life. We will focus further on Laure and the little we know about her in the next movement; suffice it to say now that Petrarch wrote that he saw her for the first time in the Church of St Claire in Avignon, on the date and time expressed above. As far as we can gather, he never really knew her. She became for him a poetic icon, a symbol of beauty and chastity whom he established in his creative consciousness as an emblem of perfection.

Her name too was hugely significant for him. Its derivation from *'lauro'* (the Latin word for the laurel tree) invoked the imagery of classical legend - specifically Ovid's account of the chaste nymph Daphne metamorphosing into a laurel tree to escape the lustful advances of Apollo. There was also the association of Laure's name with the laurel crown as an accolade for poets and lyricists. It was one of Petrarch's most fervent aspirations to be thus recognised, and the award was doubly enhanced as a symbol for him by that link with Laure's name.

As a young man, in addition to his classical studies and researches, he was now writing poetry both in Latin and in the vernacular. However he also had to find a way of earning a living. The inheritance from his father didn't last all that long and, passionate though he was about literature, it wasn't providing an income. Both he and his brother had deep religious faith, which sent them on different pathways in adult life. Gherardo eventually joined the order of Carthusian monks at Montreux. Petrarch also took orders, but minor ones, which enabled him to work as a private chaplain. His first post was with the family of one of his closest friends from his student days at Bologna; the influential Colonna family. It doesn't seem as if his ecclesiastical duties were particularly arduous or demanding, so he had plenty of time to

write and to continue his researches into classical Roman literature.

Over the next ten or fifteen years then, Petrarch travelled widely in Europe - he described himself as *'everywhere a pilgrim'* - spending time in France, Flanders, Brabant and the Rhineland, always searching for classical manuscripts. He also visited Rome - city of past greatness and the focus of so much of his writing. There's one poem *'Spirito gentil'* ('Noble Spirit') - in which he contrasts the city's glorious heritage with the situation it was now in - torn apart by factionalist rivalries; violent, ill run and dissolute. The poem is passionate and evocative, redolent of Petrarch's horror at what he saw there and his yearning for the restoration of civic pride and dignity. To me, one of the most impressive and forward-thinking aspects of Petrarch was his ability intellectually to validate the continuity between the values and philosophical ideas of the classical world with the spiritual principals of Christianity. He had nothing but scorn for the degraded and corrupt practices of the Avignon papacy, but this did not shake his own profound religious faith.

The state of the Church in the c14[th] was indeed one of chaos. It was a turbulent century - shaken by the events of the Hundred Years War between England and France, and thrown into turmoil and tragedy all over Europe by the disaster of the Black

Death from 1347. As the century advanced, situations developed which would have been unthinkable only a hundred years earlier. In 1377 the papacy returned to Rome - but the Avignon papacy remained. There were, in effect, two Popes. (At one point indeed, there had been THREE popes!) All these factors were inexorably chipping away at the totalitarian power and orthodoxy of the Church's teaching. Thinkers like Petrarch started to question aspects of doctrine - the idea of predestination, for instance - that a person's life was predetermined from birth and that whatever happened to them was God's will. It was now being mooted that human beings themselves could determine the pattern of their lives, working out for themselves how to cope rather than accepting as the will of God whatever life threw at them. Steps indeed towards Humanism.

By now Petrarch was quite a famous man with a reputation both as a poet and a scholar. For the time being he continued to live in France, but to escape the depravity of Avignon (Babylon, as he called it) he had bought a property in Vaucluse - not distant geographically but like a different world. This secluded valley, beautiful and tranquil with its gentle climate, its glowing sunshine and its proximity to the slopes of Mont Ventoux - which he had climbed with his brother years ago - was to provide the refuge he needed. It was also not far from where his adored but

unreachable Laure lived with her family. Petrarch wrote prolifically while living there, among other works beginning the creation (in Latin) what he hoped would be his masterpiece. Titled *'Africa'* - it was to be an epic poem in the classical mould about the Roman hero Scipio Africanus and his conquest of Carthage.

It was while he was living in Vaucluse that one of his dreams came true. He was invited both to Paris and to Rome to be crowned with laurel as poet - the longed-for honour which again provided a link between his present life and the heroic past. Our own institution of appointing a Poet Laureate is indeed part of that same tradition. Petrarch chose Rome for his laureation, which took place on the Capitoline Hill and, in a symbolic gesture after the ceremony, he laid his laurel wreath on the tomb of St Peter, thus linking the classical tradition with the message of Christianity.

Petrarch spent a lot of time thinking about his soul and agonising about some of the things he had done, which included casual liaisons with women. His adoration of the unattainable Laure didn't prevent him, in his thirties, from fathering two children with different mothers; he never named these women. In his forties, he started working on an extraordinary creation - a sort of confessional - called 'The Secret' *('Il Segreto')* which is expressed as a series

of dialogues between himself (Franciscus) and St Augustine (Augustinus). St Augustine's *'Confessions'*, written about the end of the c4[th] AD, had long been one of Petrarch's most scrutinised books. Now, of course, 'The Secret' is really all by Petrarch - the arguments between the two characters are actually Petrarch talking to Petrarch. But it's fascinating how he examines his own conscience and questions his own behaviour, is quite stern with himself about the errors he has made and about his own vanities and ambitions. *'You are capable of making changes'*, Augustinus tells Franciscus, and he is particularly severe about the long and unrequited passion for Laure.

One practical decision Petrarch made after all this soul searching was to move permanently to Italy. In 1348 he heard that Laure had died of the plague. He wrote a detailed death note about her, describing her as *'famous for her own virtues and long celebrated in my poetry'* and referring emotionally to her gravestone near Avignon: *'What a fortunate stone that covers her beautiful face'*. He never forgot her, but her death - and indeed the death of so many hundreds more during the catastrophic pandemic of the Black Death - made him acutely aware of his own mortality. He arrived in in Italy in 1353 and was immediately busy; his first post being with the influential Visconti rulers of Milan, working for them as an envoy and

ambassador. After stints in Venice and Padua, again working as an emissary and under the patronage of influential local families, he retired to a villa in Arquà near Padua, which would be his final home.

I say retired - but it was really only retirement from public life. He carried on writing and continued working on his many projects, which included a lot of correspondence (all his life he was a prolific letter writer) and revising works such as 'Triumphs' ('*Triunfi*'), started just before his return to Italy. The book is a roll call of the tests facing humanity, there are six Triumphs - of Love, of Chastity, of Death, of Fame, of Time and of Eternity. It's a fascinating creation, indicative of Petrarch's unshakeable religious faith and conviction as to the afterlife to come. Interestingly, although he always maintained that Latin should be the language of epic poetry, *Triunfi* was written in the vernacular, using the *terza rima* pioneered by Dante in the *Commedia*. Petrarch never admitted it, but the shadow of Dante's reputation haunted him all his life. The nearest he comes to acknowledging this is in some of his correspondence with Boccaccio, who became a good friend after Petrarch's return to Italy.

Undoubtedly, Petrarch craved fame and prestige. These he achieved, but not in the way he imagined. That epic poem '*Africa*' which he hoped was to win him glory and assure his place in history, was

never finished. His *'Canzionere'* on the other hand - those melodious vernacular poems which he always downplayed, describing them as scattered fragments - made him a pioneer of the sonnet form for future poets (most notably Shakespeare) and are among the most perfect of their kind.

Petrarch didn't need to feel insecure. He was an extraordinary, creative, complex man whose ideas were to influence future generations in a way he couldn't have imagined. He is now considered to have been one of the founding fathers of the Renaissance, opening the door to a theoretical re-evaluation of the human condition which would feed in to the artistic and intellectual glories of C15th Italy. He died in Arquà in 1374 aged 70 - a truly venerable age in that dangerous century. Working to the last, he was found dead at his desk one morning, with his head pillowed on a manuscript of Virgil.

FOURTH MOVEMENT: LAURA (LAURE DE SADE NÉE LAURE DE NOVES)

Petrarch's Laura is without doubt the most elusive of my Muses. Some reviewers think she didn't exist at all, but was a romantic creation conceived by Petrarch himself to conjure up an imaginary focus

for his haunting love poetry.

But I think she was definitely a real person, rooted in the actuality of that first sight in the church in Avignon. Various candidates have been considered by different researchers as to the identity of that girl - young and beautiful and unknown to Petrarch - she being possibly unaware of the man watching her that spring day in 1327. The most likely candidate for her identity seems to be that of Laure de Noves, the daughter of the chevalier Audibert de Noves and his wife Ermessande.

Petrarch would have been in his early twenties when he saw her - a young man emotionally fervent and physically ardent. Laure, thought to have been six years younger than him, was about seventeen but already married - she had been married at the age of fifteen to the young nobleman Hugues de Sade, who seems also to have been in his teens when their wedding took place in January 1325. It was two years later, in the Church of Saint Claire of Avignon, that the momentous sighting took place, and, as Petrarch wrote '*I entered into the labyrinth*' – in other words his lifelong obsession with her.

What else do we know? That, according to his poetry she was beautiful, with '*waving hair of pure and shining gold*' a '*celestial form*', and a '*lovely face*'. Time must have taken its toll of that 'celestial form' over the years, because according to genealogical records,

Laure gave birth to eleven children, at least four of whom died in infancy. Poor woman, she was probably pregnant for pretty well all of her married life before she died of plague in 1348 at the age of 37.

!347 was the fateful year that the Black Death arrived in France. It is thought to have originated in the far east and was brought to Europe on ships from the Levant. The Black Death was the early name for bubonic plague, and it ravaged Europe between 1337 and 1351, returning repeatedly every few years for centuries to come. What we also now know is that was probably transmitted by fleas and that it wasn't until the late c19[th] that the bacterium causing it was identified - Yersinia Pestis - named after the bacteriologist who discovered it; Alexandre Yersin. It's now treatable with antibiotics - but in the 14th century it must seemed like an apocalypse which God had inflicted on humanity as a punishment for sin. One chronicler estimated that in that first wave of the Black Death at least a third of the French population died.

I've been reading Daniel Defoe's '*A Journal of the Plague Year*'- which is about the 1665 outbreak of plague in London. Catastrophic though that was, people had by then developed some defences against the infection. Many locked down in their houses, ships were held in port, wealthier families fled the city, and businesses, theatres, ale houses and law

courts were closed. No cure was as yet available, but some preventative strategies such as pest-houses for infected people were established. Without wanting to downplay the disaster of this epidemic, at least there were tactics in place to deal with it. In fact, the effect of the Great Plague of 1665 produced reactions and policies not unlike those we had to get used to during the Covid 19 pandemic. But in 1347 there was no precedent, no central strategy, no idea how to cope.

In his *Canzioniere*, Petrarch had included 263 poems *'in vita Laura'* (on Laure's life) and he now added over 100 more *'in morte Laura'* (on Laure's death) He also celebrates her in the Eternity section of his *Triunfi;* saying *'Most happy she whom Death has snatch'd away, On this side far from natural bounds of life'* - her early death meaning that she has been spared the continuing miseries of the temporal world. He, bereft, is left on earth weeping, until he too will be united with her in heaven.

What, then, of the real Laure? How can we visualise her? Was she aware of the passionate poet who had made her into his lifetime's Muse? Would she have known that he had created an angelic spirit from her image - which was to keep his emotions tumbling from desire to despair, happiness to hopelessness - and thereby to confer on her a kind of immortality? We will never know.

But I'm imagining her in real life on a golden July day in 1340. It is the Feast of St Anne. Since Laure first became a mother, she has felt a particular affinity with this holy woman, the mother of the Blessed Virgin. Laure herself is now a mother several times over, and whenever she prays, she asks St Anne to care for those of her babies who are now in heaven. But Laure also has living children.

Today is a holiday - a special day - so she has left her little ones in the care of their nursemaids and come with the two eldest to gather lavender from the field at the Abbaye de Sénanque. She could send servants to do this, but the link with the abbey and its lavender is a cherished family tradition. Every year she comes here on this day to harvest lavender; she recalls doing so as a child, when her mother would bring her and her sisters up here at lavender time. The sun was always shining, and the memories of those visits still evoke a magical atmosphere of freedom and joy.

Laure's daughter Augière is ten and her son Audibert nearly nine. He doesn't yet feel too grown-up to enjoy a day out like this with his mother and sister, although his father tells him he must work at his horsemanship and weapon skills if he too is to become a Chevalier. Today he has left all that behind - and is chasing Augière across the meadow with shrieks of laughter. Laure smiles – what energy!

They all arose this morning before 5am for the walk to the fields, but the children are far too excited to be tired.

Laure tethers the donkey to a tree and lifts down the two deep wide wicker panniers slung across his back. He can now rest and graze while she prepares to cut swathes of lavender from the field in front of the abbey. She loves this peaceful place and always feels a lightness of the heart when she arrives here.

The first load is always for the monastery, where the monks will hang the sheaves to dry out before spreading it over the refectory floor so its sweet smell permeates the air all around.

Knives for harvesting are in a leather pouch tied to one of the panniers. It's time the children finished playing and came to help. She calls them back from the meadow and they come running; flushed and panting as they fling themselves down,' *No, no'* she says laughing, handing each of them a small curved knife - *'no more games until these baskets are full!'*

As the sun climbs higher in the sky they all work away, laying the long stems of lavender down in the baskets. The intense purple-blue florets give off an intoxicating scent, and everywhere around as far as they can see the fields show that same mesmerising miasma of blue. Not a sound can be heard apart from the swish of their knives, the songs of the of birds, and the intermittent chatter of the two children.

When the first basket is full Laure sends them both up to the monastery with it to give to the monks.

She watches them go, each holding a handle of the basket, hearing their shrill voices fade as they get further away. Enjoying a rare few minutes of solitude she takes a little break; kneeling by the nearby stream she dips her hands into the clear cool water and splashes her face before quenching her thirst. She feels at peace, contented, tranquil. Then they are back, swinging the empty basket between them. '*Look, look!*' cries Audibert as they arrive. '*They gave us honey*' adds Augière - showing her an earthenware jar in the basket. Then they all carry on cutting lavender, until the panniers are full again and it's time to load up the donkey and make their way home.

CODA

At least one, possibly more of Laure's children died with her in 1348. Petrarch was in Parma when he heard the news. He writes '*Her chaste and lovely form was laid in the church of the Frères Mineurs, on the evening of the day upon which she died. I am persuaded that her soul returned to the heaven whence it came.*' He outlived her by 26 years.

Episode 4

Emilia

*I*n late spring 2020, during the first Covid 19 lockdown, I was asked to contribute to an online magazine by the adult education centre where I'd previously lectured on English literature. All live lectures had been cancelled, including a course on some of Shakespeare's plays that I'd been booked to give. Since my mind was then very much focused on Shakespeare, I decided to offer some analyses of a selection of his sonnets. Over the years I'd seen lots of his plays in performance, had researched his works for classes and lectures, and had given talks in Stratford on various plays during study weekends for an educational travel company. But I'd never really spent much time on the sonnets. This, I

decided, would be my task for the summer. Happily, I found the whole experience utterly absorbing and fascinating - indeed I began to feel at times almost as if I was inside Shakespeare's head, getting an intensely personal and private view of his thoughts and ideas.

As explained in the previous Episode, the influence of Petrarch on Shakespeare's use of sonnet form had been a revelation to me. It also became clear how much Petrarch's work and ideas established crucial foundation stones for the dawn of the European Renaissance. Just under two hundred years later, Shakespeare's world was very much a Renaissance one. Huge cultural changes had taken place between Petrarch's death in 1374 and Shakespeare's birth in 1564.

Now, after my first three Episodes of this book based fully or partially in Italy, we are closer to home. We start in the England of Queen Elizabeth I - the era of the Tudors - colourful, larger than life figures swaggering through the pages of history, stars of innumerable portrayals on large and small screen. Surely much of the British population today is familiar with at least some of the events of Tudor times.

Queen Elizabeth had been on the throne for six years when Shakespeare was born. Her father Henry VIII - despite his bombastic masculinity, getting

through six wives and a fair few mistresses between 1509 and 1543 - had left the kingdom with only three legitimate heirs, two of whom were female. It was not known at the time that it is only the male parent who produces the chromosome necessary for the birth of a boy. So the king blamed his wives for the lack of baby boys.

To Henry, a wife who didn't produce a living son had failed to do what was expected of her. There was only one of the six who gave birth to a live boy - Jane Seymour - wife number three, who he married very shortly after the execution of Anne Boleyn. Poor Jane died probably of puerperal fever or a post-partum haemorrhage not long after the birth, and the boy Edward - his birth celebrated with great pomp and ceremony - was a sickly child. His two older half sisters, Mary and Elizabeth (respectively the daughters of wives numbers one and two), were relegated right down the pecking order, and when Henry died in 1547 Edward VI, aged nine, ascended the throne.

But at the age of fifteen the boy king died, leaving those two demoted sisters as his only legitimate heirs. The tragedy of the 'nine-day queen', Lady Jane Grey, great-granddaughter of Henry VII (the first Tudor king) through the female line, should never have happened. Edward, a zealous Protestant, had named her as his successor rather than the legal heir, his

half-sister Mary, who'd been brought up as a devout Catholic. This decree was aimed to ensure the continued Protestant succession. It didn't work, the country rallied around Mary and she was crowned queen. Poor Jane Grey was the hapless victim of all this and was executed in 1554.

Queen Mary was determined to restore England to what she fervently believed to be the true religion - Roman Catholicism - and to reverse the Protestant Reformation which had been initiated in England by her father. It was a time of fear and confusion; hundreds of prominent Protestants were executed and many others fled abroad. Determined to guarantee a Catholic succession Mary married King Philip of Spain, powerful Catholic monarch of the expanding Spanish empire. However, after several false pregnancies she failed to produce an heir, so when she died in 1558 her Protestant half-sister Elizabeth became queen. Elizabeth overturned all Mary's edicts which had enforced the restoration of Catholicism, and reinstated Protestantism as the national religion.

That brief account of the turbulent and divided state of the nation leads us to spring 1564, when their first son William was born to John and Mary Shakespeare. The seesawing of ecclesiastical statutes over the past few decades had left a bewildered and

troubled population, many of whom remained utterly perplexed as to religious allegiance.

Shakespeare's mother, born Mary Arden, was connected to a prominent Catholic family. His father John, who during Shakespeare's infancy became an alderman and later Bailiff, or Mayor of Stratford, was externally a worthy citizen and a loyal subject of the Protestant queen. But long after he died a Testament of Catholic Faith with his mark on it was found hidden in the eaves of his Henley Street house.

One of the duties he had to perform as Bailiff involved overseeing the whitewashing of ancient murals on the interior walls of the town's medieval Guild Chapel. '*Signs of idolatry and superstition*', they were categorised - but these were images which had been revered by his forefathers as representations of their faith - so I imagine fulfilling this task must have left him pretty uneasy.

The new queen established a network of spies and spymasters nationwide. This covert activity fed into a crescendo of neurosis during the early years of her reign, exacerbated by the activities of her cousin Mary Stuart, Queen of Scots. Mary had been brought up as a Catholic at the French court, and had been married to the Dauphin (heir to the throne) in 1558, briefly becoming Queen of France as well as Queen of Scots. However her young husband, the French king, died in 1560. In 1561, then, she returned to

Scotland as Queen of Scots, bringing with her the backing of the French for her claim to the English crown. Many English Catholics saw in her a possible way forward to returning England to the Catholic fold. But of course, Queen Elizabeth saw her as a very real threat, particularly when Mary fled from Scotland to England to escape the increasing anger and unacceptable demands of influential Scottish Protestant Lords..

Scotland was undergoing a tempestuous Reformation at the time. Mary's background was highly suspect: widow of the Catholic King of France, then later married with Catholic rites to the unstable Lord Darnley in Scotland. It all got completely out of hand when Darnley, furious at being denied the normal rights of a King Consort, arranged the murder of Mary's court favourite, David Rizzio, and was himself dramatically slaughtered not long afterwards. There are still conflicting theories as to who the murderers were, but suspicion fell on Mary's new lover, the Earl of Bothwell, who she had married secretly not long after Darnley's murder. The whole story is an intriguing and tempestuous one; I've only briefly touched on all the plotting and skulduggery which took place. But Mary, perhaps not unjustifiably, was seen as trouble by Queen Elizabeth, so once she got to England Elizabeth had her imprisoned in various castles for almost twenty years. Constantly

spied on, but also constantly plotting, Mary was eventually convicted of High Treason and executed in 1587.

A year later England was at war. King Philip of Spain, who'd briefly been King of England for the time he was married to Mary Tudor, was now the enemy. A devout Catholic, he saw in himself the vanguard against the Protestant reformation which was now sweeping through parts of Europe. In 1588 he sent an Armada of ships to invade England, with the intention of overthrowing Protestant Queen Elizabeth and re-establishing Catholicism as the national religion.

But, as every British schoolchild knows, he failed. 1588 is one of those memorable dates etched on our collective national consciousness as the year of the miraculous routing of the great Spanish Armada (with the help of some very stormy weather.) This was a moment of glory for the kingdom - a brief period of euphoria which seems to have spurred the imaginations of musicians, artists, writers and poets. Shakespeare, in his twenties, beginning to make his way as an actor, poet and playwright, was to play his part in that burst of creative activity.

With the defeat of the Armada the Spanish threat didn't go away. The next ten years saw rumour after rumour of new Spanish attacks.. Both Raleigh and Drake were involved in further naval skirmishes with

Spanish forces, and two more Spanish Armadas set out towards the end of the decade, however both were ultimately failures for Spain. It really wasn't until early in the next century that hostilities between the two nations came to an end. By then Queen Elizabeth was dead and her Scottish cousin James VI of Scotland (son of Mary Queen of Scots and Lord Darnley) had become James I of England - and it was he who initiated a lasting peace process with Spain, thus beginning his reign with hope for a more peaceful future

Sadly, the honeymoon didn't last long - the discovery of the Gunpowder Plot in 1605 ushered in another period of extreme national neurosis - very much comparable to today's terrorism threats. And it all came uncomfortably close to home for Shakespeare; the plot was hatched in Warwickshire with its principal conspirators key local Catholics: Robert Catesby, Francis Tresham and the three Winter brothers; all indeed distant connections of Shakespeare through his mother Mary Arden. For most of his life, it seems, Shakespeare was treading a tightrope avoiding the hazards of his times. The first of these had been when he was still in his infancy.

It's hard to imagine a world devoid of the immortal legacy of the works of this extraordinary man, which has enriched humanity in such measure for over 400 years. He was indeed '*not for an age, but*

for all time' as Ben Jonson wrote. But all this could easily have never been, because when he was only a few months old an outbreak of plague hit Stratford. *'Hic incipit pestis'* ('here began the plague') were the grim words displayed on the Stratford burial register on 11th July 1564. More than 200 people died in Stratford that fateful summer, among them several children. A few doors away from the Shakespeares' house in Henley Street their neighbours lost four young children. The three-month-old Shakespeare baby could so easily also have perished; providential indeed for us all that he didn't.

Plague however was a regular visitor throughout the period. And London, where Shakespeare spent much of his adult life, was an infection hotspot. Two devastating outbreaks took place in the time he was based there; first in 1592-3 and again just over ten years later in 1604. The city had increased enormously from the old walled medieval town it had been, which itself rested on foundations going back to the time of the Romans. The Tudor period saw the city bursting out in all directions beyond the walls, while within the walls, according to the antiquarian John Stow, there were *'encroachments on the highways, lanes and common grounds houses largely built on both side outward, and also upward, some three, four or five stories high'*

People from all parts of the country headed for London in search of work, as did an influx of immigrant workers - bookbinders and brewers from the Netherlands, tailors, silk weavers and embroiderers from France, musicians from Italy. The place was teeming, overcrowded, stinking - rats and dogs scavenging in the streets as well as birds of prey swooping down on the offal thrown out by butchers. It was also vibrant, busy and exciting; a honeypot of opportunity for a host of energetic, ambitious, aspirational young men from far and wide, hoping to prosper in the metropolis. Most of the population was under thirty years of age.

The city was a dangerous place. Criminality was rife, brawls were common and most people carried arms for self-defence. The huge number of young apprentices in the city, despite being bound by strict terms and conditions work-wise, nevertheless managed to become an unruly mob in their periods of freedom, boozing, picking fights, and harassing bystanders. This chaotic, perilous, hectic, animated metropolis was to be the backdrop for much of William Shakespeare's creative life.

When he left Stratford to work in London he also left behind a wife and three children - a son and two daughters. About once a year he would make the long journey back home, presumably to spend a few days with his family and to ensure that everything

was running smoothly. His wife Anne, living in Henley Street with her in-laws, had to manage the household and look after the children alone. Since Shakespeare's parents were getting on in age it seems likely that most of the chores would have fallen on her shoulders.

Let us therefore go to the next movement and have a look at some aspects of the lives of women during this period.

SECOND MOVEMENT: WOMEN

Had she not become Shakespeare's wife; Anne (sometimes called Agnes) Hathaway's existence would be just one of the unmarked lifespans of innumerable unnamed women of her time. As in previous centuries, women from ordinary families only made it into the history books if they achieved something remarkable or appalling, played a part in some sort of epoch-making event; or if they came from, or married into, a royal or noble family

What was life like, then, for girls and women of the c16th? The fact that this was a century which saw two reigning Queens must up to a point have upended the widely held belief that women were somehow less capable of government than men. Both of Henry VIII's daughters were extremely well

educated; as members of the most important family in the land they received an education available to very few of their female contemporaries. The emphasis of the teaching each received was greatly affected by the events of the Reformation. Both were educated on broadly humanist principals - but for Mary, brought up in the Catholic faith, certain texts and ideas from the classical period were not considered suitable, and everything her tutor Juan Luis Vives recommended had to be approved by her mother, the erstwhile Queen Catherine, as being morally acceptable.

Neither young woman was brought up with the expectation of becoming queen. Nonetheless, Elizabeth benefited greatly from being able to share the tutors who were hired to teach her young half- brother Edward. She was a very bright child and, having been taught to read and write by her governess by the time she was five, she then moved on to a much more challenging curriculum, which included foreign and classical languages, geometry, grammar, theology, history, rhetoric, logic, literature and music. There were a range of tutors, the best known of whom is the scholar Roger Ascham, who taught her Latin and Greek, and is said to have considered that she had the intelligence of a man - high praise indeed! In a letter to a colleague, he said *'She talks French and Italian as well as English: she has*

often talked to me readily and well in Latin and moderately so in Greek. When she writes Greek and Latin nothing is more beautiful than her handwriting . '. .

I suppose the most famous learned *non*-royal woman of the c16th is Thomas More's daughter Margaret. She and her two siblings were educated in the humanist tradition by More; a system rooted in the new ideas which had been spreading out from the Italian Renaissance. With the rediscovery and re-assessment of classical literature, as well the humanist sense of the intrinsic significance of the human condition, forward-thinking men like More began to encourage learning for their daughters as well as their sons. In his 1516 book *Utopia* More had argued for a national system of education for men and women alike. The Protestant reformer Thomas Becon likewise enquired in 1559 that if there were schools '*for the youth of the male kind*' why should there not also be schools *'for the godly institution and virtuous upbringing of the youth of the female kind?'*

However, More and Becon were voices in the wilderness. Becon indeed was pretty limited in his view of how girls should be treated *'a maid should be seen and not heard'* he wrote in his *Catechism*. The majority of girls didn't experience any of the impact of Renaissance humanism, which was confined to a few exceptional households like More's, and to the exalted circle around royalty. Most upper-class girls

were educated at home - they would probably be taught to read and write, but the desired outcome was still a good marriage. Activities such as music, dancing and needlework were considered more important for these girls than studying ancient languages or classical literature. Sometimes a girl would be sent to another household to learn and practice domestic skills. It seems that to most men, too much learning for women was a dangerous thing; these [4]*'weaker vessels'* needed from childhood to be made aware of their subordinate status.

In most families, the sons of the family were educated to a much higher level than their sisters. Indeed the 16th century brought a plethora of newly established boys' grammar schools, no longer controlled by the church as most schools had been before the Reformation. The syllabus in these undoubtedly admirable institutions - many of which are still in existence today (including Shakespeare's alma mater, the King Edward VI Grammar School in Stratford) - was based around broadly humanist principals.

There was also a type of institution known as the 'Petty School' (as in '*Petit*' School) where children from lower class households without the resources for private tutoring could go for a small fee. These were

4. *reference from the Bible; 1 Peter; 3:7*

usually run by women, often in their own home, and would take children aged from five to seven, after which boys could progress on to Grammar School if their families didn't need them to work. Some little girls also attended Petty School - but for them there was no progression to further learning at the age of seven. Nevertheless, basic literacy did improve over the course of the c16[th] both for men and (at a lower level) for women. One set of statistics suggests that by the end of the century 30% of men and 10% of women were literate, a considerable advance on the previous century.

But for most children - male or female - school wasn't an option. Learning and literacy was not a priority, survival was. It was in the home and its surroundings that girls learned the skills they would need as adults. So they might be helping with domestic jobs - which could include looking after younger siblings as well as baking, sewing and sweeping - also helping outside in the fields or garden; and if the family owned livestock there would be milking and butter churning. These were the important daily tasks of life which needed to be done. There was no room, no time - indeed no perceived need - for reading and writing.

The story of Anne Hathaway, because of her circumstances, is in a way a gift for historians because it opens a window into a very different life from

that of the upper-class women who are the main representatives of their sex in historical records until the modern period. Anne was a farmer's daughter. The family were not poor; Anne's father was tenant of a reasonable sized farmhouse with quite a large acreage of land in Shottery, about a mile's walk away from Stratford. The house, today one of the touristic 'jewels in the crown' of the Shakespeare Birthplace Trust, is a commodious and attractive building, now beautifully maintained and curated by the Trust and attracting throngs of visitors every year.

The family had occupied this house and farm for some generations. After their father died the tenancy was inherited by Anne's brother Bartholomew, who was able to purchase the freehold. At the same time Anne received a legacy from her father's will. The eldest of eight children and still unmarried, Anne stayed at the farm after her father's death and would have worked both inside and outside the home, making butter and doing other dairy work, as well as helping out at lambing time - the Hathaways were primarily sheep farmers.

Socially their status would have been not dissimilar to that of the Shakespeares; John Shakespeare too originally came from yeoman farming stock; I suppose today they might be described as lower middle class. In such families, as we've seen, girls were not educated to the same level

as their brothers, and traditionally historians have tended to assume that Anne was illiterate. Nowadays, more modern assessments suggest that this may not have been the case; it is certainly hard to envisage the woman married to the greatest writer of the era being unable to read and write, even if she acquired these skills as an adult.

Dealing with her absentee husband's business, rearing three children and running a household would require administrative as well as practical skills. Anne would have had to embark on a steep learning curve when she left the farm behind and became a townswoman, a manager and virtually a single parent. It brought challenges and grief as well as security - coping with her ageing in-laws and their needs, and, tragically, the death of hers and Williams's son Hamnet aged eleven. And as her husband became more famous and the family became richer, Anne's life would have changed exponentially. In 1597 - a year after Hamnet's death - Shakespeare bought New Place in Stratford which was one of the town's grandest and most imposing houses. The country farmer's daughter was now a wealthy woman, presumably enjoying the prestige and recognition locally which accompanied being married to a rich and successful man. She outlived her husband despite being eight years his senior, and stayed on at New Place till her death in 1623.

What of her thoughts, her inner life? What of her relationship with the famous husband who left her to hold the fort on her own for so much of their marriage, but who never cut his links with Stratford - and who, when he retired from the theatre, came back to New Place to spend the final years of his life with her there? We can only conjecture. But I can't help concluding that, after his adolescent passion of the early years faded, he must have continued to trust and respect her. By staying at home and managing their affairs she enabled him to fulfil his own destiny.

THIRD MOVEMENT: WILLIAM SHAKESPEARE

It's often said that not much is known about Shakespeare, but actually we have an absolute plethora of information about him compared with what we know about most of his contemporaries. We know where he was born and the year and probable date of his birth; we also have a record of his baptism. We know when and whom he married, the names and birth years of his children (Susanna, born in 1583 and twins Hamnet and Judith, born in 1585). We also know about his father's occupation, life and death. We know some of the different places where he lived - both in London and in Stratford.

We know when he died and where he is buried
....and of course we have the inspiring and priceless
written archive of many of his works. In particular,
by reading his sonnets we can gain insights into some
of his thoughts, impressions and ideas. His will and
various bits of legal stuff are also extant - so despite
the so called 'lost years' during a period in the 1580's
when we don't really have much idea of what he was
up to, I would say that, for a commoner of the early
modern period, much of Shakespeare's life can be
fairly clearly traced.

Comparing all this with many of his
contemporaries in the literary and theatrical world
of the late c16[th] and early c17[th], we see that most of
them are much more shadowy figures. Of course,
the spotlight of celebrity continues to shine for
Shakespeare - hardly a year passes without some
new nugget of information about him being brought
to light. Contrast this, for instance, with the little
that is known about John Webster's life - at least two
of whose accomplished and intriguing plays, *The
Duchess of Malfi* and *The White Devils* are very much
in the modern repertoire. Or what about Robert
Greene - a prolific and popular playwright of the
1580's and 90's - but who is now chiefly remembered
for his bitter attack on Shakespeare as an *'Upstart
Crow, beautified with our feathers'* in his angry 1592

pamphlet 'A *Groatsworth of Wit*'. These are just two examples of many.

The fact is, that in general, commoners in early modern England rarely attracted much public notice. In an era without news media and a largely illiterate population; necessary information about important events would still have been spread largely by public proclamation. Caxton had produced the first English printing press in 1476 and for the first hundred years or so it was used almost entirely for book printing. During the c16[th] printing was under the control of the crown, so important public statements would be printed and displayed; the news then disseminated by town criers or the like. It would not include details of the lives and achievements of the '*hoi polloi*'.

Until he became rich and famous, therefore, Shakespeare's life attracted little notice. Most of what is known about him has been pieced together by later research - first based on hearsay like the writings of the c17[th] gossip writer John Aubrey - later through assiduous (and ever ongoing) research. The minutiae of every word, allusion, context and setting of his plays and poetry are constantly and forensically examined, re-assessed and analysed. Theory after theory has been advanced for the so-called 'lost years'– but no reliable evidence has yet been uncovered as to his actions and whereabouts during that time.

My c19[th] '*Complete Works of Shakespeare*' suggests that he could have spent some of those years either as a student at Oxford University or at one of the Inns of Court. No validation for this conjecture has ever been discovered, nor does another suggestion - that he might have spent some months travelling in Italy - have any credible verification behind it. Besides, it's extremely unlikely that the poor condition of his family's finances could have funded such ventures. Another suggestion is that he worked for a time as a tutor for the son of a prominent Catholic family in Lancashire - again, it's only rumour. Until primary source evidence is found for any or these and all the other ideas, they remain guesswork.

It's possible (though again, only as yet a supposition), that he spent some of this period working in one of the many itinerant theatre companies around at the time, and that he ended up in London around the end of the 1580's as part of an acting company such as the Queen's Men. He certainly surfaces in London by about 1590, working for Lord Strange's Men at the Theatre in Shoreditch; but how long he had been in the city before this time isn't clear.

During the 1590's William Shakespeare progressed from being a jobbing actor and writer to becoming one of the most sought-after playwrights of his era. He also achieved a notable reputation as

a poet. While at school he had studied (in Latin) the works of the c1st AD Roman poet Ovid, which remained a favourite all his life, and which he ransacked very effectively when in 1593 he produced his first best-seller, *'Venus and Adonis'*. The original story was based on one of Ovid's *'Metamorphoses'* which tells of love goddess Venus's passion for the handsome young hunter Adonis. and his transformation into a wild boar after refusing her advances.

Shakespeare's version is much raunchier; a naked and lustful Venus pursues Adonis, imploring him to make love to her. First he refuses, then relents, but allows her just one kiss before heading off for his next boar hunt. She warns him of the dangers of hunting such a vicious creature, but he ignores her. When the next day she searches for him, she comes across a wild boar with blood dripping from its jaws. Hearing the yelps of hunting dogs, she rushes after them and comes across dead Adonis, covered with blood, his groin pieced by the boar's tusk. She is distraught, and takes away, to cherish forever, the purple anemone which has grown from his spilt blood.

This piece was an instant hit - I suppose one could describe it as a piece of elegantly crafted erotica which probably offered some welcome escapism from a grim year with another outbreak of plague, rising

unemployment and rumours of a new Spanish attack. It went through several printings; one testosterone-fuelled student wrote *'I'll worship Mr Shakespeare, and to honour him will lay with his Venus and Adonis under my pillow'*. Fellow writer Francis Meres said *'the sweet witty soul of Ovid lives in mellifluous and honey-tongued Shakespeare, witness his Venus and Adonis'*. Just as popular was Shakespeare's next poetic effort, *'The Rape of Lucrece'*, based on the Roman story of the ravishing of virtuous Lucretia by lustful Tarquin (alluded to in Episode 1 of this book).

These two long poems - probably written while having to take an enforced break from the theatre due to the plague - confirmed Shakespeare's growing reputation and burgeoning fame. By now he had acquired an influential patron in Henry Wriothesley, Earl of Southampton - a cultured literary nobleman to whom Shakespeare penned elaborate and obsequious dedications for each of these poems. He was also, as well as creating an impressive output of plays for the expanding world of the theatre, writing more poetry.

During the 1590's the sonnet became an extremely popular verse form. Shakespeare included sonnets in many of his plays as well as, according to Francis Meres, circulating *'sugar'd sonnets among his private friends'*. Had Shakespeare written these sonnets as personal, intimate expressions of his inner

thoughts and feelings? A publication entitled '*The Passionate Pilgrim*' arrived in the bookstalls in 1599; it included a few of Shakespeare's sonnets as well as works by other poets, but such was Shakespeare's reputation by then that the publisher asserted all the contents were by him. Those that were had almost certainly been pirated. Shakespeare was reportedly angry at this violation of what would today be described as his intellectual property.

However, in 1609 a collection of all 154 of Shakespeare's sonnets '*never before imprinted*' as it says on the title page, was produced with the authority of the poet. The order in which they appear seems to be carefully arranged, possibly organised by Shakespeare himself. And it is a group of 24 sonnets in this collection which bring me to the next section of this book; those sonnets which are about the mysterious and captivating woman who has become known as the 'Dark Lady'.

FOURTH MOVEMENT: EMILIA LANIER NÉE EMILIA BASSANO

It was while studying Shakespeare's sonnets in summer 2020 that I got the idea of writing about Muses. I had been working on one particular sonnet, no 147, in which the poet is being driven mad by his

passion for his beloved: *'My love is like a fever, longing still for that which no longer nurseth the disease'* he starts. Things have become unbearable for the poor poet in the progress of his frenzied love affair. No longer is he able to rationalise the liaison between himself and his mistress, accepting the unspoken deceits of their relationship as a quid-pro-quo for the undoubted excitement of their sexual relationship. He now feels himself literally sick with the malady of love. In this sonnet he lets us into the turmoil of his torture.

I felt really sorry for him, and even more sorry as I progressed through more poems outlining the progress of the affair, which was pretty well from the start a cause of as much anguish as ecstasy and led him into behaviour which he knew was destructive. As I read these poems, transfixed by the poet's graphic accounts of the sexual cravings he felt, his obsessive jealousy of any other lovers, and the self-delusion he had allowed to take possession of him, I started to wonder what the lady thought about it all.

Who was this desirable and seductive woman for whom the poet - and others seemingly as well - was driven into a sort of self-destructive frenzy of lust? The fact is, no-one really knows. It has indeed been suggested by some scholars that she never existed at all but was a product of Shakespeare's fertile imagination. I don't agree; the emotion expressed in

these love sonnets is so raw, so intense, the agony so palpable that I don't think they could be fabricated.

There are plenty of candidates. In fact, there has been, and continues to be a continual plethora of theories, ranging from the ideas of Thomas Tyler and Bernard Shaw in the c19[th] right up to the present day. Almost every year another book comes out and another suggestion as to identity is proposed. Likely candidates include Mary Fitton, the mistress of William Hervey, Earl of Pembroke (himself believed by some to be the original of the mysterious 'Mr WH', dedicatee of Shakespeare's sonnets). Then there's Aline or Avis Florio, sister of the poet Samuel Daniel and wife of the Italian linguist, translator of Montaigne (and possibly government spy) John Florio. The Earl of Southampton was also patron of this gifted and interesting man; Shakespeare, another of Southampton's protégés, would have known him well. Another contender was 'Black Luce', a Clerkenwell brothel keeper of African descent. She makes several appearances as Lucy, the easy-going publican, in the BBC's Shakespeare sitcom, '*Upstart Crow*'*!* Finally we have Emilia Lanier, a musical lady from the Italian Bassano family who were court musicians to Elizabeth I and James I.

Looking for clues in the sonnets one learns that the lady is dark eyed and brown skinned – as expressed in several of the poems: for example, '*my*

mistress' eyes are raven black' (sonnet 127); *if snow be white, why then her breasts are dun; if hairs be wires, black wires grow on her head'* (sonnet 130); then *'do witness bear, thy black is fairest in my judgement's place'* (sonnet 131). Is the lady, then, a foreigner - someone from a hotter climate maybe? The poet also says, at the very beginning of sonnet 127 *'In the old age black was not counted fair'*.

This statement is about the ideal of female beauty at the time - which was blonde hair and fair skin. Darkness wasn't considered beautiful. The poem goes on to hint at the degeneracy of the times, in that although dark beauties had now become fashionable, terms like *black* and *dark* were still used as metaphors for evil, maybe also for overt sexuality. It's possible that dark haired women were considered more highly-sexed, and therefore both more desirable and more dangerous than others, hence association with them could be more sinful.

Another thing we learn about this woman is that she was musical. One of the most appealing of this group of sonnets is number 128, when she is playing the virginals, and he is listening. The poem opens with a charming image of the beloved playing. We imagine her fingers flitting over the keys, *'that blessed wood'* (the poet, in his desire for closer intimacy with her, suggests that her touch is a benediction on the keys). We can picture the lady, as she *'gently sway'st'*

while she plays, producing the *'wiry concord'* of the music - the word 'wiry' immediately conjuring up the sound of a plucked keyboard instrument.

The poet is standing by, flushed with desire. He envies the keys, tapped by her fingers as she plays, saying that his *'poor lips… which by thee blushing stand'* should be the recipient of her touch. The poem is full of erotic implications - using words like *leaping, tickling, saucy* - all of which have sexual inferences. There is also an undercurrent of anxiety - the poet is desperate to be her only love, but he knows there are others. One of them, we learn from other sonnets, is a young man who's a very close friend, much loved by the poet. This individual has also not been conclusively identified, but possible candidates include Shakespeare's patron the Earl of Southampton and William Hervey, Earl of Pembroke. Poor Shakespeare then suffers double anguish, still himself obsessed with the lady, feeling betrayed by his friend but also protective about him and worried about what damage the liaison with this *femme fatale* will do to him. At this stage Shakespeare feels that he himself is beyond salvation, so deep and damaging has been the relationship for him, but perhaps the youth can be saved.

So, then, we have a very alluring lady, accomplished and sophisticated. She's a talented musician, experienced in the art of courtship, and

much admired. The clues in the sonnets as to her appearance indicate that she could be of southern European origin, black haired and dark eyed. I feel that the most likely candidate, then, for the identity of the Dark Lady is Emilia Lanier, born in 1569 as Emilia Bassano.

The Bassano family were Italian musicians who came over to England from Venice during the reign of Henry VIII and became court musicians to both Elizabeth I and James I. Emilia was the daughter of royal musician Battista Bassano and later the wife of Alphonse Lanier, who was also a musician at Queen Elizabeth's court. A miniature by Nicholas Hilliard purporting to be of Emilia depicts her with thick curly dark hair and brown eyes. She is beautiful; elegantly dressed, with a wide lace collar framing her face, and an elaborate decorated headband over her hair.

Shakespeare, by the second half of the 1590's, had performed before the Queen several times. His company, now the Lord Chamberlain's men, had become the most sought-after theatrical group of the decade. And Emilia Lanier, now married, had some years previously been the mistress of their patron, Lord Hunsdon - who was then Lord Chamberlain. She still moved in or near court circles, in fact as she herself told the astrologer she visited in 1597, she had *been favoured much of her Majesty and of many noble men,*

and hath great gifts and been made much of. This implies that, after Lord Hunsdon's death, she had had a lot of love affairs. To Lord Hunsdon, 45 years older than her, this beautiful and talented young mistress had been a symbol of his enduring virility. He left her a substantial pension when he died, and she moved on to other lovers. The marriage to Alphonse was not a happy one and was really one of convenience; she had become pregnant with Hunsdon's child so was found a husband '*for colour*' as she put it.

But there was much more to Emilia than being a high-class courtesan. As well as her skilled musicianship, she was a poet. Highly intelligent, she was one of the first women in England to publish a volume of her own poetry. She and Shakespeare would have been able to converse on many levels - he must have found her irresistible from the start - beautiful, talented, amusing and with an intellect which could match his own.

I'm imagining her, conscious of him as he stands by the keyboard, yearning over her while she plays. She is well aware of his passion for her, but she's also rather irritated that he is watching her and is not really listening to the music. She's playing a piece by William Byrd - '*Lord Willoughby's Return*' it's called - and it demands expression and virtuosity to do justice to its rippling cadences. She loves Byrd's music, particularly his keyboard variations like this

one, and also his settings of English songs. The poet now standing beside her told her once that he hoped Byrd might set some of his sonnets to music, she smiled and said *'If he does, I will play them for you.'* When she has finished playing, he seizes her hand, turning it over and pressing her palm to his lips.

Emilia enjoys his company - he is clever and funny, a breath of fresh air after the elegant nobles she became accustomed to when she was at the centre of court society. They share a love of classical literature and the new poetry of today. He is also keen on the traditional tales of her family's homeland, and has drawn on Italian themes for some of his plays. They have always had plenty to talk about - if only he hadn't fallen so passionately in love with her, he could still be a good friend. When they first met there had been an instant connection and the repartee between them sparkled with energy and wit. Initially everything had been light-hearted and lovely - and she had assumed that he knew the rules of the game when he joined her circle of admirers.

To start with, their affair had been like a sort of civil contract. They both agreed to accept one another's claims and conceits without challenge. But it didn't really work, Emilia always knew he was older than he claimed to be. She didn't actually mind this - after all she had spent some years living with a man more than 40 years her senior. She, on her

part, allowed the poet to pretend that he was her chosen - even her only lover - both he and she knew unequivocally that this was not so. Punning on his name he urged her to '*Think all but one, and me in that one Will*'.

But now it isn't going so well. His demands and expectations are becoming ever more desperate, so much that now her heart sinks when she sees him approaching. She has also started to have a lighthearted fling with someone else. Her new lover is an eager boy who just happens (unluckily as far as she's concerned) to be the poet's young friend. This of course has made the whole situation even more stressful; Emilia now finds herself at the centre of an unhappy love-triangle. What really saddens her though, is that the interesting, amusing, unusual man who used to love her is now beginning to hate her.

She starts to takes refuge writing down her feelings, lamenting the patriarchal establishment which gives men sovereignty over women and enables them to demand constancy and fidelity while often observing a completely different set of principles regarding their own behaviour. The poet, for instance, is already married; so is she, however society's judgement gives her a questionable reputation but condones his conduct.

'Forgetting they were born of woman, nourished of woman, and that if it were not by the means of woman they would be quite extinguished out of the world, and a final end of them all, do like vipers deface the wombs wherein they were bred' she writes; a powerful feminist statement in a pre-feminist age. Women, she declares, have the right to be free from male subjugation.

CODA

In 1609 Shakespeare's little book of sonnets was published. Its reception, due to the fame of the poet, was assured. A year so later Emilia's own book of poetry was registered, coming out in 1611. It's a fascinating piece of work, entitled '*Salve Deus Rex Judaeorom*' (Hail God, King of the Jews) - but it's in no way a conventional religious treatise. She tells the story of the crucifixion from the point of view of Pontius Pilate's wife. There are several dedications to distinguished women, and throughout the book she produces well-argued and forceful statements regarding the misinterpretation of events which always put women into a subordinate rôle.

On the birth, life and crucifixion of Christ, she says: *It pleased our Lord and Saviour Jesus Christ, without*

the assistance of man … to be begotten of a woman, born of a woman, nourished of a woman, obedient to a woman; and that he healed women, pardoned women, comforted women: yea, even when he was in his greatest agony and bloody sweat, going to be crucified, and also in his last hour of his death, took care to dispose of a woman: after his resurrection, appeared first to a woman, sent a woman to declare his most glorious resurrection to the rest of his Disciples. Many other examples I could allege of divers faithful and virtuous women, who have in all ages, not only been Confessors, but also endured most cruel martyrdom for their faith in Jesus Christ. She also makes a spirited defence of Eve and gives the male reader this robust poetic declaration on women's rights - and all this nearly two hundred years before the work of Mary Wollstonecraft:

> *Then let us have our Liberty again*
> *And challenge to your selves no sovereignty*
> *You came not in the world without our pain*
> *Make that a bar against your cruelty*
> *Your fault being greater, why should you disdain*
> *Our being your equals, free from tyranny*

Emilia's book didn't become a best seller; in fact, it was ignored for centuries. The controversial viewpoint of its contents was rejected and the book was forgotten. But after the historian AL Rouse in

1973 made a considered identification of Emilia Lanier as Shakespeare's Dark Lady, renewed interest in her started to develop. The book of poetry was rediscovered and recognised not just for its original and seminal proto-feminist text, but also for the quality of the poems. Modern scholars have brought it to light again as an important work of Renaissance literature. Emilia was indeed a remarkable woman; with ideas well ahead of her time and expressed through her powerful poetry with lyricism and elegance.

Catharina

FIRST MOVEMENT: BACKDROP

I'm looking at a postcard I bought in The Hague
a few years ago. It's a view of a city, looking over
from the other side of a river which ripples over
much of the lower half of the painting and reflects
in its waters dark images of the buildings behind. On
the near bank of the river are a few people - a woman
in yellow and blue, apparently pregnant, talking to
another woman who's all in black except for her white
headdress. To the left is another group, two women -
one holding a baby - and two men, hatted and caped.
Behind them, in the water, is a long barge. Across
the river, other boats, large and small, are moored.

The city is Delft. I see two medieval gates with
a bridge between them and a canal running under

it into the town. In the far distance, spiking up into the sky to the left, is the bell tower of the '*Oude Kerk*' (old church.) Then towards the right, illuminated by the morning sun, is the tower of the '*Niewe Kerk*' (new church). There are red gable-roofed buildings - people's homes presumably - in the near and middle distance behind the gates and the ramparts. Most of them are in the shade, but just behind the bridge a bright shaft of sunshine makes a group of them vivid pink.

It's early in the morning - I can see on the clock tower nearly at the centre of the painting that the time is about ten past seven. The sun must be towards the east, outside the picture, because it's illuminating parts of the buildings in the other half of the painting. More than half the picture is of sky, a mixture of cloud and blue. Cumulus shades into grey cumulonimbus above the water; a recent shower perhaps has intensified the colours in those places where the sun is spreading its light over roofs and towers.

As I look at this evocative and meticulous portrayal of the c17th city I can almost imagine myself there, so vivid and beguiling is the view in front of me. I want to get into a barge and float under the bridge and then explore the cobbled streets behind. I want to go into the '*Niewe Kerk*' and listen to some

baroque music; then perhaps wander out for a coffee in the c17[th] café by the canal…

Johannes Vermeer created this painting round about 1660. Much of his work is set in domestic interiors - intimate, at times enigmatic, always intriguing - so seeing this vivid and completely different work of genius in the Mauritshuis Art Gallery was an unexpected revelation of delight to me. It never fails to draw me in.

What, then, was Vermeer's world like? What was going on around him and in the wider world of the Dutch Republic during that phase of the c17[th] which has become known as the Dutch Golden Age? This term is usually associated with the extraordinary flowering of Dutch art during the period, encompassing the works of Rembrandt and Vermeer, Frans Hals, Jan Steen, Willem Van Der Velde (both father and son), and Nicolae Maes among many, many others. But in a wider sense, the Golden Age saw a remarkable burgeoning of creative thought, mercantile development and maritime venture in this small European country during those mid-century decades.

It was also a time of chaotic political upheaval, religious strife and almost incessant foreign wars. The history of the formation of the Dutch Republic is a tumultuous one. Up until the late c16[th] the seventeen provinces which made up the Netherlands had been

under the rule of the Spanish Habsburgs. There was something of a religious divide between north and south; the seven northern provinces, influenced by the Reformation and the ideas of John Calvin, inclined towards Protestantism. In general, there was a greater degree of religious tolerance here, with different groups - Lutherans, Calvinists, Catholics and Jews - all able to practice their religion without too much interference. The southern provinces (roughly coterminous with today's Belgium) remained more universally Catholic.

By the end of the c16th those seven northern provinces had united in a resistance movement against Spain, initiated by William the Silent of the House of Orange-Nassau. In the end they managed to break away from Spanish domination, forming a confederation called the United Provinces. Each province was autonomous and ruled by an elected 'Stadhouder'- (roughly translated as 'Steward or Lieutenant). Often a single Stadhouder would end up governing more than one province; the able and influential princes of the House of Orange-Nassau were often elected to such posts

This fledgling republic engaged repeatedly over the period in warfare with the Spanish, the French and even the English; but managed to hold its own and indeed to build a prosperous and productive state. Even in wartime it continued trading.

Economic prosperity was based around shipping and fishing - acknowledged areas of expertise in this low-lying country where for centuries the management of water was essential for its survival. Dutch ports and trading centres became the busiest in Europe, this dominant position fed in to the establishment of banking institutions for storage of wealth. They also offered credit facilities and provided brokerage for financial transactions.

Through increasing commercial activity and population growth, many towns began to develop industrial outlets - sugar refining for example - but existing artisan workshops for handcraft production all also flourished and expanded. The manufacture of Delft blue and white tin-glazed earthenware had started in the late c15th; by 1640 it was in great demand and outselling ceramics from the Far East. In farming too, agriculture responded to the new needs - grain and cereal production was encouraged on inland farms, while nearer the coast more polderland was reclaimed and dikes built to provide extra pasture for dairy herds and horticulture.

With growing confidence, the economy buoyant and the population expanding, the nation started to express its civic pride through architecture and art. The Royal Palace in Amsterdam, originally the Town Hall, was built in the mid c17th, facing out towards the landing wharfs where much of the

country's goods and produce were both delivered and despatched. It's a huge, magnificent, slightly austere construction, classical in style but without the ornate embellishments and decorations typical of the French and Italian architecture of the time.

In art there was the same emphasis on simplicity. The Protestant Dutch merchants, wealthy and prudent, never really embraced the baroque style in art and architecture so popular elsewhere in Europe. Also, after the Reformation, as had happened in Shakespeare's England, there had been a turning away from religious painting and statues in churches, and religious subjects in art. No longer could aspiring painters in Protestant areas produce painted altar panels to earn money; they had to look instead for more secular subject matter.

The Netherlands had a long tradition of outstanding craftsmanship and an exceptionally high standard of visual art. Such painters as Jan van Eyck, Peter Paul Rubens and Pieter Brueghel (elder and younger) had made names for themselves in past centuries for their stylistic and brilliant depictions, many of Biblical and classical subjects as well as portraiture. These artists had all been from the southern half of the country - mainly Flanders. This was the area, together with Brabant and Cleves, which didn't become part of the United Provinces, remaining Catholic and for the time being remaining

under Spanish rule. So artistic traditions already established there continued to flourish and develop.

But the painters living in the new republic now had to adapt to a fresh set of values. Mythological and classical subjects were no longer centre-stage, and religious art too became less appealing to the new bourgeoisie than, for instance, portraits of themselves and their families. Group portraits - as, for example, Frans Hals's 1616 *'Banquet of the Officers of the St George Militia Company'* - were also popular. This painting is full of conviviality and bonhomie as the colonel at one end of the table raises his glass - no dull boardroom gathering here! The most illustrious and celebrated military grouping of all came a generation later with Rembrandt's huge and splendid *'The Night Watch'*. Now one of the most famous paintings in the world, *'The Night Watch'* with its dramatic use of light and colour, the energy of the soldiers and the expressive symbolism of the imagery, continues to have an unforgettable impact on the viewer.

Painters also had to get used to other changes. The developing commercial economy led to new business practices, moving away from the old system of patronage and commission. Before and during the Renaissance, works of art tended be produced to order, but the new system was that a painter now had increasingly to create a picture first then find a buyer

for it. This could be a tricky business, sometimes involving a middleman who might buy cheap and then sell for profit. As we shall see, most of Vermeer's income came not from his own exquisite works of art but from his work as a picture dealer.

Artists quickly realised which subjects were popular, and would then produce works accordingly. For example, in a country so dependent on the sea and on water management for rural agriculture, popular themes included seascapes and scenes from pastoral life. Dutch genre paintings of this type were very different from the idyllic arcadian landscapes, for instance, of French painters Nicolas Poussin and Claud Lorrain. Dutch landscape art depicted windmills, farms, peasants and milkmaids; the simple realism of the life and work of the countryside.

Sea pictures too were realistic rather than romantic; painters became expert at depicting the foam, texture and motion of the waves as well as the varied moods of the skies above. The ships they painted weren't the barques of antiquity and legend, they were working Dutch ships out in all weathers. The Van de Veldes, father and son, were key painters of warships and shipping during the three Anglo-Dutch wars fought at sea between 1652 and 1674. These paintings, with those of other Dutch maritime artists, have provided valuable historical records of a

period when England and Holland were competing for mastery of the seas and imperial expansion.

It truly was a Golden Age - a remarkable era during which this small republic developed a global colonial empire, became a centre for international financial dealings, and was a cultural hub not just for artists but also for writers, philosophers and scientists.

Largely missing in this success story so far seem to be the achievements and contributions made by women. What part did they play in the triumph and transformation of a few small provinces into such a significant player on the world stage? As we shall see, it was quite a significant one. A surprisingly encouraging picture of women's work and achievements emerges in the story of this new republic, described by some historians as the first modern state.

SECOND MOVEMENT: WOMEN

On first impression, looking at the many Dutch genre paintings of domestic scenes depicting women at work in the home, it might appear that not much has changed from the past. Women still seem to be bound by household chores and childcare while their menfolk are active in a variety of ways in the wider

world. It's true that traditionally the domain of the Dutch woman was considered to be the home, while that of her husband started outside the front door of the house. However, a more detailed look into this generalisation reveals a more complex state of affairs.

Let's take education, for instance, as a starting point. The Dutch Reformed Church laid down fundamental principles regarding education. In order that the adult population could function as industrious, sober, godly and worthy citizens, the process had to start with the right sort of schooling for the young. Elementary education for both boys and girls was therefore available for a small cost (equivalent to a few euro cents today) at the Reformed primary schools, where Protestant teachers would instruct pupils on reading, writing and Bible studies.

Young children were often taught to read at home by their mothers; there are paintings by Dutch artists of the time showing this taking place, such as Casper Netcher's charming painting 'A Lady teaching a Child to Read' which is in the London National Gallery. The child, I'm pleased to note, is a girl! There were also ABC schools, usually run by women, taking children from age 3 to 7 - I suppose comparable to today's nursery and infant schools. Children therefore sometimes arrived at the Reformed School

already knowing the alphabet. Teaching was in the vernacular, with the aim of enabling all pupils to read the Bible in the language of the people, rather than Latin.

Unusually for the time, Reformed Schools took children up till the age of twelve although children from poorer families were often withdrawn earlier to help with the family or, in the case of boys, to be apprenticed for a trade. This all sounds pretty impressive, but these schools varied greatly in quality. There was no such thing as teacher training, so in rural areas teachers might be barely more literate than their pupils. Teachers were also poorly paid; many had to take additional work to make ends meet. Nor was education compulsory; and inevitably some families could not or would not spare the money to pay that small fee. Imperfect though this all was, it is a fact that more ordinary working people, men and women, could read in the Dutch Republic than anywhere else in Europe at the time.

There were also private schools for more advanced learning, costing more and varying in quality. The élite Latin Schools, originally established in the late medieval period by monks, were normally attended by boys from wealthy families and followed a humanistic and Catholic educational regime much like the early English Grammar Schools.

One of the great joys of studying the lives of people in the Dutch Republic during this period is the amount of fascinating pictorial evidence of different aspects of life, provided by the painters of the time. There are school scenes – showing male and female children. Jan Steen's' *A School for Boys and Girls'* gives us a look into a chaotic, uproarious classroom in a state of total mayhem - the somnolent teacher seems to have given up completely! It must be a country school, because a pig has somehow found its way into the classroom and is snuffling around. Steen did quite a lot of school paintings - fascinating and intriguing glimpses into past times.

Significantly, we also have artistic evidence of women in the workplace. The workforce included quite a lot of literate and numerate women, who got involved in the labour market in various ways. The Guilds at the time seem to have had a flexible attitude to women working, and many of them admitted women. Husband and wife partnerships in food markets, for instance, were common - but women also sometimes worked independently. There's a painting by Gerrit Dou in the Royal Collection at Windsor entitled '*The Grocer's Shop*' showing the female shopkeeper about to weigh an onion; her customer, holding a bucket, will take it and others when weighed. We also see another customer leaving the shop, holding a pot which she has paid to have

refilled with coffee. In front on the counter are a block of salt, dish of lemons, and a jar of sweetmeats and biscuits. and hanging from the ceiling are sponges and poppy seed heads. It's an engaging and interesting picture, conjuring up an atmosphere of cheerful efficiency.

It seems that businesswomen had a quite a lot of legal freedom. For example, widows and unmarried women older than 25 were deemed capable of managing the legalities of setting up an independent business without a man. Even if a woman was already married she could become an independent businesswoman. Although her husband was still classified as the legal guardian of the family she could, as a female trader, make independent business decisions without needing his consent. But if working in equal partnership with her husband, he remained the pre-eminent partner.

The new Dutch republic, then, was breaking new ground in all sorts of ways, looking into the future rather than dwelling on the traditions of the past. So what I want to do now is to give an account of three remarkable Dutch women who even today stand as icons of female achievement. Despite the progress so far described, the patriarchal principal was still dominant. These three women, each in her different way, began to break the mould.

I've referred quite a lot so far to the unique qualities and varied subject matter of Golden Age Dutch painting - including portraits, civic and military groups, domestic and workplace scenes, rural views and seascapes. What I can't help noticing is that hardly any women's names crop up in any list of the most celebrated artists of the period. Yet the three I'm focusing on next were all extremely talented and as highly accomplished as any of those famous men.

Anna-Maria van Schurman was born in 1607 in Cologne in Germany. Her Calvinist family originally came from Antwerp, but had fled the country to escape Catholic persecution. Returning to the Netherlands in 1615, they settled in Utrecht, part of the Protestant north which had become the United Provinces.

Anna-Maria was a brilliant child. She was also lucky, coming from an affluent, educated family with an intelligent open-minded father who ensured that she had every educational advantage he could provide. He spoke French to her - which she quickly mastered - and when he noticed she was correcting her brothers' Latin exercises he let her join their classes. He also introduced her to the works of the ancient classicists as well as to theological debate. Growing up as she did in this enlightened household, at the heart of a wider society where intellectual ideas

and philosophical concepts were constantly under discussion, Anna Maria was encouraged to develop her own responses to them.

Before she was out of her teens she was invited to deliver a Latin ode to celebrate the opening of a new university in Utrecht. She delivered the oration beautifully, to great acclaim. Van Schurman also used the opportunity to include in her speech a plea to the founders of the new University to admit women as well as men. Sadly this was not granted, but as a concession to her own exceptional ability she was herself allowed to attend lectures there - albeit hidden behind a curtain so the young men would not be distracted by the presence of a woman! This seems incredible and indeed ridiculous today; but at the time it added to her growing reputation as a polymath with a formidable intellect. Descartes himself heard about it and mentioned it in a letter to a colleague,

Van Schurman became a philosopher of distinction, engaging with Descartes and other thinkers; notably and very publicly critical of distinguished philosophers and scholars past and present who failed to challenge the current norms on gender. Many of those enlightened and illustrious men still believed that most women were not fit for access to higher education, dismissing their intellectual capacity as lesser than that of men.

Philosophy and theology were only two of the areas of expertise achieved by this remarkable woman. She was a talented linguist, in ancient languages such as Latin, Greek and Hebrew, as well as a fluent speaker of French, German and English. She also wrote poetry and painted - several self-portraits by van Schurman have survived, some of them now on display in Holland and the USA, and one in the London National Portrait Gallery. It seems there was nothing she couldn't turn her hand to - she was also a talented embroiderer and sculptor as well as a glass engraver. Despite all this, there is only one brief reference to her in my Encyclopaedia Britannica - as a glass-engraver. She studied diamond-point engraving in the Van der Passe printshop, producing exquisite decorations of flowers and insects with elaborate calligraphic epigrams on glass.

She is now featured on several feminist websites but I think it's fair to say that despite her extraordinary intellect and achievements, she still remains largely unknown.

Another almost forgotten name is that of my next artist - Judith Leyster, born in 1609 as one of the eight children of a Haarlem brewer. Her professional name, Leyster, was taken from the name of her father's brewery - called *Het Leister* (the Lodestar). Her paintings were highly regarded in her lifetime, but for many years after her death a lot of her work

was wrongly attributed to her artist husband, Jan Molenaer, or to her fellow Haarlem artist, Frans Hals.

Leyster's painting career was a brief one - of just six years between 1629 and 1635. After her marriage in 1636 she didn't paint any more; few women carried on working after marriage. She was a busy woman - as well as helping her husband with his art she was running their home, caring for their children and managing the family business. Her brewer father seems to have had money troubles; it's suggested that some of Leyster's time was spent supporting him through bankruptcy proceedings.

She was obviously talented from an early age - indeed as a teenager she was mentioned as a local artist in a book about the city of Haarlem. However she had no studio and no teacher, until the 1630's when she was registered as a member of the Haarlem Art Guild of St Luke, which enabled her to set up her own workshop. This in itself was a considerable achievement - the Guild only ever accepted two women members; Leyster is thought to have been the first. It seems also that she received some painting tuition from Hans Pietersz De Grebber, who, among others, numbered the great Peter Lely among his students.

Leyster's paintings, perhaps not surprisingly since she was the daughter of a brewer, included convivial drinking scenes and pictures of people playing cards,

socialising and generally enjoying themselves. She also produced some delightful pictures of children playing, as well as jesters, musicians and other such genre paintings. Another very popular subject at the time was the still-life, which was the speciality of our next painter, Maria van Oosterwijk, but Leyster also showed herself proficient in this area. Paintings of hers are today displayed in the Rijksmuseum, Mauritshuis and Frans Hals Museum in her native Holland, as well as in the London National Gallery, the Louvre in Paris and in the National Gallery of Art in Washington DC.

Nevertheless until the late 19th century Leyster was pretty well forgotten. Despite most of her paintings being signed with her with her distinctive monogram, many were left unattributed. Some of her works were credited to her husband, but others were attributed to Frans Hals, who was a fellow Haarlem artist. In the end it was a painting, seemingly signed by Hals, at the Louvre, which led to a re-assessment. This picture, entitled 'The Jolly Companions' or 'The Carousing Couple', was found to have a fake Hals signature painted over Leyster's monogram. This led to a re-examination of several other pictures and the rightful restoration of Leyster's work to its creator.

The story of Maria van Oosterwijk is a very different one. She reached the top of her profession and her name remains as one of the few women

artists of her time who makes it into anthologies about Dutch painting in the Golden Age. Indeed, she's the only female painter to feature in a book about the magnificent collection of Dutch art in the Royal Collection in Great Britain.

Van Oosterwijk was born in 1630 in a small town called Nootdorp, near Delft (Nootdorp is now part of the suburban sprawl of The Hague). Her father was the local Dutch Reformed Church minister so the household was a godly and reverent one; Maria remained devout throughout her life. She also showed early artistic talent which was able to flourish and develop in the artistic milieu of her surroundings. The family had close contact with the world of art - one of her aunts married the widowed father of a well-known still-life painter, Abraham van Beijeren. Then after her mother's death, and after a move to nearby Voorburg, her father remarried Maria Cloetingh, who came from an established family of printers in nearby Delft.

Delft was a hub for artists at the time, and it's possible this is where van Oosterwijk was able to set up her first studio, in a house owned by her grandfather. Her aunt's stepson Abraham van Beijeren, together with his wife Anna, also a still-life painter, had studios there. Maria probably worked with them, acquiring some of the techniques and artistry which were to make her into one of the most

sought-after still-life painters of her time. By 1660 she had moved to Utrecht where she was apprenticed to Jan Davidsz de Heem, a still-life painter specialising in fruit and vegetable pictures.

Still-life painting had become one of the most popular subjects in the c17th Netherlands. Jan Davidsz de Heem had developed his own intricate, almost baroque style with overlapping forms, bringing elements such as water drops, shells, and insects into his pictures. Van Oosterwijk embraced these ideas, realising that symbolic meanings could be woven into such creations. For example, different flowers might represent the passion of Christ, but by introducing more alien elements the picture could be seen to symbolise intimations of mortality. Beauty must die, but perhaps the inclusion of a butterfly in the picture could be a metaphor for Christ's resurrection.

When van Oosterwijk moved to Amsterdam round about 1670 her work was becoming sought after. She formed a professional bond with still-life painter Willem van Aelst, who had a studio nearby. They worked well together, but when Willem asked her to marry him she turned him down. At that time, when a woman married she was expected to give up her profession, as indeed had Judith Leyster. Van Oosterwijk wasn't prepared to do this - her work was too important to her. She was beginning to attract the attention of influential possible buyers such as

Cosimo III de Medici, who praised her work as being as good as that of the much more famous van Aelst.

By this time not only was she selling her still-life paintings at a high price, she was also getting an international reputation. Her most famous painting '*Vanitas with Celestial Globe*' was bought by Emperor Leopold I of Austria and is now in the Kunsthistoriches Museum in Vienna. So it would seem that Maria van Oosterwijk truly did break through the 'glass ceiling' of her times, achieving international recognition and making a good living with her art,

But van Oosterwijk was never granted membership of the Artist's Guild - because she was a woman. Some of her paintings too were attributed to other artists. According to the painter and writer Arnold Houbraken, who in the early c18th undertook the first major appraisal of Dutch art, she created many more still-lifes than were currently recognised. He himself, while full of praise for her work, and despite the fact that her paintings sold for large sums of money all over Europe, still classified her as an amateur artist.

Undoubtedly too because she had prioritised art over marriage and motherhood - traditionally viewed as the optimal path in life for a woman - she was eyed somewhat askance by the male art critics of her time. To them perhaps it made her

seem somehow unnatural and unfeminine, and this caveat undoubtedly affected their analysis of the symbolisms in her paintings,

These three women, then, can be seen as inspirational examples - women who carved out a career path for themselves with determination and dedication, against all the prevailing odds. Talent was only half, perhaps less than half of what a woman needed to be accepted into the art world. And being female meant that even of you did make it, often your work would be disregarded or attributed to another (male) artist.

The next movement focuses on Vermeer, a hugely gifted painter whose talent, undoubtedly recognised while alive by fellow artists and a handful of connoisseurs, did not lead to any sort of prosperity. The fact that now he's right up there in the pantheon of the greatest painters of all time may have made fortunes for many since his death, but wasn't much use to him during his lifetime as he struggled to feed his children.

THIRD MOVEMENT: JOHANNES VERMEER

I started this Episode with a look at Vermeer's extraordinarily evocative painting - *View of Delft*. This

small city in the western Netherlands first made its name through the creation of the distinctive blue and white china - Delftware - which in its heyday outsold the imported Chinese porcelain that had inspired its manufacture. But Delft was also, during a period of the mid c17[th], a city which was not only home to Vermeer, but also to other distinguished painters including Pieter de Hooch and Carel Fabritius, both of whom set up workshops there for a time.

Johannes Vermeer was born in Delft and spent all his life there. His family was familiar with the art and craft world - his father, who ran a tavern, was a part time art dealer as well as being a professional silk weaver. Vermeer, born in autumn 1632, was the second and final child to his mother, Digna Baltens, and his father Reynier Janszoon Vermeer, and was christened in the Niewe Kerk in the city. Practically nothing is known about his childhood, but his father's connections with the art world and involvement with picture dealers can be assumed to have had some influence on his son. In fact, Reynier Vermeer had joined the Delft Artists' Guild of St Luke as a dealer the year before his son's birth, so the little boy would have absorbed an awareness of the presence of paintings from his earliest years,

Nothing more is known about the young Vermeer. It is perhaps reasonable to assume that he attended the local Dutch Reformed School, and that

during his childhood he may have started to draw, living as he did in a family where pictures were part of the environment. Certainly by the age of fifteen he must have been on the way to becoming an artist, because then he would have started his six-year apprenticeship with a master painter. Without this apprenticeship he wouldn't have been able to join the Delft Artists' Guild, which he did in 1653, aged 21.

Another certain milestone is his marriage earlier that year. Perhaps his forthcoming acceptance into the Artist's Guild, and the career advantages it would ensure, gave him the confidence to ask Catharina Bolnes, about a year older than him, and also living in Delft, to marry him. Catharina - who we will learn more about in the next movement - was the daughter of a devoutly Catholic mother and an abusive father. Neither Vermeer's family nor hers was in favour of the match. There was the question of religion, for a start. The Vermeers, like most of their compatriots in the Dutch republic, were Protestants. Maria, Catharina's mother, was a very committed Catholic and a devotee of the Jesuit movement. She had fled her violent husband and was living with her daughter in a small quiet quarter of Delft known as Papists Corner.

There could also have been the class factor, Vermeer's family, not wealthy, might be categorised today as lower middle class. Catharina, on the other

hand, came from a well-off family, not aristocratic, but definitely socially several cuts above the Vermeers. However, the marriage did take place - on April 5th 1653. It's likely that Vermeer had become a Catholic; they were married according to Catholic rites not far from Delft. They are thought then to have moved in with Catharina's mother who had a sizeable house in the Catholic enclave, near to the Niewe Kerk. Vermeer seems to have had an affectionate relationship with his mother-in-law, and his and Catharina's marriage is generally judged by biographers to have been a happy one.

It was certainly a productive one. In the 22 years of their life together Catharina gave birth to fifteen children, eleven of whom survived. Interestingly, and perhaps indicative of their father's religious re-orientation, two of his sons were named after Catholic saints - Ignatius (after the founder of the Jesuit order) and Franciscus (after St Francis). The first daughter, Maria, was named after her grandmother, and another daughter, Cornelia, after her mother's aunt.

Vermeer appears to have fully embraced the milieu of his wife's life with barely a backward glance towards his own family. His father had died a few months before the wedding; his mother lived on until 1670 by which time she was living with her daughter, Vermeer's elder sister Gertruy. Vermeer's

childhood, born as he was, twelve years after his sister and seventeen years after his parents' wedding, must have been a solitary one. Despite Maria Bolnes' initial reservations about the marriage, the young Vermeer appears to have felt more of a sense of belonging in his mother-in-law's household than the one he grew up in.

It may not be all that surprising that there are so few paintings attributable to Johannes Vermeer. Even a spacious house, such as the one they occupied, will be full of noise when there are so many children around. I imagine this quiet man, upstairs in the second-floor room which he has established as his studio, silently mixing his paints while outside the closed door he can hear the voices of his family, children shouting and playing, babies crying, the low murmurs of their mother and grandmother from time to time raised in remonstrance or laughter, and the rising and falling footsteps of Tanneke, their maid, as she plods up and down stairs doing her chores.

Against this background of varied sounds, he would put up his easel and plan his picture, perhaps setting up lights and mirrors to create the juxtaposition of light and shade which he needed. It has been suggested that he may have made use of a camera obscura or a magic lantern to reflect images onto a screen – but this remains unproven, certainly

both devices did exist in the mid c17[th] when he was working.

But Vermeer, with that huge family to support, was unable to earn enough money solely through his paintings. Like his father before him, he became an art dealer; buying and selling pictures, sourcing particular subjects to order, and presumably attending estate auctions of deceased collectors to buy pictures for resale. As far as his own art was concerned, he had been able to sell many of his paintings to a wealthy local patron, Pieter van Ruijven, who much admired his work. This was a great help, but it did limit the possibility of his works reaching a wider clientele. After van Ruijven died in 1674 Vermeer had to manage without this patronage; there are accounts of him exchanging his paintings for food and other goods from local shopkeepers and tradesmen to discharge debts. He also received generous financial help from his mother-in-law Maria; she obviously trusted him, sending him on business trips on her behalf on several occasions.

The catastrophe of the French war in the 1670's put paid both to Maria's healthy financial situation and to her son-in-law's precarious one. A tract of land that she owned was destroyed when the fields were flooded to prevent the French army crossing into Holland. The dikes which protected reclaimed polderland from the sea were opened and the land

flooded; this was a method of keeping invaders out which had been used by the Dutch for centuries.

Vermeer's fortunes were affected by the same circumstances. War with England in the mid 1660's had led to a decline in the art market, and it fell even further after 1672 when the French-Dutch war broke out. This debilitating conflict was to last for six years and caused the almost total collapse of the Dutch art market. By the time the war was over, Vermeer, aged only 43, had been dead for three years.

FOURTH MOVEMENT: CATHARINA VERMEER NÉE CATHARINA BOLNES

Some people may disagree with my choice of Vermeer's wife as Muse for some of his work, so I'm starting this movement with an explanation. Firstly, all the biographical material that I have read about this elusive and reticent man has concluded that their marriage was a love match. Unions based on mutual love rather than family expediency were not unknown at the time. The fact that in this case neither family initially approved of the match indicates that it was the determination of the two young people which led to their getting married. Secondly, several interpreters of Vermeer's life

and art have suggested that Catharina was the model for at least four, and very possibly more of his paintings. Since there are only about 34 extant paintings categorically attributed to Vermeer this represents quite a significant proportion. Finally, in fiction and on-screen and stage Catharina has been recently depicted without evidence as a jealous bitch consumed with resentment about her husband's passion for an invented Muse. So I'm lining up behind the real Catharina and trying to imagine what her life with Vermeer was like, what she brought to his work, and some of the thoughts she might have had.

I mentioned earlier that she had an abusive father. Reynier Bolnes was a well-off brickmaker with a violent temperament. Catharina's mother Maria had to put up with verbal insults, constant belittlement and physical attacks. It must have been terrifying for Catharina and her sister Cornelia as children, hearing the incessant shouting and the sound of the beatings inflicted on their mother. Maria was repeatedly physically attacked, her hair pulled, hit with a stick when pregnant, and chased out of the house. On one occasion Catharina, aged nine, ran outside panic-stricken, arriving at a neighbour's home sobbing that her father was threatening to kill her elder sister Cornelia. A few months later Maria ran away to her sister's house. Poor little Catharina

was then taken by her father to a neighbour's who he asked to take charge of the child. The woman said the little girl looked as destitute and dishevelled as if she had been a beggar's daughter. Any child growing up in such an atmosphere is profoundly affected and never forgets it.

The only family member to escape his father's reign of terror was the couple's son Willem. He was favoured by his father over his mother and sisters, permitted to eat with him while the female members were denied the family dining table, and encouraged to denigrate and abuse his mother and sisters just as his father did. Unsurprisingly Willem grew up to become as much of a monster as his father. With no safety net provided by the state, no police force or any other sort of refuge for abused women, Maria's only way out was to flee. She escaped to Delft with Catharina, who would have been about ten when they settled there. Maria then initiated legal proceedings against her husband. He refused to divorce her but was obliged by law to pay her a large sum of money. That quiet house in Papists Corner must have seemed like a haven of tranquillity after everything that had happened. But there was another chapter to come in this appalling tale of domestic violence.

While Catharina and Vermeer were married and living with Catharina's mother in Delft, Willem arrived and moved in with them. Very quickly it

seemed as if the nightmare had started all over again because Willem initiated another period of abusive tyranny. He was foul to his mother, calling her an *'old Papist sow'* and a *'she-devil'* and once again forced her to have her meals alone upstairs. He also attacked poor Catharina, who was heavily pregnant, threatening to beat her up with a metal-pointed stick.

In the end Maria managed to have her son committed to a House of Correction - I suppose roughly equivalent to being sectioned today. This was in no small way facilitated by the evidence of her maid Tanneke, who provided graphic accounts of Willem's outrageous conduct before a notary, or lawyer. Other similar testimonies came from neighbours. Thereafter the family could heave a collective sigh of relief and settle into a much calmer life, where the children could play in peace, Vermeer could paint, and they could perhaps all enjoy music together.

There are several different musical instruments depicted in Vermeer's works. In one of his paintings, *The Procuress,* there is a young man who is generally considered to represent Vermeer himself, holding a cittern which was a sort of long-stemmed lute - did Vermeer perhaps play this instrument? We don't know how many, if any, of the instruments in his pictures belonged in the house; some were probably borrowed to be included in his paintings. But it's

possible that he, his mother-in-law Maria and also maybe his wife and some of his children played instruments; music was a very important part of cultural life in the Dutch republic. More than a third of Vermeer's paintings depict girls or young women playing musical instruments - giving us fascinating glimpses of the instruments around at the time - virginals, recorder, lute, cittern, viola da gamba, guitar and trumpet.

Is Catharina depicted in any of his musical paintings, as well as in some others? Vermeer had no pupils and not much money; it's likely therefore that he would have used his wife and other members of the household as models. Certainly the maid Tanneke is usually assumed to be the model in his 1660 painting of a woman pouring out milk and entitled *The Kitchen Maid*.

There are at least four pictures which are thought to have featured Catharina as a model. The French writer André Malraux (1901-1976), in his book on Delft recognised Catharina in several more paintings, suggesting that Vermeer worked mainly within the close circle of his family. More recently Arthur K Wheelock Jnr, until 2018 curator of Northern European Art at the National Gallery of Art in Washington DC, wrote that the likeliest candidate for the young woman in the painting entitled *Girl reading a Letter at an Open Window* was

Catharina. She would have been in her late twenties at the time - the painting has been dated 1657-9.

If this is so, we can identify this woman in several other pictures. We see her, with the same distinctive high forehead and straight nose in *Woman in Blue reading a Letter,* and in *Woman holding a Balance -* both probably dating from the early 1660's. In each painting the woman appears to be pregnant - not surprising if it is Catharina, who was repeatedly pregnant throughout their 22-year marriage. Another picture *A Lady Writing* is another possible candidate for Catharina, who would have been about 35 when this picture was painted sometime in the mid 1660's. Lastly, I wonder if the *Woman with a Lute*, dating from the early 1660's, could also be Catharina. The family likeness is there again. Despite its poor condition, it's a charming depiction, I'm touched by the smile on the woman's face as she tunes the instrument.

So I'm visualising Catharina, tuning her lute as she sits in the studio. She's testing the strings, plucking each one and listening to its twanged note, then tightening or loosening it by twisting the pegs at the end of the fingerboard. She's hardly aware that her husband has started his painting of her, so absorbed is she in getting the sound just right. Each correctly tuned string brings a smile to her face. Her gaze is fixed idly on the opened window; she can see down into the street below. But her thoughts are not

really on the view which she knows so well, it's merely somewhere to place her eyes as she concentrates on what she's doing. Earlier she was looking through some music manuscripts, the sheets she has chosen are laid out on the floor. A friend of the family is expected later and she and Catharina have planned to play some music together.

It's a tranquil atmosphere, broken only by the reverberations of the lute strings and her little gasps of satisfaction when the pitch is right. From the other side of the room comes the quiet breathing of her husband and the gentle sound of his brush as it sweeps and dabs at his canvas. Catharina has experienced so much stress and fear in her life that she is profoundly thankful for this serenity. Three of her little girls, Maria aged seven, Elizabeth aged five, and the toddler Cornelia, just two, are out with their grandmother. The baby, Aleydis, is asleep, watched over by Tanneke. It's a rare and precious thing to be spending this quiet afternoon alone with her husband. She looks back on their eight years of happy married life with pleasure and gratitude.

Catharina doesn't know what lies ahead. She doesn't yet know that she is already pregnant again. She doesn't know that her brother Willem will soon be back, to gate-crash into their peaceful lives before being dispatched for good by her courageous mother. She doesn't know that this gentle and much-

loved husband of hers will become poverty-stricken and desperate, and will be dead before his time, leaving her a destitute widow with eleven children to support,

She also has no idea that his paintings, all she has left of his work, and most of which she will have to sell cheaply in order to feed their children, will one day be globally extolled for their unique beauty and technical mastery, and that her husband's name will be famous worldwide..

CODA

Catharina survived her husband by about twelve years. As we've seen, the collapse of the art market in the 1670's had had a disastrous effect on Vermeer's business dealings. His mother-in-law Maria had helped the family financially on many occasions, but her assets too were affected by the French war. She did authorise Vermeer to collect - and probably to share - a sum of money owing to her son Willem, whose property she had been appointed to administer since his committal to a House of Correction. Vermeer was also borrowing money and trying to exchange paintings for food

and cash. But the situation became more and more desperate; culminating in the poor man suffering a sort of breakdown.

There follows the only known instance of the voice of his wife Catharina. In her plea to her creditors after his death, she said: *'During the long and ruinous war with France not only had (he) been unable to sell any of his art but also, to his great detriment, was left sitting with the paintings of other masters that he was dealing in. As a result and owing to the very great burden of his children, having no means of his own, he had lapsed into such decay and decadence, which he had taken so to heart that, as if he had fallen into a frenzy, in a day or a day and a half he had gone from being healthy to being dead '.*

She sold as many paintings as she could find buyers for, including works by her husband as well as by many other artists. Nevertheless she was declared bankrupt by the Delft High Court in early April 1676, a day after what would have been her 23rd wedding anniversary. Poor Catharina's life thereafter was one of constant struggle and stress. After her mother's death in 1680, she left Delft with ten of her eleven living children, many of whom were still minors. The eldest, Maria, had married before her father's death. Burdened by debt, Catharina moved to Breda, then Gouda, and eventually back to Delft. By now in in very poor health, she spent the final weeks of her life living with her married daughter Maria and her

husband Johannes Kramer. Catharina died there in December 1687.

And what about all those children? This is what we know about some of them.

Maria (born in 1654), as we have seen, married and lived in Delft. It has been suggested that she may have inherited her father's artistic talent and could even have painted some of the works attributed to Vermeer. Some people also see her as the possible model for Vermeer's painting *Girl with a Pearl Earring*.

The second daughter Elizabeth is thought to have died as a young adult. Cornelia, the third daughter, is reported as possibly owing money to a book dealer in Delft – the only extant bit of information about her.

Aleydis, the fourth daughter (born 1659) lived until 1749, a great age for her time. She, with her sisters Gertruyd and Catharina (6th and 7th daughters), received an allowance from the Gouda Orphan Chamber for many years. Gertruyd, despite, according to her mother, being very sick when her father died, survived, and indeed lived for thirty years more.

The fifth daughter, Beatrix, (possibly born 1661 or 2) married John Christophorus Hopperus and they had a daughter, Elizabeth Catharina; nothing more is known but the parents are thought to have died young. What happened to their little girl we don't know.

Then in 1663 we have the first son, Johannes, named after his father. His education was financed with money from a Bolnes family trust fund and he was possibly educated at a Catholic seminary in the southern Netherlands. He may have become a lawyer. He also married and had a son, another Johannes.

The last two sons were Franciscus, who became a master surgeon and lived with his wife Maria near Rotterdam, and Ignatius, the youngest son. In 1686 Ignatius witnessed and signed various documents pertaining to his grandmother's will - boys were authorised to do this from the age of 14. There was also an eleventh child, whose gender and name is unknown. Descendants of this enormous brood of children were few, as only four of them are known to have married.

There is one intriguing further suggestion. Both Catharina and her mother, in times of trouble, may have been supported by members of the local Béguinages (described in Episode 3 of this book)

Fanny

FIRST MOVEMENT: BACKDROP

When I was seven my family moved to the tall Victorian villa in Hampstead where my grandparents were living, so my parents could support them in their old age. The house was near the High Street and just a short walk from Hampstead Heath. My mother, a countrywoman, was delighted to be close to such a large expanse of what was almost as good as open countryside. She also appreciated the cultural milieu of Hampstead, home to lots of artists, musicians and writers, and would take my sister, my brother and myself on educational walks in which she told us about some of the famous people who had lived there.

One of our regular walks was down to Hampstead Heath via Downshire Hill. As we walked past the pretty Regency chapel on the hill, she would tell us about John Constable, Dante Gabriel Rossetti and John Keats who had all lived for a time on the street. When our mother was particularly enthused by anything she gave an eloquent and compelling account of it; the story she told us the first time we did that particular walk was, memorably for me, about John Keats. So saddened was I by the tale of his life and death that I wept as we stood in Keats Grove and looked over at the elegant white house where the poet had lived, and which is now a museum.

We did visit the museum soon after that, and over the years I have returned frequently when in the area. It's always a moving experience. It feels as if the place holds a special atmosphere conjured up by the spirit of the young poet. The last time I was there was a few years ago, accompanied by my adult son, who also felt that same rich and strange combination of melancholy and exaltation. While I'm writing this, I'm aware that it's over 200 years since Keats died, and the house has only recently reopened after its Covid 19 closure. Perhaps that's one of the reasons why I'm thinking about him so much at the moment - this gifted young man who trained as a surgeon-apothecary, to learn how to heal the ills of the body,

but instead became a poet, who through his writing tried to ease the troubles of the soul.

Great Britain in the late c18[th] and the first decades of the c19[th] was going through a turbulent time, one in which life had become difficult and indeed perplexing for much of the populace.

The age was one of extreme political instability as well as social and economic change. Keats was born in 1795 - only a few years after the political storm clouds which had been gathering across the Channel had culminated in the cataclysmic events of the French Revolution. The overthrow of the *Ancien Regime* sent shock waves through Europe, plunging France into turmoil and chaos; reverberations from that firestorm would be felt for well over than a generation - for all of Keats' short life in fact. Three years before he was born, the newly established First Republic came into being in France.

This established the end of the French monarchy and set up a National Convention which drafted a new constitution to get rid of the old system of privilege. The upheavals were chaotic and violent - there was rioting, widespread hunger and lawlessness - leading to the bloody events of the Reign of Terror and to mass public executions. Religious observance was outlawed. The new secular state set up a revolutionary calendar in which each month was given a new name with no religious connotations

- and churches were nationalised. Some were converted to other usage; others were renamed Temples of Reason, where people could praise the Goddess of Reason and celebrate the Revolution...

Here in Britain the ruling classes were horrified; terrified of revolutionary fever crossing the channel, appalled by the execution of the French king and shocked by the abandonment of religious worship. A reactionary 'Anti-Jacobin' movement arose in opposition to these alarming events, and the wider British establishment lined up behind the government, forcefully promoting the importance of maintaining stability and the status quo. A succession of repressive Tory administrations invoked patriotism as a justification for curtailing individual liberties, leading to widespread treason trials, censorship, spying on suspected malcontents and the suspension of Habeas Corpus - that is, the right to be freed from unlawful detention. Militia forces were stationed across the country to keep the peace.

The Combination Acts had been set up in Britain in the 1790's to stop working people getting together in clubs or forming societies. The perceived danger of the working classes being fired up by events in France led to the punishment by imprisonment, or even transportation, of anyone who seemed to pose a threat of sedition. It must have felt to many that the world as they knew it was crumbling away, that

the old certainties were gone - even possibly that the apocalypse was imminent. There often seems to be a sort of *'fin de siècle'* neurosis' - a residual fear that attends the last years as any century turns. As the c19[th] dawned a collective anxiety gripped much of the nation.

By the early years of the new century Napoleon Bonaparte had re-established stability in France, setting up a robust bureaucracy and a well-trained army. He now turned his attention to rebuilding France's power and influence in Europe. Britain had been at war with France since the 1790's, but now this re-invigorated France under Napoleon posed an existential threat. In 1805, Britain formed a coalition with other European powers to halt the advance of Napoleon's forces, but the Napoleonic Wars were to dominate the next ten years. Napoleon himself was categorised as a hate figure by the people of Great Britain, a bogyman to frighten children into behaving themselves. The nation also had to put up with food shortages caused by Napoleon's blockade of British trade. Unsurprisingly those who suffered most were the poor, for whom bread was the staple of their diet.

Internally in Britain great changes had been taking place economically and socially too. The force of industrial development was altering the whole pattern of working life, with a mass flow of the rural

workforce towards the burgeoning new industrial centres. A new social structure developed as cities expanded, with the growth of the manufacturing classes giving rise to an emerging entrepreneurial bourgeoisie. There were indeed now new rich, but also new poor.

In London the expansion of the city had been going on apace since the second half of the c18[th], stretching its boundaries out to the villages around. As early as 1787 the clergyman and academic Henry Kett wrote about what he described as *'the contagion of the building influenza'*, adding that *'the metropolis is manifestly the centre of the disease…Mansions daily arise upon the marshes of Lambeth, the roads of Kensington, and the hills of Hampstead'*. Fortunes were being made and continued to be made as the building boom went on.

During the early c19[th] John Nash formulated his grand plans for London, creating Trafalgar Square and Oxford Circus as well as linking St James' s Park with his new Regent's Park by means of Regent Street and Waterloo Place. These were elegant and beautiful enhancements to the growing metropolis, but the underbelly of this was a built-in demarcation between rich and poor areas. Nash himself said that he wanted to establish a barrier between *'the Streets and the Squares occupied by the Nobility and the Gentry'* from *'the narrow streets and meaner houses occupied by mechanics and the trading part of the community'*.

At the very bottom of the population heap were the impoverished and the homeless. By the dawn of the c19th it was estimated by the historian Dorothy George that there were more than *'twenty thousand miserable individuals of various classes, who rise up every morning without knowing how.. they are going to be supported during the passing day...or where they are to lodge the succeeding night'*. This, in a population of about a million, created a miserable underclass of beggars, vagrants, feral children and unemployed labourers who had been thrown out of work and were now destitute.

William Blake, in his *'Songs of Experience'* (1794) gives an evocative poetic depiction of London as an unhappy city in the iron grasp of commerce, state religion, poverty, suffering and injustice. Blake had seen the French Revolution as a new dawn and the start of a worldwide revolutionary movement. He was not alone; many of his fellow writers and artists rejoiced in the hope of a better world. Wordsworth, for instance, who'd been in France when the Revolution began, famously wrote in The Prelude: *'Bliss was it in that dawn to be alive, But to be young was very heaven'*. We have seen in our own times how uprisings against illiberal regimes generate emotions of hope and optimism. Sometimes they do indeed lead to lasting change for the better, but sadly many of them are either crushed by the administration

or dwindle into something which may not be much better than the system they rose up against.

The Britain of the early c19[th] was in many ways an unhappy nation. For educated middle-class liberals like Keats and his fellow poets, as well as artists, writers, teachers and philanthropists, the terrible sufferings of the poor were a running sore at the very heart of the body-politic. Many were outspoken critics of the totalitarian harshness of the regime. The radical journalist and poet Leigh Hunt was imprisoned in 1814 for his derisive mockery of the Prince Regent and his advocacy of political reform in his radical magazine, The Examiner.

Like-minded liberals flocked to his defence - his prison cell became a sort of magnet for poets, artist and writers, and when he was released, John Keats, aged 20, wrote a sonnet entitled *'Written on the Day that Mr Hunt left Prison'*. What Hunt and his fellow liberals wanted was democratic reform. The members of the aristocracy ruled the country with an iron fist, committed to safeguarding their hereditary privileges while leaving the bulk of the population suffering. As the counter-revolutionary war against Napoleon dragged on, Keats, young and idealistic, was hoping to be able to help change the world through poetry.

He wouldn't be able to change it through the ballot box, because at that time there was no

such thing as universal suffrage. Out of a national population in 1800 of about ten million, fewer than 5% had the right to vote. As MP's did not get a salary, only the rich could afford to stand for Parliament - this of course excluded the bulk of the population. In order to be eligible to vote, you needed to be a landowner, over 21, and male. Keats, as he owned no property and no land, never had the vote. And that brings us back to that half of the population who didn't get the vote until over a hundred years later - women.

SECOND MOVEMENT: WOMEN

In the mid c18th the term 'Bluestocking' was coined - a word which categorised a woman who was more interested in wit and learning than in marriage and manners, more interested in studying and writing than in dressing up and gracing fashionable society. The Bluestocking Circle had started off as a literary salon founded by Elizabeth Montagu, who came from a well-off Yorkshire family and had had a much more enlightened education than many girls of her social class. She and her sister were taught by a retired Cambridge don, who focused on their intellectual development and the study of literature and languages.

By the second half of the c18[th], Montagu's salon was hosting literary evenings for mixed groups of women and men. The members included several prominent women writers such as Hannah More (founder of the Sunday School Movement). Sarah Fielding (educational pioneer and author of didactic books for children), Fanny Burney (satirical novelist and playwright) and Hester Thrale (diarist and friend of Dr Samuel Johnson). As well as these and other women, the circle included Dr Johnson himself, Sir Joshua Reynolds, Edmund Burke and other eminent men. Unlike many other such gatherings, card playing and strong drink were banned. The term Bluestocking originated when male members of the group took to arriving casually dressed, in worsted blue stockings rather than more formal black or white silk ones.

Later it became a pejorative term, because despite the new ideas of the Enlightenment thinkers, the natural and optimal purpose of womanhood was still generally believed to be as wife and mother. By the beginning of the c19[th] several eminent men, themselves often vociferous critics of the existing Tory status quo, nevertheless lined up to disparage the Bluestockings.

Lord Byron wrote that the female poet Felicia Hemans should '*knit bluestockings instead of wearing them*'. William Hazlitt, humanistic philosopher and

social commentator, said '*The Bluestocking is the most odious character in society,*' And Samuel Taylor Coleridge, romantic poet and friend of Wordsworth, added his own bit of vitriol: '*The longer I live the more do I loathe in stomach and deprecate in judgment all Bluestockingism*'.

Nevertheless, the very fact that such a term arose and endured, and that many successful men obviously felt challenged and outraged by it, shows that by the turn of the century the tide was beginning to turn, albeit slowly. Those women, getting together in discussion groups and engaging intellectually with the issues of the day, well before the later educational and political reforms of the c19[th], were the vanguard - an early indication that change could be on the distant horizon.

It's estimated that by the end of the c18[th] about 60% of men and 40% of women in Britain were literate - still a long way to go, but a considerable advance on the previous century. The real changes were yet to take place; schooling for working class children was pretty well non-existent apart from in Hannah More's Sunday Schools, and the education of girls in general was still stuck in the accepted stereotype of a woman's rôle in life. Middle-class girls were often taught at home, either by their mothers or by a governess, with the emphasis on accomplishments – sketching and watercolour

painting, music and French – and a suitable marriage was still the ultimate goal. '*A Father's Legacy to his Daughters*' (1774) by John Gregory was considered a useful manual - it urged young women to be mindful of their duties and behaviour and to conduct themselves in a modest and docile manner.

But as the country became wealthier, the growth of the middle classes in both urban and rural areas resulted in schools for girls being set up. To start with these seminaries had a similarly limited curriculum to that of home education, but pioneering men and women began to develop pedagogical ideas which could be followed in schools and integrated into the syllabus. The writer Maria Edgeworth (born 1768), daughter of innovative Irish educationalist Richard Lovell Edgeworth, had been brought up by her father on rationalist principals. He incorporated some of the ideas of Rousseau - that children should learn from nature and reason - into his own educational method, also drawing on a pioneering reading primer by the c18th educationalist Anna Barbould (one of the original Bluestockings). Edgeworth's and Barbould's ideas began to find their way into many schools.

When Maria grew up she and her father collaborated on a series of education manuals and moral stories - which included large print books for early reading lessons as well as her seminal instruction

book *Practical Education* (1798). She thought boys and girls should be educated equally and together, and also campaigned for the self-fulfilment of women as individuals rather than in relation to husbands and fathers, stressing the importance of personal identity. She felt women should be able to get involved in politics, and, perhaps the most revolutionary of all her pioneering ideas, she stated that women should only marry if they met someone whose character and feelings were in harmony with their own. Marriage should be a union of like-mindedness and mutual respect; it was better to remain unmarried than to be in an incompatible relationship. These precepts might seem obvious today, but they were radical ideas at the time.

Contemporary with Maria Edgeworth was another trail-blazing woman, Mary Wollstonecraft. She, like William Blake, William Wordsworth and many other liberal-minded English people, had rejoiced when the citizens of Paris marched on the Bastille Prison on July 14th 1789. In its early stages, the French Revolution seemed to be a symbol of change to a better, fairer world. Also fired up by the events across the Channel was the radical philosopher William Godwin. His book, *Political Justice,* setting out a measured and rational case for justice in a fair society and condemning the current practices of organised religion, marriage and central

government, came out in 1793. It sold well - as did Wollstonecraft's feminist treatise, '*A Vindication of the Rights of Woman*', which had been issued the previous year,

Mary Wollstonecraft (born in 1759) was from her youth a passionate and articulate advocate of equal rights for women. She was the second of seven children born into a middle-class London family. It seems to have been an unhappy family; her father was often drunk and squandered his inheritance in unwise financial speculations. What money there was left was spent, to Mary's resentment, on her brothers' schooling. Mary seems nevertheless to have acquired a reasonable education; enough to equip her for the limited career opportunities available to poor but educated girls at the time: hired companion, schoolteacher or governess.

She started off as a paid companion to a lady in Bath but had to come home to nurse her ailing mother, who died soon afterwards. Her next venture was to set up a girls' school with a close friend and two of her sisters, this however failed to attract sufficient pupils to provide a reliable income. She had plenty of ideas about educating girls, but it was the publisher Joseph Johnson's advance on her first book '*Thoughts on the Education of Daughters*' *(1787)* which kept her solvent, rather than revenue from the school.

There were already plenty of what were known as 'conduct books' available - hers placed less emphasis on modesty, obedience and submissive behaviour, instead encouraging mothers to teach their daughters analytical thinking, self-discipline and honesty. Not yet the full-blown radical she was to become, Wollstonecraft suggested that girls should be content in their social position, but did recommend the acquisition of skills which would enable them to support themselves financially if necessary.

The next venture was also a bit of a disaster. She went over to Ireland as governess to the children of Lord Kingsborough. Rather like Charlette Brontë about 60 years later, she found the situation of the governess humiliating - with the family but not of them, considered their social inferior but expected to be genteel. She resented her ambivalent status and felt her abilities and talents were undervalued. All this time she continued to write, producing a novel and, after returning to England, was offered a job by her publisher. This was her first big break. Johnson obviously recognised in her a young woman of considerable ability so provided her with accommodation and work as in-house copywriter, editor and translator.

During her time there she wrote her children's book *'Original Stories'* which aspired through fiction

to promote the education of women. The book is framed around two little girls and their maternal teacher, who though a series of conversations with them, aims to teach them how to think rationally and independently. She does this by means of anecdotes and stories, each containing a humanistic moral lesson: thus well-educated, rational, sensible girls will become women who are in control of their emotions and can pay their part usefully and productively in the changing world.

'A Vindication of the Rights of Woman' was written by Wollstonecraft in a sort of white-hot heat of fervour in autumn 1791. It caught the public imagination - human rights being very much on the radar at the time. The publication of her previous riposte 'A Vindication of the Rights of Man' in response to Edmund Burke's patriotic and nationalistic 'Reflections on the French Revolution', had attracted attention. Her reputation was then enhanced by the publication in 1791 of Thomas Paine's seminal opus 'The Rights of Man'. By the time 'A Vindication of the Rights of Woman' came out in 1792 Wollstonecraft had established herself as a writer of substance.

In the book she expresses frustration with the current situation in which women were categorised by men in terms of sexuality; treated as men's playthings and reduced to flirtatious wiles in order to catch a man's attention. 'From the tyranny of men, I

firmly believe, the greater number of female follies proceed' she says. Furthermore, she denigrates the definition of women as men's property rather than as human beings in their own right, and says that marriage *could* be interpreted as a legalised form of prostitution. Women, she says, must take responsibility for change. They must learn to rationalise their behaviour and ideas, and stop accepting the male-dominated forms of conduct and expression which have made them subordinate. All these ideas were to feed into the first-wave feminism of the 1970's, but at the time, it was a hammer blow into the heart of the extreme patriarchy of her era.

In her personal life Wollstonecraft didn't at times seem able to follow the rationalist principles so persuasively outlined in her writings. She became involved in a passionate but unsatisfactory love affair with the painter Henri Fuseli - despite the fact that he was recently married. Attempting to justify her very irrational infatuation by rationalist argument, she suggested that they establish a sort of ménage à trois, she providing the platonic and intellectual side of the liaison, and his wife providing, presumably, sex, nurture and the more traditional wifely aspects of the marriage. Unsurprisingly neither Fuseli nor his wife was keen!

By this time the French revolution was underway, and Wollstonecraft, fired up again with hope, and

needing to be part of these epoch-making events, headed off to France. Here she became embroiled in another love affair which was to cause her considerable anguish and distress. She became involved with the American adventurer Gilbert Imlay, who registered her as his wife but didn't actually marry her. The protection of his name did not lead to the lasting relationship Wollstonecraft hoped for. What it did lead to was the birth of a daughter.

Imlay proved himself unreliable and unfaithful. Wollstonecraft, distraught by his treatment of her, twice attempted suicide. And it was in 1796 when she was back in London, now a single mother with an infant daughter, that she got to know William Godwin. Working again for her publisher Joseph Johnson she came into contact with a group of influential radicals, including Thomas Paine, William Blake, William Wordsworth, and William Godwin.

Godwin had never married. As a young man he had become a nonconformist minister, but by the time he and Wollstonecraft got together he was an atheist. Godwin had advocated the abolition of the institution of marriage in *Political Justice,* so when he and Wollstonecraft began their love affair they did not marry. But theirs was a real love-match. He had previously read one of her books and written '*If ever*

there was a book calculated to make a man fall in love with its author, this appears to be the book'.

He was a kind, gentle and clever man, with political and societal beliefs very much in tune with hers, and an optimist. Wollstonecraft, still fragile after the tempestuous events of the last few years, aroused his compassion as well as his admiration. He wrote later about her *'Perhaps no human creature ever suffered greater misery...'* After their secretly conducted love affair had been going on for some months, she became pregnant. Although, in line with both of their radical and atheistic values, she insisted that he didn't need to marry her, she could 'go it alone', his loyalty and concern for her wouldn't let this happen. He knew her reputation would be destroyed. So they both temporarily swallowed their principles and were married at St Pancras Church at the end of March 1797.

I'm glad Wollstonecraft and Godwin had those happy months together. They planned how they would bring up the baby; it was sure, they felt, to be a boy, who would be called William after his father. Mary's own little girl, Fanny, would be brought up too with all the love and care that they planned for the unborn William, and would receive an equal education. They also agreed that each would respect the other's right to independence, so they would move into adjoining houses. In the days long before

mobile phones and emails, they kept in touch several times a day through letters delivered by servants.

On 30th August 1797 the baby was born - not William but Mary. Eleven days later, on September 10th, Mary Wollstonecraft died. There was retained placental matter which had failed to come out with the afterbirth and which had been manually removed by the doctor. This was what probably caused the puerperal fever which killed her - in a time before the use of effective antiseptics it was a common cause of maternal mortality.

After her death Godwin wrote to a friend '*I firmly believe there does not exist her equal in the world. I know from experience we were formed to make each other happy. I have not the least expectation that I can now ever know happiness again*'

That baby, Mary, was to become the wife of poet Percy Bysshe Shelley and the author of Frankenstein, one of the most influential books of the last two hundred years. Mary's creature, both horrifying and pitiful, has cast its spell over readers of every succeeding generation; and continues to the present day to inspire debate and inspiration.

THIRD MOVEMENT: JOHN KEATS

Two years before the death of Mary Wollstonecraft, John Keats was born, the first of five children (one of whom didn't survive beyond infancy) born to Frances and Thomas Keats. Keats senior worked at the Swan and Hoop Inn and livery stables at Moorfields, Moorgate, in the city of London - a business owned by his wife's father. Later in his poetic career, Keats would be referred to derisively in a hostile review of his work in Blackwood's Edinburgh magazine as one of '*The Cockney School of Poetry*'. The scornful Tory reviewer was not referring to Keats's place of birth - which he probably didn't know - but making a snobbish dismissal of Keats and some of his contemporaries as vulgar, low-class writers of '*crude, vague ineffectual*' work, exuding a '*sour Jacobinism*'; shades here of the extreme establishment neurosis about the French Revolution referred to in the first movement of this Episode.

Keats was indeed a Cockney in the traditional sense, in that he was born in a street within the sound of Bow Bells - the Wren church of St Mary-le-Bow on Cheapside was only about a mile or so away. Nowadays the sound of the bells is often drowned by traffic, but in Keats's time they could be heard loud and clear. The Swan and Hoop Inn in Moorgate is

now gone, but there's still a pub on the site; the early c19th The Globe. Next door is a bar named *Keats at The Globe* and there's a blue plaque on a building nearby.

The first few years of Keats's life seem to have been untroubled. By the time he was eight his father was running the inn and stables, and all seemed set for a reasonably prosperous and secure future. Thomas Keats even toyed with sending his two oldest sons to Harrow. But in the end it was decided that John, aged eight, and younger brother George, aged just seven, would be enrolled at Clarke's school in Enfield where their maternal uncles had been educated. As it was near to the village where their mother's parents lived, the boys would have kindly relatives nearby.

The school was run by an open-minded and inspirational man, John Clarke. The syllabus, together with the intense Christian guidance central to any education of the time, was also rich in humanistic teaching. This included the culture and literature of Greece and Rome, musical appreciation, and literature and poetry in both English and French. The school also aimed to train boys in more practical skills for entry into commerce, trade and the professions. This liberal and enlightening education was to provide the young boy with not just mental and emotional enrichment but was also to

provide a benign and stable haven for him in what would turn out to be a childhood full of instability and tragedy.

The headmaster's son, Charles Cowden Clarke, was a sympathetic, well-read young man, both musical and sensitive - a future writer and Shakespeare scholar. Eight years older than Keats, he took the two boys under his wing, mentoring and protecting them, and it was he who imbued in Keats the love of the classics and the arts which were to be such an inspiration on his poetic life. Thus for Keats, the romance of the ancient world started in boyhood, fired up by stories of the Greek and Roman gods and heroes - what Cowden Clarke always referred to as '*the riches of the past*'. Such informed tuition and the reading it sparked off gave young Keats a key to classical culture and a knowledge of those deities which he would later transform into poetic metaphors for virtue, beauty and suffering. Apollo, the Greek god of healing and of music, poetry and art, was the figure who captured his imagination most and who continued to inspire him throughout his life.

Thank goodness for this world of the imagination, because the everyday one soon became riven with turmoil and suffering. By the time Keats was fourteen both his parents were dead. His father had been killed in a horrific accident when thrown from

his horse, and his mother, in a melancholy portent of things to come, declined and died of tuberculosis. This meant his childhood was abruptly curtailed. No more school fees were paid; the young boy now had to train for a profession. Unlike fellow Romantic poets Shelley and Byron, whose schooling at Eton and at Harrow led to university for each of them - Shelley at Oxford, Byron at Cambridge - this was never an option for John Keats. He left school and before he was fifteen was apprenticed to a surgeon-apothecary in Edmonton. Like his muse Apollo he would become a healer. But alongside his medical duties he kept in touch with Clarke, continued his reading, and began to write poetry.

It was Clarke who introduced Keats to Leigh Hunt, who I mentioned in the previous movement: essayist, journalist, political campaigner and editor of the liberal newspaper The Examiner. In 1814 Hunt was imprisoned for seditious libel against the Prince Regent - calling him, among other things '*this fat Adonis*'! Prominent liberal literary figures including Byron and Shelley supported Hunt financially; his prison cell (which he decorated with rose trellised wallpaper, hung blinds over the windows to hide the bars, installed a piano and busts of his favourite poets and made a garden in the prison yard) became a sort of shrine for all the leading radicals of the day. Jeremy Bentham, Charles Lamb and Byron himself

(who called him *'the wit in the dungeon'*) visited him regularly as did other friends, including Charles Cowden Clarke, who brought him regular gifts of fruit and eggs.

Meanwhile Keats had finished his apprenticeship and was working at Guy's Hospital, studying for his Licentiateship of the Society of Apothecaries and hoping later to achieve membership of the Royal College of Surgeons. Richard Abbey, the Trustee and Guardian who now had control of the limited funds belonging to the Keats family, was very much in favour of the plan, releasing the necessary money for books, instruments, lodgings and fees. But Keats often found the duties of his work gruesome and upsetting, and suffered frequent - as he put it - *'fits of melancholy'*. So when Clarke, after showing some of Keats's poems to Leigh Hunt, returned with the news that Hunt would like to meet the young poet, Keats was thrilled. *'Twill be an Era in my existence'* he said - as indeed it proved to be.

Since his release from prison Hunt had been living with his wife and children in a cottage in the Vale of Health on Hampstead Heath - a pastoral setting, but near enough to London to keep him in touch with contacts and affairs in the city. Keats arrived there with Clarke one evening in October 1816, having sat up all night a day or two earlier reading the newly translated edition of Homer's Iliad

and Odyssey by George Chapman. The effect of this work he found so exhilarating and uplifting that he composed a sonnet '*On First looking into Chapman's Homer*'- the first real manifestation of his greatness as a poet. It's a wonderful and exciting poetic expression of the electrifying impact Chapman's work made on him: '*then felt I like some watcher in the skies, when a new planet swims into his ken*' - that amazing feeling when something hits the senses so radically that one feels one has always been waiting for this moment. Hunt, impressed by the poem, published it in his magazine.

Becoming part of Leigh Hunt's circle, joining his gatherings of artists, writers and musicians was the beginning of a new world for John Keats, and the beginning of the end of his planned career in medicine. New acquaintances included the artists Joseph Severn and Benjamin Robert Haydon, the writers John Hamilton Reynolds and Charles Lamb, the musician Vincent Novello, and in due course the poet Percy Bysshe Shelley. Keats now made the momentous decision to devote his life to poetry - he would turn from healing the body to working through poetry to heal the soul, as he put it '*to soothe the cares, and lift the thoughts of man*'. This didn't go down well with his Trustee, Richard Abbey, but Keats was determined. He produced a volume of poetry for publication which came out in 1817 but sadly didn't make much of a mark. His epic poem

'Endymion' the next year also flopped, having been attacked scathingly in the Edinburgh Review. The article dismissed Keats as a Cockney rhymester and offered him this piece of insulting advice: *'It is a better and a wiser thing to be a starved apothecary than a starved poet, so back to the shop, Mr John, back to plasters, pills and ointment boxes'.*

Luckily for future generations, Keats didn't take this advice. He worked on, fervent in his vocation as a poet. Over the next two years, 1818 and 1819, he was to write some of his greatest poetry. It was also to be a period of some of the most acute anguish and despair he had yet suffered. His poetry was not selling. His much-loved youngest brother Tom was declining; always frail, Tom was now showing the unmistakeable signs and symptoms of the tuberculosis that had killed their mother. Keats, nursing him devotedly, knew that the end was near. His other beloved brother George, newly married, was planning to emigrate with his wife for a new life in America.

But this is also the period in which Keats wrote his great Odes. The *'Ode on a Grecian Urn'* was partly inspired by a visit to see the Elgin Marbles, which had arrived in England a few years earlier. The Urn of the poem is of Keats' own invention; with features of some of the scenes on the marbles but also owing something to other classical Greek vases. He did

a tracing from a picture of a vase in the Louvre known as the Sosibios Vase - he could never have seen the original. The poem is wonderful; drawing for inspiration not just on the Elgin marbles and on the Sosibios Vase but also on the imagery from engravings of works of art by Poussin and Claude, which he had seen at Leigh Hunt's house.

This Ode is a perfect poetic fulfilment of the classical ideal in art, describing simultaneously a state of movement yet arrestedness - the figures are frozen in time - '*forever panting and forever young....*' The Urn itself however is a symbol of death. Keats turns from the transient ecstasy of those images to the world of ultimate suffering and death. The spectre of Death was indeed again waiting. In real life, his brother was dying. On December 1st 1818 poor Tom died; he was just nineteen years old. Keats, who had looked after him throughout the last harrowing months of his illness, was at a very low ebb indeed. What he didn't know at the time was that he too had been infected with the disease.

It was his friend Charles Brown who rescued him. Visiting Keats during the weary aftermath of Tom's death, he suggested that Keats come to live with him in his Hampstead home, Wentworth Place. Brown occupied one half of the house and his friend Charles Wentworth Dilke lived with his family in the other. Both men were also good friends of Keats, so it must

have seemed a lifeline to him, lonely and bereaved as he was, to move into this tranquil place. Although it looked - and still looks - like a single house, it was in fact built as two separate units; Brown's was the smaller one and had a side door entrance. This was to be Keats's last English home,

The peaceful ambience and serene atmosphere there began to have a healing effect on Keats's troubled soul. It seems that the intense suffering of the last year now gave rise to a sublimity of vision which took him to a completely new level. Keats himself described it as 'negative capability' - what someone is capable of when unhappy, uncertain, irritable. Such a state of mind can lead to an openness and understanding of pain and suffering, so when the spirit is at rock bottom it can be at its most receptive. A mind empty of positivity allows access to a full range of feelings and experiences

His great '*Ode to a Nightingale*' of 1819, with its intermingling of suffering and ecstasy is a rich and inspirational evocation of this idea. He was sitting, melancholy, in the garden in one summer morning, when a nightingale started to sing. He addresses this poem to the nightingale, yearning for its blithe uncomplicated world, and imagines slipping out of the travails of his life on the wings of its song. Into this sublime poem - simultaneously uplifting and heartbreaking - he pours out his suffering at the

death of Tom *'where youth grows pale, and spectre-thin, and dies'* and his yearning for the peace of death. He had longed for it as a release from pain for Tom, but now, perhaps he's also expressing his own death-wish: '*for many a time I have been half in love with easeful Death*' he says. But the poem also exults in life and vitality - ' *Dance, and Provençal song, and sun-burnt mirth! O. for a beaker full of the warm South';* and ends with transcendent imagery: '*Was it a vision, or a waking dream? Fled is that music - do I wake or sleep?*'

Charles Brown remembered that day and later wrote '*A nightingale had built her nest near my house, Keats felt a continual and tranquil joy in her song, and one morning he took his chair from the breakfast table to the grass plot under a plum tree, where he sat for two or three hours. When he came into the house. I perceived he had some scraps of paper in his hand, and these he was quietly thrusting behind the books. On inquiry, I found those scraps, four or five in number, contained his poetic feeling on the song of our nightingale*'

Keats was able to restore his spirits and regain some health in that first year at Wentworth Place, as he wrote in this happy letter to his sister in early May 1819 '*O there is nothing like fine weather, and health, and books, and a fine country, and a contented mind, and diligent habit of reading and thinking - and, please heaven, a little claret wine cool out of cellar...with a few or a good many ratafia cakes...*'

And it was here that he fell madly, passionately in love with Fanny Brawne, the pretty daughter of the widow living next door. He had first met her a few months earlier, and certainly noticed her - he seems to have indulged in a bit of gentle raillery with her - but his attention was mainly taken up with Tom. But in April 1919 the Dilke family moved out of the other side of the house and the Brawne family moved in. They knew the place well, as they had previously been tenants of Charles Brown, occupying his half of the house. They then spent a brief time living elsewhere, when Brown returned and Keats later moved in with him, but were delighted now to be able to come back and rent the Dilkes' half of the house.

Keats had had little to do with women in his life. Losing his mother in his teens, he had turned for friendship and emotional support to Charles Cowden Clarke and to his two younger brothers George and Tom. His sister - another Fanny - was being brought up in the family of Richard Abbey, their family Trustee and Guardian, and the Keats boys were not allowed much contact with her apart from through letter-writing. Keats seems to have been wary of women, feeling much more comfortable in the company of his many male friends. Unlike a lot of those male friends though, he seems to have had very limited sexual experience.

There is however an indication in his letters that at one point in his life he was dosing himself with drops of mercury. This was used to treat syphilis and, more commonly, gonorrhoea, which was thought to be an early stage of syphilis, but was also prescribed in treatment of other disorders. Keats said it was recommended for his sore throat, which may or may not be true. He does seem to have had a casual flirtation with a woman who he met while visiting Sussex. Isabella Jones was well-read, attractive and very good company. Keats, as he wrote, *'warmed with her and kissed her'*. What does this mean? Difficult to guess - but the probability seems to be that this relationship developed into a friendship rather than a full-blown love affair. There may possibly also have been one or two other liaisons.

His first impressions of Fanny and her mother in a letter to his brother George indicate a mild approval with no hint of the obsession which was to come: '(Mrs Brawne) *is a very nice woman and her daughter senior is I think beautiful, elegant, graceful, silly, fashionable and strange. We have a little tiff now and then – and she behaves a little better, or I must have sheared off.'*

But as 1819 progressed so did their love affair, a definite understanding developing between the two of them. They became privately engaged - he gave her a garnet ring (now on display at the Keats House Museum) but, as with so much in poor Keats's life, the

hope of a future together would never be realised. He was short of money, deeply in debt, in poor health, and not in a position to support a wife. His passion for her grew into an obsession, worshipping her as an ideal of perfection but also consumed by a frantic possessive jealousy. He tortured himself imagining her flirting with other men, pouring out his fears in series of letters. His developing illness, with its fluctuations of temperature, would have contributed to this feverish and at times paranoid state of mind.

The persistent sore throat which he had been suffering for months was the harbinger of the fatal disease which had killed his mother and his younger brother. In the bitterly cold winter of 1820 he started to cough blood. His medical training instantly gave him the awful truth. '*It is arterial blood*' he said. '*That drop of blood is my death warrant*'. Although a brief remission followed, by the time summer came it was obvious that his only hope was moving to a warmer climate. He had yearned for '*the warm South*' for years, now he was distraught at the prospect; sick in body and soul and heartbroken to have to bid farewell to Fanny forever. Accompanied his faithful friend, the artist Joseph Severn, in September 1820 he left England for Italy. He died in Rome on 23rd February 1821. He was 25 years old.

And what of Fanny Brawne, whose name became famous worldwide as the adored beloved and Muse

of John Keats, but whose own personality and inner life has played little part in the story?

FOURTH MOVEMENT: FRANCES LINDON NÉE FANNY BRAWNE

'*Shall I give you Miss Brawne*' Keats wrote to his brother George and sister-in-law Georgiana in America, soon after he had met her '*She is about my height* (Keats was only five feet tall) *with a fine style of countenance of the lengthen'd sort - she wants sentiment in every feature - she manages to make her hair look well - her nostrils are fine - though a little painful - her mouth is bad and good - her profile is better than her full-face which is indeed not full but pale and thin without showing any bone - her shape is very graceful and so are her movements - her arms are good, her hands baddish - her feet tolerable - she is not seventeen* (actually she was over 18) *- but she is ignorant - monstrous in her behaviour, calling people such names that I was forced lately to make use of the term 'Minx' - this I think not from any innate voice but from a penchant she has for acting stylishly*'

Such a detailed and not all that flattering description shows, I think, that although he didn't really know her yet - getting her age wrong - his curiosity was aroused; in today's parlance he fancied her. There must have been a little bit of

flirting between them for him to apostrophise her as '*minx*'. But it wasn't until Christmas 1818 that the relationship between two of them became more than a mildly flirtatious friendship.

That first Christmas period after Tom's death saw Keats getting various invitations from concerned friends and their families, hoping to divert him from the travails of the last few months with social life and excursions. For Christmas itself he had two invitations, but the one he opted for was from Mrs Brawne. The Brawnes had not yet moved back to Wentworth Place but were living not far away in Elm Cottage at the end of Downshire Hill near to the Heath. Fanny was later to say that this Christmas was '*the happiest day I had ever spent*'. They must have exchanged presents, Fanny's to Keats could have been a miniature medallion engraved with a Greek lyre with a motto and the words '*Qui me néglige me désole*' (whoever neglects me, makes me sad). Keats certainly started to use this as a seal just after that Christmas.

Fanny, five years younger than Keats, was a north London girl. She had been born in 1800 in the settlement then known as West End, not far from Hampstead. West End Lane in West Hampstead is a relic of this area which was, at the beginning of the c19[th], a hamlet of about thirty houses surrounded by parkland. Fanny was the eldest of five children,

two of whom had died in infancy. When Keats met her she was living at Elm Cottage with her widowed mother, her brother and little sister. Tuberculosis was one of the main causes of death at the time and it had taken Fanny's father Samuel when she was only ten years old - which could well have been a cause of mutual understanding and empathy between Fanny and Keats. Another link was the fact that both their grandfathers had been stable keepers. Grandfather Brawne had owned the Coach and Horses - an inn and stables off the Strand.

So the pair of them came from similar backgrounds; both were also from families which had to cope with a similar degree of financial insecurity, and both had experienced the loss of a parent in childhood. Keats was now nursing his dying brother; Fanny's brother too was to succumb to the same disease. Sam Brawne would die of TB aged 23 in 1828, seven years after Keats's own death.

Some subsequent biographers of Keats have been dismissive of Fanny, taking their cue I think from the reaction of those of Keats's contemporaries who felt she was not worthy of their gifted friend. What we do learn about her is that she was quick-witted, vivacious and at times opinionated, flirtatious, and pretty rather than beautiful according to the tastes of the time. Like many young women both then and now, she loved clothes and followed the fashions of

the day; she was herself a skilled dressmaker. She had been educated typically for a girl of her time and class, could both read and speak French and German, admired Shakespeare and adored the Gothic novels which were all the rage at the time. *'I am not a great poetry reader'* she admitted with ingenuous honesty, this girl who was to become the immortal beloved of one of the greatest English poets.

In 1878 Keats's love letters to Fanny were published. This unleashed a widespread torrent of invective against Fanny; accusing her of tormenting the dying poet with her coquettish behaviour and of teasing him by flirting with his friends. Many of these critics concluded that she wasn't worthy to be the wife of such a noble spirit, calling her commonplace, vain and shallow. It was only when Fanny's own letters to Keats's sister were published in the 1930's that people read of her sincere grief. In one letter she says *'All his friends …have got over the first shock…They think I have done the same… but I can tell you…that I have not got over it and never shall'*. Her loyalty and devotion to him in the last months of his life, and her long period of mourning after he died, wearing widow's black and wandering alone on the Heath, was now acknowledged, and those who had denigrated her changed their minds.

Fanny was not yet 21 when Keats died. She had already lost two younger siblings as well as her father,

and she had to accept the fact, as the bitter winter of 1820 continued and he became more sick, that the marriage she and John Keats had planned would never happen. She had nursed him at home, and when he was too ill for her visits she had written him a letter every day.

I'm visualising her a year later, in spring 1821. A few days ago she received the news of John's death from Charles Brown. In front of her is the copy of Dante's *Inferno*, which she and John read together and which he then gave to her. Into it she has copied *'Bright Star'*, the sonnet he wrote for her in summer 1819. She looks at it now, remembering how she had not really understood the imagery when he read it to her, and how she had felt a little overwhelmed by his ardent adoration. Could she live up to it? Was she really worthy of such idolisation, she had wondered. She remembers a letter that he had sent her when she herself was unwell. *'You absorb me in spite of myself, you alone'* he wrote, *'I will imagine you Venus tonight and pray, pray, pray to your star like a Heathen'.*

Fanny understands the poem better now, and treasures it as a symbol of that unique, gifted, anguished and extraordinary man who is no more, but, miraculously as it seems, who loved her. She realises that to have been the recipient of such passion is a privilege granted to few women, and for her part she had sincerely and dearly loved him.

She recalls imagining what it would be like to be his wife, and mother to his children - but even then, there had been an element of unreality about these fantasies. Did she always know subconsciously that there would be no future for them? She remembers seeing her father sicken and die young. When she and John had first met, he was looking after his dying brother. Their shared experience of grief had been a bond between them, but before he became so ill, there had also been a lot of joy in their relationship. He teased her, nicknaming her 'Millamant' after the charming and spirited heroine of William Congreve's Restoration Comedy '*The Way of the World*'. He was gay, funny and kind. They had collaborated in planning lighthearted practical jokes, laughed and danced together, and enjoyed carefree rambles on the Heath.

Fanny closes the book. She will take a walk on the Heath, perhaps retracing some of the paths she and John used to take. She has lost interest in many of the things that used to make her happy and has put aside the spotted and sprigged gowns and fur trimmed [5]pelisses which used to give her so much pleasure. Now she understands why her mother wore black for so long after her father had died. She will use her dressmaking skills to create widows' weeds

5. *A dress-shaped long-sleeved coat*

for herself. And she will make a private memory box to keep his letters in, together with the ring he gave her, the books they enjoyed together and his other little gifts to her. She can't imagine ever loving another man.

CODA

Fanny wore black for several years after the death of John Keats. She lost weight, grew pale, and let her hair become faded and lank. A close friendship developed between her and Keats's younger sister, another Fanny. They had been corresponding since Keats departed for Italy, but now their mutual grief for him deepened their friendship and was a comfort to them both. Fanny said that she could share with his sister a little of the literary companionship she had known with Keats.

This is an extract of a letter she wrote to Fanny Keats after his death:

'I am patient, resigned, very resigned. I know my Keats is happy, happier a thousand times than he could have been here, for Fanny, you do not, you never can know how much he has suffered. So much that I do believe, were it in my power I would not bring him back. All that grieves me

now is that I was not with him, and so near it as I was....
He at least was never deceived about his complaint, though
the Doctors were ignorant and unfeeling enough to send him
to that wretched country to die, for it is now known that his
recovery was impossible before he left us, and he might have
died here with so many friends to soothe him and me with
him. All we have to console ourselves with is the great joy
he felt that all his misfortunes were at an end. At the very
last he said 'I am dying, thank God the time is come' (this
was according to a letter from Severn)

She did eventually marry, but Keats had been
dead for twelve years by then. Her husband, Louis
Lindo (later anglicised to Lindon) was several years
younger than her, of Spanish or Portuguese descent,
a Sephardic Jew who came from a wealthy banking
family. They met in Boulogne and it seems to have
been a happy marriage. There were three children,
one of whom possibly died young. It was Fanny's and
Louis's son Herbert who, after the death of both his
parents, sold Fanny's collection of Keats's letters.

Fanny herself died on December 4th 1865, more
than 40 years after Keats, and is buried in London's
Brompton Cemetery.

Episode 7

Harriet & Estelle

FIRST MOVEMENT: BACKDROP

*H*ector Berlioz started to put together his Memoirs while he was in London in 1848. He was probably relieved to be away from Paris, because for the third time in his life, a violent uprising was raging there. Barricades had once more gone up in the streets, with chaotic scenes of riot and disorder erupting all over the city.

But unlike previous episodes of revolutionary activity in France, a wave of insurrections was also brewing in many other European countries. Sometimes called '*The Springtime of Nations*', the year 1848 saw the populace rising all over Europe to demand the removal of old and outdated monarchical structures. The aim was the establishment of democratic constitutions but also, for some countries, the creation of independent nation-states. A tidal wave of fervour for change, combined with the romantic concept of patriotic nationalism, swept up artists, writers and liberal intellectuals in its wake. This idealistic energy, like every movement for reform, would lead to tragedy as well as triumph, but would lay out the bare bones of the Europe of the first part of the c20th.

Britain, in contrast, had by now settled into a period of relative equanimity under Queen Victoria. A reformed parliamentary system and a stable constitution meant that apart from the rumblings of the Chartists, things stayed peaceful - although as we shall see in the next Episode, parliamentary reform hadn't yet advanced sufficiently to give women the vote. Berlioz commented that despite, as he put it '*the Juggernaut of Republicanism*' which was rolling across Europe, Britain seemed secure and calm and indeed was providing a safe refuge for many escapees from the Continent.

The c19[th] was a tumultuous one for France. After Napoleon Bonaparte was appointed first Consul in 1799, he applied himself to the re-establishment of stability and the reorganisation of the country's internal structures. He reformed the outdated and wayward financial system, setting up the Bank of France and centralising tax collection and management of revenue. He also initiated local government reform in the Communes and Departments which had been established during the post- revolutionary period. Napoleon centralised things by personally appointing a Prefect to be in charge of each Department. Local elected councils were then only able to act in an advisory capacity; even the Mayors of Communes were centrally appointed.

Napoleon's most complicated task was the overhaul of the French legal system. Hitherto there had been no system of common law, just a mixture of local laws and jurisdictions, all tangled up with feudal traditions, royal edicts and ecclesiastical statutes. The Revolution had totally changed traditional property rights and civic entitlements; a completely new set-up had to be established. The '*Code Napoléon*', an entire remodelling of the law, was arguably Napoleon's most significant peacetime achievement and one which largely lives on in today's France. It was a huge and complex labour - of synthesis, codification and

re-classification - embodied in over 2000 articles, and became law in 1804. Hector Berlioz, in La Côte-Saint-André, 48 kilometres north-west of Grenoble, had been born the previous year.

Napoleon also initiated educational reform - setting up the Lycées which are still at the heart of French secondary education, as well as encouraging scientific research and establishing technological training alongside the ancient medieval universities. Both the Arts and the Sciences were supported by the government. Napoleon wanted to rebuild France's distinguished reputation in the realm of intellectual and artistic achievement after the totalitarian excesses of the Revolutionary period. So far, so good - and indeed all massively necessary as well as extremely impressive.

Napoleon's next priority was to re-establish France's place on the international stage. His army - *'La Grande Armée'* - had won him power, it was now sent out to win him an empire. In 1802 he became Consul for Life and by 1804 he had taken the title of Emperor of the French. At his coronation he didn't receive his crown from the Pope as tradition dictated, he placed it on his head himself! This was hugely symbolic - the declaration of the self-made Sovereign - in power not through the inheritance of a dynastic entitlement but through his own achievements. In reality his position and authority had been gained

largely through his military triumphs. A successful and popular general, he needed to hang on to the loyalty of his army now that he was running the country.

So he sent his soldiers to war again, to regain the glory of France. He also authorised and oversaw colonial expeditions, seizure of territories and the mandatory incorporation of many European nations into the French sphere of influence. By 1808 only Great Britain and Portugal resisted him; so, for instance, when Lord Byron embarked on his Grand Tour in 1809, Napoleon's blockade of British trade and the ongoing hostilities with Britain rendered a conventional Grand Tour impossible. Byron's tour had to start in Lisbon and didn't take the traditional route but instead took in countries much further afield including Malta, Albania, Greece and Turkey.

When Berlioz visited Russia for a concert tour in 1847, while travelling through the frozen landscape by sledge he was overwhelmed by thoughts of the tattered remains of the Grande Armée: '*I kept imagining our poor shattered army on that murderous retreat, and pictured the wretched men, coatless, no boots on their feet, without bread, without brandy to warm them, their morale and their physical strength reduced to nothing... by day dragging themselves along, a ghost army, by night stretched out in the open, corpselike, on this appalling snow....*'

Napoleon's Russian campaign was initiated mainly because Tsar Alexander refused to join his *'Continental System'*. The aim of this system was the defeat of Britain not just through war but also through a pan-European trade blockade. There were also other factors; the rival empires of France and of Russia both had their eyes on achieving mastery of the Near East. Realising he couldn't conquer Britain at sea Napoleon gambled on the hope that adding the might of Russia to his sphere of influence would lead him to total mastery of Europe.

The harrowing tragedy of the French retreat from Moscow is one which has inspired art, literature, poetry and song. It was, I think, the nail in the coffin for Napoleon's grandiloquent plans. Other European nations began to change allegiance; a coalition of Russia, Prussia, Austria, Britain, Sweden and Spain plus other smaller nations was established. In 1814 Paris fell to this coalition and Napoleon admitted defeat. He abdicated as emperor, renounced his European plans and retired as sovereign of the little island of Elba.

Monarchy was not dead after all - it re-emerged recast in [6]Louis XVIII, brother of the executed King Louis XVI. The Bourbons were back - the

6. *Louis XVII was the little Dauphin who perished in the Revolution*

old concept of kingship now transformed into a constitutional monarchy incorporating a charter guaranteeing specific rights and liberties to the people. But Louis XVIII had hardly got started when Napoleon escaped from Elba and arrived back in the south of France, welcomed by large crowds. The army promptly deserted the new king and rallied again to Napoleon; meanwhile Louis XVIII hot-footed off to England as fast as he could.

The Hundred Days of Napoleon's campaign to take France back and reclaim his empire was, however, destined for failure. Europe had basically had enough of him. His defeat at Waterloo put paid to him for good and he was now banished to St Helena in the South Atlantic, where six years later he died. The new king, returning hastily from his brief exile, was willing to accept most of the reforms initiated in the aftermath of the revolution, as well as the domestic policies introduced by Napoleon. This ensured a few years of relative stability for war-weary France.

But the new administration had to deal with several political factions, each with its own axe to grind. It included Royalist reactionaries (known as Ultras) who wanted a return to the *Ancien Régime*, more moderate Royalists who believed in a constitutional monarchy, and also those more extreme left-wing elements who were determined

that the revolutionary changes of the 1790's should be irreversible. An uneasy coalition lurched from right to left, the Ultras started by winning a large majority in the new Chamber of Deputies but successive elections led to a more moderate Chamber. Liberal-leaning left-wing supporters were gaining ground, so the years from 1815-1820 were on the whole reasonably stable.

It all kicked off again however a few years later, when a fanatical Bonapartist assassinated the King's nephew, the Duc de Berry, hoping thereby to annihilate the Bourbon line. This brought the Ultras back into play; and when Louis XVIII died in 1824, his successor and younger brother Charles X was all for a complete return to the *Ancien Régime*, including a re-instatement of the principle of the Divine Right of the King. A succession of partisan laws were rushed out, including paying compensation to Royalist émigrés whose property had been confiscated during the Revolution. The authority of the Catholic Church was reinstated - new seminaries being set up to counter the secular education provided by the Lycées. It was even rumoured that the King himself had become a secret Jesuit.

This all built up over the next few years into total polarisation of the political system. The leftists became increasingly aggressive, but a moderate royalist faction then galvanised into action,

championing the cause of the King's cousin Louis-Philippe, Duc d'Orleans, who offered a constitutional monarchy, The Ultras on the other hand, under the fanatical reactionary the Prince de Polignac, advocated a royal coup d'état. The King had no hesitation in favouring this last and most extreme option, dissolving the Chamber, reducing still further the already limited suffrage, and stripping away what remained of the freedom of the press. It was like throwing a blazing torch into an already smouldering bonfire.

The July Revolution of 1830 (brought vividly and unforgettably to life by Victor Hugo in '*Les Misérables*') was the incendiary result of the King's and his supporters' obduracy and ineptitude. In Paris the barricades went up again, and for three days the city was in the hands of a loose but impassioned citizen army of students, workers, disaffected soldiers and members of the public.

It was brief but bloody. By early August Louis-Philippe was proclaimed King of the French and again pledged himself to a constitutional monarchy. Censorship of the press was abolished, freedom of religion was re-instated, and the franchise was extended to all (men) over 25 with the property qualification reduced. Known as the July Monarchy, in which the king presented himself as 'The Citizen King - a bourgeois monarch - this regime

nevertheless had to deal with constant challenges from both the Right and the Left. Serious outbreaks of insurrection in Lyon and Paris in 1831 and 1834 by angry workers had to be suppressed by the National Guard, resulting in hundreds of casualties.

There then came a reminder of a period that many of the population were now looking back on with pride and nostalgia - the time of Napoleon. His nephew Louis-Napoleon Bonaparte presented himself in 1836 as the true heir of France. By this time Napoleon was revered by many and had indeed become a sort of legendary figure. The arrival of the nephew of '*le petit caporal*' (the little corporal) crossing the border into France, calling on troops from Strasbourg to rally to his cause, caused quite an upset. In the end it came to nothing, as did a second attempt a few years later. Both were quickly suppressed and Louis-Napoleon escaped to exile in Britain - but it stirred up old emotions.

The 1840's was a tough period for much of Europe. Potato blight in the mid-decade plus poor weather and harvest failures caused widespread suffering in many countries. Often described as 'The Hungry Forties', this had its most devastating effect in Ireland, but the toll was also considerable in many other nations. On the Continent, Belgium, Prussia and France were particularly hard-hit; it's estimated that in France alone several thousand people died

of starvation. Coupled with the factors outlined earlier, all this contributed to the unrest and the widespread craving for change which led to the Year of Revolutions in 1848.

In France King Louis-Philippe, confronted by an angry mob of insurgents in Paris and the prospect of civil war, in February abdicated and fled again to Britain. After months of unrest, disagreements and failed attempts at establishing a stable administration, the Second Republic was established. But this ran into trouble after elections to elect a Constituent Assembly resulted in a victory for moderate conservative candidates. By now the workers and radicals had had enough. The brief and bloody few days in Paris from June 23rd-26th - known as the June Days, again saw the barricades going up, unemployed and angry workers once more joined by students, sympathisers and artisans.

The extraordinary outcome of all this turmoil was the appointment, in December that year, of Louis-Napoleon Bonaparte as President. He had returned from his English exile and had successfully stood in a by-election as a candidate for the Constituent Assembly. In the subsequent presidential election he won by a landslide. With a name that to many Frenchmen symbolised glory, strength and stability, the hopes of the nation were invested in this scion of a celebrated predecessor.

He started prudently, trying to please the most powerful factions in the awkward mixture of radical left and monarchist right which now constituted the Assembly. At first his inclinations were aimed at pleasing the latter, who held the majority of seats, so he initiated measures to placate Catholics, including giving the church a firm grip on public and private education, approved a reduction of the franchise, restricted the freedom of the Press and banned large public gatherings. History seemed to be repeating itself, with a return to the policies which had cost Charles X his throne. And like Charles X, Louis-Napoleon's next step was an extreme one. Frustrated by the curbs which the Assembly was putting on his plans and the constitutional statute which decreed that the President could not stand for re-election, he prepared for a *coup d'état* in late 1851.

This time it worked. On December 2nd 1852 Louis-Napoleon, having ruled for a year as President after sacking most of his ministers, dissolving the Assembly and initiating a new, more liberal constitution after his seizure of power, was crowned [7]Napoleon III, Emperor of the French.

Conditions were very different in the Second Empire than they had been nearly fifty years earlier

7. *Bonaparte's son and heir, Prince-Imperial of France, was nominally Napoleon II after his father's death but never reigned*

in the Imperial reign of his uncle. Internally, in his first few years of power Napoleon III concentrated on modernising the country's infrastructure - investing in railways, steam power, building, banking and the economy. Externally, he was dealing with a new Europe after the revolutions of 1848. *'The Empire means Peace'* he claimed early on, hosting the Paris Peace Conference in 1856 after the Crimean War. France had actually supported the British in this debilitating conflict and had played a key rôle in the ultimate victory. He also worked with the new Italian Republic to evict Austria from northern Italy. Nice (Nizza), had still been part of Italy when Berlioz won the Prix de Rome in 1830. Thirty years later both Nice and Savoy were ceded to France in gratitude for the Emperor's help in Italy's path to unification.

On the whole Napoleon III's rule was a reasonably moderate one. He restored manhood suffrage (French *women* didn't get the right to vote till 1945) and the freedom of the Press; encouraged private enterprise while at the same time encouraging workers to form trade unions and mutual aid societies. He also authorised, through his Minister of Education, the establishment for the first time of secondary education for girls - to be explored in more detail in the next movement of this Episode. With stability came prosperity. The restoration of Franco-British entente was advantageous to both

nations. In 1860 Louis-Napoleon negotiated a low-tariff treaty with Britain; this upset some of the business classes, who lost the protectionism which they had hitherto enjoyed, but overall, it was a fair and productive move.

So, in conclusion, the Second Empire was, in many respects, a time of renewal and stability for France. What conclusively ended it was the disaster of war in 1870 with a resurgent Germany. It was a military catastrophe for France; the Emperor himself was taken prisoner by the Germans, and the Third Republic came into being.

SECOND MOVEMENT: WOMEN

In front of me is a copy of Eugène Delacroix's picture '*Liberty Leading the People*', created in 1830 to commemorate the July Revolution and the toppling of Charles X and his extremist government. It's one of Delacroix's best-known paintings, now on display in the Louvre - and is a vivid and symbolic depiction of the uprising. The mythic figure of Liberty, a bare-breasted woman in classical style, holds the Tricolour flag aloft with one hand and grasps a bayonet in the other. On her head is a Phrygian cap - the cap of liberty adopted by supporters of that first, epoch-changing Revolution of 1789.

She is the only female figure in the painting. Following her are the revolutionaries, the nearest of whom represent the universal demographic of the rebellion - different social classes all committed to a common goal. We see a bourgeois in top hat, jacket, cravat and waistcoat, both hands clasping a musket. Behind him is an artisan, bare chested and shirt-sleeved, wielding a sabre, and on the other side is a youth in a student's beret, brandishing a pair of pistols. A mass of activists as far as the eye can see is pushing forward behind these foremost figures. Fires are burning, smoke billows across the scene, partly obscuring the cathedral of Notre Dame - (Our Lady) - symbol of Paris and of course of another female redeemer.

On the ground are some of the bodies of the fallen. One of these, at the very front of the picture, is a soldier – perhaps one of the many National Guard troops who joined the Revolution. On the other side is a ragged semi-naked man who was perhaps taken by surprise and was only half dressed when he was slaughtered. Delacroix walked through the thick of it, and later wrote *'A simple stroller like myself ran the same risk of stopping a bullet as the impromptu heroes who advanced on the enemy with pieces of iron fixed to broom handles'*. When he made it back safely to his studio he began to sketch out his painting.

It's interesting, but maybe not surprising, that the only bits of female imagery in Delacroix's magnificent painting are the symbolic figure of Liberty and the emblematic significance of the Virgin Mary embodied in his depiction of Notre Dame. In reality women certainly played their part in the revolutions of 1830 and 1848. One such was Marie Deschamps, who fought on the barricades in 1830, having snatched the musket of a citizen who had been killed. She fired at the Swiss Guards, unperturbed by the bullets aimed at her, one of which went right through her gown and out the other side. And she wasn't the only one; many other women fought alongside the men.

Women as symbols of glory, of patriotism, and of other ideals appear throughout history. The Britannia on our British coins, the Marianne of France, the Italia Turrita of Italy - each personifying patriotism and nationhood. Justitia - the Lady of Justice - also crops up in the statuary of many countries. And Delacroix's 'Liberty' is the evocative representative of freedom - the most seminal of human rights.

So what of actual women's rights during this century of upheaval in France? The Napoleonic Code, efficient, detailed and pragmatic, was undoubtedly an extraordinary achievement. But as far as women's rights were concerned, it went

backwards. The series of articles on marriage which form a section of the Code classifies women as legally subordinate to men. '*The husband owes protection to his wife, the woman obedience to her husband*' it states. There follows what can only be described as an outrageous series of statutes and prohibitions outlining a woman's obligations in law. Here is an account of some of them:

Women were considered subservient with regard to property. They couldn't enter into any contract without permission from their husbands or fathers, and, despite the description of property ownership by a couple as joint, a woman had no right to examine or oppose any action taken or decision made by her husband. A husband was allowed to dispose of any part of a household's property without consultation with his wife, who had no legal right to object.

If a husband had debts before marrying, his wife was obliged to accept these as joint debts. Women were not permitted to enter into any legal dispute or defend themselves at court without permission from their husbands. They couldn't travel out of the country unless their husbands allowed it - and if they were away from home, husbands were legally entitled to read any letters addressed to their wives.

Napoleon himself, when instructing his scribes and researchers in the drawing up of the code, asked them to ensure that the promise of obedience from

women to their husbands should be part of it. He also stated '*It is women who give men children, they thus belong to men just as the fruit tree belongs to the gardener.*'

The setting up of the Lycées by Napoleon provided a good and varied secular education for boys. He did believe that girls should be educated, but not in the same way as boys. His Concordat with the Pope on the rôle of the Catholic Church in the new France re-established traditional religious schools. These would be the main providers of female primary education. With regard to girls, he said '*What we ask of education is not that girls should think, but that they should believe*'. When he visited a girls' school he suggested that religion and domestic skills geared towards the attraction of potential husbands should be the priority. Women, after all, would not be running the country or going to war to defend it. It wasn't until after the 1830 revolution that the government passed a law enabling the launch of elementary schools for girls, leading at last to a considerable rise in female literacy.

Outside the legal framework of the Code, influential and prominent writers had outlined their own equally patriarchal ideas. Jean-Jacques Rousseau, c18[th] philosopher and a key influence in the run-up to the Revolution of 1789, had opened his treatise '*The Social Contract*' with these famous words: '*Man is born free, and he is everywhere in chains*'.

The book suggests that true freedom is only possible in a civilian society that ensures the rights and well-being of all its citizens. But actually, he is talking not of the rights of humankind, but of the rights of men! There is a natural, unquestioned assumption of gender superiority.

In another equally famous work, *'Emile'*, Rousseau argued that the main aim of a woman's life should be directed to satisfying the wishes of her father, husband, brothers and sons. Too much education would detract from a woman's desirability. He condemned the intellectual *'salons'* in which women met to discuss literature, poetry, art and philosophy as inappropriate. A woman should concentrate on domesticity, which, with the bearing and rearing of children, was the natural purpose of a woman's life. I'm reminded of the opprobrium cast on the Bluestockings in the same period in England.

Much more extreme views came about a century later from the self-proclaimed anarchist philosopher Pierre-Joseph Proudhon. He made no bones about his anti-feminism, but went further by stating that women were both morally and intellectually inferior. A woman's destiny, he said with uncompromising chauvinism, was either as a housekeeper or a harlot. His main justification for these views was the greater physical strength of men, which he recommended they should use to keep women in their place. To be

fair, Proudhon had pretty extremist views on several aspects of life and many of his ideas and values were not supported by the majority.

Despite this widespread misogyny, many women continued to express their ideas and prove themselves as creative, able and talented. So I want to focus on a few of those brave individuals who put their heads above the parapet and thereby impacted on the gradual shift in attitudes to women.

The name George Sand is a pretty familiar one. What many people know when considering this gifted and prolific French writer is that the male name is a pseudonym, that she often wore man's attire, and that for several years she lived with the composer Frederic Chopin. Let us now delve more deeply into the life and ideas of this remarkable woman to see how through her fiction she explored the travails and struggles of her female protagonists, and how in her life and behaviour she was able to challenge the very rigid patriarchy of her time.

Amandine Aurore Lucie Dupin was the only living child of an aristocratic father and a much more humbly born mother who worked as a dancer. Attractive young dancers have long been the recipients of amorous attentions from well-connected men, and Maurice Dupin obviously fell for this particular one. Often such liaisons were fleeting affairs, but this case, the man actually married the

woman. They then lived together in Paris where their daughter was born in 1804. But when the child was very young her father, an army officer, was killed in a riding accident. His mother, wealthy owner of the family estate at Nohant in Berry in central France, then took over the care, education and upbringing of the little girl. Apparently Madame Dupin gave her daughter-in-law a financial settlement which enabled her to return to Paris - perhaps to resume life as a dancer - and thus the grandmother gained custody of the child.

It was a childhood of contrasts. Little Aurore was allowed to run wild and to play with the children of the labourers who worked on the estate - she soon became fluent in the local patois - but was also being brought up and educated in a cultured and literary household. As a writer George Sand describes her intense love of the countryside. The freedom she enjoyed and the beauty around her during those early years left a deep and lasting impression. However this idyll had to come to an end when she reached puberty and was sent as a boarder to an English convent school in Paris.

After the death of her grandmother in 1821 Aurore - still in her teens - inherited the entire estate. Aged 18 she married Casimir Dudevant, who like her father was an army officer descended from minor aristocracy. But this was not a happy marriage.

Aurore was soon having both platonic and amorous relationships with other people and she left her husband after the birth of two children. This really heralded the start of her new life as a journalist, a writer of fiction and an independent woman.

Her first novel *'Indiana'* - published in 1832 - was an instant hit. It's a powerful and passionate protest against the social conventions of the day which tied women into loveless marriages as well as depriving them of any independence. The heroine of the story, like Aurore, abandons her marriage and looks for love elsewhere. The book was published under the name George Sand; Aurore had collaborated with the journalist Jules Sandeau when writing for *Le Figaro*, creating the male pseudonym of Jules Sand for herself. Possibly to avoid confusion with Sandeau she then changed it to George Sand, launching her literary personality; thereafter all her works were published under that name. She became a best seller; the combination of drama, history, politics and passion in her very accomplished writings made her a literary superstar.

In a letter to one of her correspondents she sets out what might be described as her personal manifesto: *'People think it very natural and pardonable to trifle with what is most sacred when dealing with women; women do not count in the social or moral order. I solemnly vow - and this is the first glimmer of courage and ambition*

in my life - that I shall raise woman from her abject position, both through my self and my writing. God will help me ... let female slavery also have its Spartacus. That I shall be, or perish in the attempt'

As a child she had enjoyed a lot of freedom and had ridden around the estate wearing trousers for the practical reason that they were the most comfortable garb for being on horseback. Now in Paris she took to dressing as a man. Women were not supposed to go out unchaperoned; but by cross-dressing Sand could walk around town unnoticed and unmolested. This wasn't a statement about her gender preferences, but simply a way in which she could be accepted as an independent person subservient to no man. She also smoked in public - another demonstration of her right to behave as she chose rather than accepting the limitations imposed on women.

Both in her writings and in her life Sand engaged with political issues. She was a vehement advocate for an equivalent standard of education for girls as that available to boys. Commenting that a married woman's status in law was comparable to that of a child, she said that without doubt women should be allowed to vote. However she coupled that aspiration with this caveat: women would need a proper education and legal freedom before getting the vote, so they could make informed and independent choices. In the current situation, if they

were enfranchised, they might well be persuaded to vote as their husbands did, which would perpetuate the current patriarchal hegemony. Incidentally it was not until over a century later that French women actually got the vote.

Regarding the plight of poverty-stricken citizens in towns as well as the rural peasantry, she felt that care and support shouldn't be left to the church and charitable institutions, but should be provided by the state. One of her abiding concerns was the treatment of destitutes, orphans and people with physical or learning disabilities. If such an individual was incapable of learning any practical skill, he or she was usually turned out and abandoned - thus becoming a target for all sorts of cruel and abusive treatment. As a wealthy heiress Sand cared for such individuals on her estates, but the official attitude to them was a callous one. Care in the community was what she advocated - an idea well ahead of its time.

The 1848 revolution, which she initially supported, raised her hopes. She felt that a just and humane society might result from the upheavals; sadly, her hopes for a socialist republic were dashed by the mob violence which prevailed. She never lost her political convictions, but was so upset by the anarchy of the June Days that she left Paris and returned to Nohant. Thereafter she continued writing; the pastoral novels she produced during this

period became enormously popular. They were also influential. Through such works Sand continued throughout the rest of her life to address injustice, abuse, and the struggles of women for recognition and equality.

I ended the last movement with the capture of Napoleon III by the Germans and the subsequent establishment of the Third Republic. But by 1871 Paris again erupted into violence, with the birth of that short-lived but extremist radical regime known as the Paris Commune.

It all began in the aftermath of the Franco-Prussian war. The National Guard had been stationed in Paris to defend the city while it was under siege from the Prussian army. After the armistice, through which the victorious Germans exacted huge financial indemnities as well as taking parts of the Alsace-Lorraine territories, disaffected and angry National Guardsmen refused to leave their positions. The inhabitants of working-class neighbourhoods in Paris were already stuck there, hungry and suffering in the besieged city - unlike the rich, most of whom had fled the siege to their estates in the countryside. So the workers came out in support of the protesting guardsmen. To them all, the new conservative-leaning republic seemed to be indifferent to the tribulations of the poor.

Basically, poverty-stricken Parisians had had enough. They were further infuriated by the triumphal parade of the Prussians through their city in March 1871. Together with the rebellious National Guard, they revolted and took control of the city, establishing the Paris Commune, a radical left-wing regime which would rule the city for the next two months. Women joined men on the barricades, set up support groups to maintain the city and organised discussion groups to debate the way forward. Over its tenure the Commune held (male only) elections, passed laws and defended the city against government-backed French troops from Versailles.

Large numbers of women played a part in the Commune. In early April, Nathalie Lemel and Elisabeth Dmitrieff established the *Women's Union to Defend Paris and Care for the Wounded*. The Union's aims long-term were ambitious and progressive. They wanted gender equality and equal pay for women, including the right of a woman to initiate a divorce from an unhappy marriage. They also demanded secular education and professional training for girls. And of course they wanted the vote. Even the innovative plans of the Commune didn't include female suffrage.

Dimitrieff escaped when the Versaillaise army broke into Paris and destroyed the Commune in May.

Lemel was deported to New Caledonia but eventually returned to France after an amnesty was granted to the remaining Communards. *Place Elisabeth Dmitrieff* and *Place Nathalie Lemel* in the 3rd Arrondissement were renamed in their memory on International Women's Day 2007.

THIRD MOVEMENT: LOUIS-HECTOR BERLIOZ

When Hector Berlioz was twelve, he fell in love with a beautiful young woman. She was six years older than him, and her name was Estelle. This wasn't his first feeling of ardent passion; from early childhood he seems to have been an intense and emotional little boy. In his Memoirs he talks about the ecstasy which flooded his senses when he took his first communion and heard the eucharistic hymn. That singing was his first experience of music.

Not only did this sacramental event turn him into a fervently religious child for several years, but it also awakened his musical awareness. The hymn - a tune from a popular light opera of the time adapted with suitably ecclesiastical lyrics - sent him into what he describes as a '*mystical, passionate unrest*'. From then on, music was to grow into every part of his creative consciousness.

Estelle was the granddaughter of a neighbour who owned a summer cottage up the mountainside at Meylan, which was also where young Hector's maternal grandfather lived. It wasn't far from Grenoble and La-Côte-St-André, Hector's village, so most years his family would spend a few weeks there. There he beheld Estelle for the first time, statuesque, elegant and exquisite, with large lustrous eyes, a glorious head of hair, and, he noticed, on her feet an irresistible pair of fashionable pink half-boots! He fell for her instantly – a *coup de foudre* in effect - and spent the rest of the holiday yearning for her, much to amusement of the rest of his family who teased him unmercifully about his adolescent adoration.

Music was to prove a more dependable passion. He found a flageolet (an early form of flute, not unlike a recorder) in a drawer at home one day, and started to blow on it, attempting to play the French nursery song '*Malbrouck s'en va-t'en Guerre*'. So excruciating were the sounds he made that his father quickly intervened to teach him how to play the instrument properly. This proved easy, within couple of days young Hector had mastered the technique and was ready to learn to read music.

From then on, the boy became more and more enchanted. Fairly soon he was playing the flute with other local amateur musicians, having regular instrumental tuition, and puzzling out the principles

of harmony on his own. By his mid-teens he had written two quintets for flute and strings. Composing was a good way of expressing pent-up emotions of hopeless love as he continued to yearn for Estelle – his '*Stella montis*' (star of the mountain) as he privately named her, creating wistful songs in the minor key about his melancholy love. She was, in effect, his first Muse.

Composing music was not however part of his father's plan for this clever and promising son. Louis Berlioz was a doctor. As Berlioz says in his Memoirs, his father was highly respected locally and had also distinguished himself in a wider sense with the publication of a treatise on chronic diseases and therapy procedures. Dr Berlioz's intention was that his son should follow in his footsteps, so a few months before his 18th birthday young Hector was sent to Paris to study anatomy. His first reaction to the dissecting room was one of absolute horror: '*At the sight of that terrible charnel-house - the fragments of limbs, the grinning heads and gaping skulls, the bloody quagmire underfoot and the atrocious smell it gave off.... such a feeling of revulsion possessed me that I leapt through the window of the dissecting room and fled...as though Death and all his hideous train were at my heels*'.

The ongoing lure of music was proving irresistible. A visit to the Opéra one evening fired him up in a way that his medical studies, although he was by

now finding them increasingly interesting, could not do. He continued attending the Opéra and started visiting the library at the Conservatoire, which was open to the public, where he could study manuscripts to his heart's content. He had loved the works of the c18[th] German composer Christoph Willibald Gluck for a long time – now he could immerse himself in the scores of Gluck's operas. When he heard Gluck's *Iphigènie en Tauride* performed for the first time it was a watershed moment for him - exposing a sudden passionate certainty that his destiny too was to be a composer.

For a while Berlioz tried to balance the two parts of his life - medicine and music - but although in early 1824 he did indeed qualify as a *Bachelier des Sciences Physiques* (Bachelor of Physical Sciences) the die was cast. He wrote to his father telling him that music was his vocation. This resulted in an increasingly furious and bitter correspondence between them, leading to a rift with his family which was to last for several years. It also led to the reduction and at times complete withdrawal of the funds with which his father had been sustaining him in Paris.

By this time Berlioz was taking composition lessons at the Conservatoire and had been creating various orchestral and operatic pieces. Unsurprisingly one of these - *Estelle et Némorin* - was based partly on a pastoral romance by Florian which he had loved as

a child - but also incarnated his idea of the fictional Estelle as the '*Stella montis*' of his adolescence. This and other early efforts he eventually destroyed; he is scathing about them in his Memoirs, describing them as pallid and clumsy. He did however later incorporate one of the themes from *Estelle et Némorin* into the first part of his *Symphonie Fantastique*.

Poor Berlioz was also struggling to make ends meet. Without financial support from home he underwent several years of poverty. He took private pupils, did a bit of musical journalism and worked for a time as a chorus singer at a theatre which specialised in vaudeville and operetta - music theatre as it might be described today. Renting a tiny fifth floor room and cutting down on food, he lived mainly on bread, raisins and dates. Things improved slightly when he met an equally poverty-stricken friend; they pooled their resources, rented a pair of adjacent rooms and subsisted on 30 francs each per month. Later, his ability to write fluent, witty and erudite articles was to gain him a contract with the respected *Journal des Débats*– producing *feuilletons* (critiques). He didn't enjoy writing them much, but he did them very well and earned himself a small regular income.

Meanwhile he continued to study composition, fugue, counterpoint and instrumentation at the Conservatoire and, despite the unconventional quality of his work, was beginning to attract quite

a bit of attention. A mass that he had written had, by 1827, had two successful performances, both of them at churches in in Paris. His unique musical voice was emerging. In 1826 he started to write his first opera '*Les francs-juges*' (The Free Judges) - his setting of a libretto written by his close friend Humbert Ferrand. A talented and cultured young man, as a lawyer Ferrand had been researching a system of secret courts in medieval Germany and the terrifying effects they had. This inspired the plot of the opera. Later Berlioz destroyed the work but kept the overture, which is still performed today.

His music for this opera was impassioned and powerful. Its first performance was scheduled to take place at the Odéon Theatre - but it never happened. The theatre couldn't secure a licence because the government wasn't prepared to support new French operas, preferring to stick to the established repertoire of tried and tested pieces. Berlioz was coming up against the ingrained conservatism of the musical establishment, something that was to blight him all his working life. He found himself constantly at variance with the practices of the time, vehemently opposing, for instance, the practice of mixing movements from different symphonies in performance as if they were parts of the same work. Beethoven's compositions habitually suffered this indignity, with a pot-pourri consisting of parts of

various of his symphonies interspersed with excerpts from other composers. Nowadays copyright laws provide protection, but it was a routine procedure in France and many other European countries at the time.

It infuriated Berlioz. Never one to keep his anger to himself, he railed loudly and vehemently against this practice, and even more at the cavalier rewriting of bits of works considered too complex, too tragic, too erotic - and substituting them with alternatives felt to be more ameliorative. *'No, no, no, a million times no!'* he cries *'You musicians, you poets, prose-writers, actors, pianists, conductors, whether of third or second or even first rank, you do not have the right to meddle with a Shakespeare or a Beethoven, not even to bestow on them the blessings of your knowledge and taste'*

Despite the entrenched opposition he had constantly to deal with, he battled on at the Conservatoire, submitting works for examination and developing an increasing confidence in his own musical powers. His masters might not approve of what he wrote, but they couldn't ignore his talent. For five years in succession he entered a composition for the prestigious Prix de Rome. His first attempt didn't even get shortlisted. More submissions followed in subsequent years, all of which were accepted for consideration, but rejected. One of his efforts was dismissed as unplayable (in fact it was successfully

performed the following year) - but he persevered, coming second in 1828 and finally winning the prize in 1830. He was slightly dismissive of the quality of what he had produced this time, having deliberately decided to curb his more extreme ways of expressing his musical ideas in order to create something in a style that was more conventional and therefore more acceptable to the judges.

The past few years had been momentous ones in many ways for the young man. His childhood adoration of Estelle was suddenly eclipsed when he went to a performance of Hamlet at the Odéon Theatre. The company was an English one, performing in English a repertoire including several of Shakespeare's plays, which were at the time relatively unknown in France. This event was to precipitate what he described as *'the great drama of my life'*. Ophelia was played by the Irish actress Harriet Smithson. She took the city by storm with her performance, causing many in the audience to weep uncontrollably when she acted Ophelia's mad scene.

The timbre and resonance of Harriet's speaking voice and her heartbreaking interpretation of Shakespeare's words sent Berlioz into a state of frenzied emotion which seems to have rendered him temporarily incapable of leading his normal life. Coupled with the overwhelming revelation to him of Shakespeare's genius, which, as he said *'struck me*

like a thunderbolt' these impressions caused him such emotional upheaval that he felt he couldn't cope with attending another performance. But of course he was unable to keep away, and a few days later he was equally overwhelmed when Harriet played Juliet.

In order to try and get her to notice him, he decided to mount a concert of his own compositions and show her that he too was a creative artist. This took place in May 1828 - and while it did get his works more widely recognised by the public as well as giving him a useful understanding of all the procedures involved in order to launch a public performance - it didn't bring Harriet any closer. In fact she was completely unaware that it was happening. Over the next few months he wrote to her repeatedly but had no replies; later he learnt that she had been so alarmed by the passionate content of his letters that she told her maid not to accept any more of them. A further attempt involved Berlioz persuading the manager of the theatre to include one of his overtures before one of her performances. While it was loudly applauded, she heard nothing, being in her dressing room preparing to go on stage. Shortly afterwards she left the country for a series of performances in Amsterdam.

Berlioz tried unsuccessfully to forget her. The *Symphonie Fantastique,* still the best known of his works, was written in the aftermath of all this. Its

five movements take the listener through an intense and transfixing dream of hopeless passion and unrequited love. I remember very vividly hearing it for the first time; it was like nothing I had ever heard before and I found it both fascinating and haunting. I listened out excitedly for the repeated *idée fixe* (the musical leitmotiv which symbolises the beloved). The effect of the way Berlioz distorts it in the final movement -*The Witches Sabbath* - left me simultaneously shocked and spellbound. The work never fails to enthral me whenever I listen to it.

Perhaps working on the composition of this extraordinary piece achieved a sort of catharsis for Berlioz, because, trying to put Harriet out of his mind, he now embarked on a passionate affair with a young virtuoso pianist; she too is thought to have influenced some of the themes in the *Symphonie Fantastique.* He then went off to Italy as part of the conditions incumbent on his winning the Prix de Rome. In the Memoirs he gives an amusing and delightful account of his time there; despite the musical prize which got him to Italy to work he seems to have had plenty of free time for exploring, hunting, meeting people and generally having a sort of extended holiday.

By the time he returned to Paris in 1832, his erstwhile mistress - who had briefly become his fiancée - had married someone else. His initial

murderous fury at this betrayal was forgotten when, with emotions of shock and confusion, he heard that Harriet was back in town. Now he needed to find somewhere to live, and by a strange coincidence the rooms where Harriet had previously lodged were available. It started to seem like some predestined plan, especially when he was told that she had only just vacated the place and was now staying not very far away in the Rue de Rivoli. He moved in. Occupying the place where she had been living so recently must have felt both thrilling and erotic.

Berlioz knew, through his past experience of the effect Harriet had on him, that he would be good for nothing if he immediately sought her out. He had a concert planned and needed to be in his right mind preparing for it. It was to feature the *Symphonie Fantastique* and also its sequel, entitled '*Le retour à la vie*'('The Return to Life'), described as a 'monodrama'. This involves spoken monologues, celebrating the recovery of the artist from the events of the *Symphonie Fantastique* in which he suffered the madness and torment of unrequited love, culminating in the horrors of *The Witches Sabbath*. Both works were largely inspired by Berlioz's obsessive passion for Harriet Smithson; - the *idée fixe* motif reappears in the sequel. But there's a life-affirming ending to this second piece in the form of Berlioz's orchestral and choral fantasy on Shakespeare's '*The*

Tempest'. Nowadays this sequel is known as *Lelio,* the name Berlioz gave his artist (really himself).

A friend of his took a box for the performance and invited Harriet to join him there. She had no idea that she was the subject of both works, so when the actor playing the 'artist' in Lelio said mournfully *'Oh, if only I could find her, the Juliet, the Ophelia whom my heart cries out for......* she realised with a shock that he was speaking about her. The outcome was that they met after the show, and their real-life romance began.

Despite opposition from both their families, they were married in October 1833 at the British Embassy in Paris with Franz Liszt, a close friend, as a witness. It was a very happy day, despite the fact that both bride and groom were broke. Harriet was in debt - her theatre company had failed and the momentous reception Paris had given her only a few years earlier had faded away. Berlioz still had the remains of his Prix de Rome grant and had borrowed 300 francs from a friend to pay for the wedding. They managed a brief honeymoon in a pretty country cottage at Vincennes, which, now a suburb of Paris, was then a pleasant rural village. Berlioz describes their first evening - with a meal delivered by a local restaurant and ending with fruit picked from the cottage garden - in a charming letter to his sister Adèle.

So far so good - and so truly romantic. For the first few years they were happy; the birth of their son Louis in 1834 was a great joy to them both. But their financial situation was dire. A benefit concert they organised together turned into a bit of a shambles. Harriet, recovering from a fractured leg, was unable to move with the fluidity and grace of her previous stage appearances; half the orchestra left before the show was over, having decided their allotted hours had been exceeded, and all the meagre proceeds of the event were swallowed up in the bottomless pit of Harriet's debts. These had become Berlioz's responsibility, since she was now no longer getting much work.

A commission from the government to write a requiem mass at last gave Berlioz the opportunity to create his splendid *'Grande Messe des Morts'*. He had long wanted to write a large scale setting of the requiem and this was the chance he had been waiting for. The scoring is monumental - appropriately so as it was originally intended for an official commemoration of those soldiers who had died in the 1830 revolution. In the end though, it took place as part of a solemn service commemorating the sacrifice of hundreds of French soldiers in the Siege of Constantine in Algeria. Berlioz produced an extraordinarily powerful work, with forces including a huge chorus, a tenor soloist, a full orchestra and

four brass bands. Over four hundred musicians and singers took part in the first performance.

But the 1830's proved to be a tough decade for both Berlioz and his new wife. He endured recurrent snubs from the established artistic directors of the Conservatoire and the Opéra; he was overlooked, for instance, for the Professorship of Composition at the Conservatoire - a post for which he was far and away the best qualified candidate and which would have assured him a regular income. The Director's dislike of him and distrust of his creative originality meant someone far less able got the job. Berlioz instead became the Conservatoire assistant librarian. But the crowning disappointment of these difficult years was the failure of his opera *'Benvenuto Cellini'*. Habeneck, the 'old school' conductor, wasn't up to the job; Berlioz's original and unconventional music defeated him, and the tenor soloist Gilbert Duprez walked out after three performances. Berlioz had wanted to conduct it himself but at the time composers weren't allowed to direct their own work at the Opéra.

Unfortunately too, in his private life things weren't going well either. Harriet was increasingly unhappy; her own career on stage had dwindled as her husband's was growing. Her health wasn't good, and she found Berlioz's frequent absences from home hard to cope with. His career eventually took

off in the 1840's with tours to Belgium, Germany and Austria, where he was féted in a way that had never happened in France. He later had equal succcss in Czechoslovakia, Russia and Britain.

But for Harriet, stuck at home, her health deteriorating, it was tough. She was angry, frustrated and jealous. Berlioz, as he puts it somewhat disingenuously in the Memoirs, had by now acquired '*a travelling companion*' - an opera singer called Marie Recio. There was none of the passion he had felt for 'Henriette', as he always called Harriet, nevertheless this affair lasted for twenty years and he married Marie a few months after poor Harriet's early death in 1854. Marie too was to predecease him, she died suddenly in 1862.

Berlioz and Harriet separated in 1844, Harriet moving back to Montmartre, where they had lived in the happy early days of their marriage. He continued to support her until her death.

We move on now to Harriet's story.

FOURTH MOVEMENT:
HARRIET (HENRIETTE) BERLIOZ
NÉE HARRIET SMITHSON

In the 1820's Berlioz read the French translation of Thomas Moore's 'Irish Melodies'. Moore was a poet,

lyricist and writer, a close friend of Lord Byron and his first biographer. The haunting, wistful beauty of Moore's poetry inspired Berlioz's song cycle '*Irlande*', written in 1829, when he was in the early throes of his unrequited but overwhelming passion for Harriet Smithson. The land of Ireland took on a mystic significance for him. '*I read Moore; his melodies draw tears from me from time to time. He is her compatriot: Ireland, always Ireland…*', he wrote. This dreamlike green island to the west of Britain, with its ancient traditions of bardic poetry and song, had become an enchanted place in his imagination, infused with the spirit of the Irish actress who had entranced him.

Harriet was actually Anglo-Irish; her father William Smithson came from Gloucestershire and became the actor-manager of a theatre in Dublin. He married an Irishwoman who was herself an actress; they had at least three children, one of whom, like Harriet, would have a career in the theatre. Harriet was born in Ennis, County Clare in 1800, but as a baby was put into the care of the Anglican clergyman James Barrett. I assume this was because her parents were often away on tour, but perhaps also it was to ensure a good religious upbringing for the child, away from the disreputable world of the theatre. When she was eight, after the death of James Barrett, the little girl was sent to boarding school. It's hard to

imagine what this child's emotions must have been; one hopes the school was a kind and humane place.

Whatever her parents' intentions were for their daughter, the fact is that she did indeed follow in their footsteps. Only six years later, at the age of 14, she made her debut on stage in Dublin. A crit of the time states: '*She certainly is a most interesting and promising young actress, and there is no doubt she would prove a great acquisition ... in the line of performance which her taste, as well as her talents, incline her to pursue*'. By the next year she had joined the Montagu Talbot Theatre Company in Belfast, and with them she played all over Ireland, mainly in comedy rôles. Her first English appearances came soon afterwards, in Birmingham in 1816 and in London in 1818. Her debut at Drury Lane saw her playing Letitia Hardy in '*The Belle's Stratagem*', a late c18th romantic comedy of manners.

So far Harriet had only done light comedy; when she went to Paris with Charles Kemble's theatre company in 1827 one of her first appearances there was as Lydia Languish in Sheridan's 'The Rivals'. But the real game-changer for Harriet Smithson was when Kemble mounted a Shakespeare season. French translations of Shakespeare's works were now available, and, despite these plays being performed in English, Parisians were enraptured. Kemble's programme offered Hamlet, Romeo and Juliet and

Othello. As we've seen, Smithson as Ophelia created a sensation - it wasn't only Berlioz who was overcome with emotion. Alexandre Dumas (père), despite knowing no English, wrote *'Oh Shakespeare, thank you! Kemble and Smithson, thank you! Thank you to my God! Thank you to my angels of poetry!'* The audiences were blown away by the English way of acting - depicting scenes which showed genuine passion, utterly unlike the stylised interpretations which were the custom in France at the time.

Harriet had in fact shut herself away for two days before the first night of Hamlet, thinking herself into the part. Her performances, as Ophelia, as Juliet, as Desdemona and as Jane Shore (an early c18[th] tragedy by Nicholas Rowe) showed Parisian audiences the new English theatrical techniques, wherein actors effectively 'became' their characters instead of just portraying them. It was really a forerunner of the Stanislavsky technique pioneered in the early c20[th], which developed in to what we now call 'method acting'. The classical tradition had focused on declamation and action; this new 'romantic' style emphasised the inner feelings and mindset of the character. Harriet Smithson's name is probably largely unknown today, but I think she really does qualify as one of the forerunners of modern theatrical performance.

We've already seen, sadly, that Harriet's glory days didn't last. Her return to Paris in 1832 with her own theatre company had failed, leaving her deeply in debt. Sadly too, the marriage to Berlioz didn't work for either of them. When you have been a theatrical superstar, reaching the very heights of dramatic interpretation, when your beauty has been celebrated in innumerable portraits and lithographs, and you have been described as '*la Belle Irlandaise*' and '*The Divine Ophelia*' - and when you have been the Muse for works of originality and virtuosity composed by one of the most talked-about musicians of the day - who happens to have fallen in love with you and married you - it must be well-nigh impossible to adjust to a traditional life as wife and mother. Harriet also spoke little French and Berlioz's English wasn't fluent, so she must have felt extremely isolated.

It wasn't only Berlioz's growing reputation and frequent absences on long European tours which finished things for Harriet. I don't think either that it was entirely the affair with Marie Recio from 1841 onwards - which seems to me to have been a symptom rather than the cause of their incompatible marriage. (It did however prove to be the last straw for Harriet, who moved out of the marital home not long afterwards). I think it was, on both sides, the realisation that they were actually not really suited to one another at all. He had married a vision, an

ideal, a mystic image based on the effect of her stage performance on his emotions. She had married a demonstrative, gifted and passionate young creative genius who adored her stage personas. She was very beautiful; he was strikingly attractive with a shock of dark red hair, animated features and deep-set blue eyes. There was obvious physical chemistry between them. But as he was later to say '*We could neither live together or apart*'.

Ongoing financial problems didn't help. But the saddest thing of all was Harriet's deteriorating health. Suffering from depression as her career declined, she spent long periods of time alone at home while her husband was away on tour. She became jealous and angry, and started to drink too much. Then a few years after she moved out she suffered a series of strokes which in the end were to render her paralysed and unable to speak. Berlioz continued to support her, visiting her regularly and hiring nurses to care for her. He writes movingly about her suffering, his grief and regrets, and about the glory of her past, when she '*had blazed like a meteor*'. The starry young actress who had taken Paris by storm and inspired a composer to dazzling creativity died in 1854 aged only 54, and was buried in the Saint-Vincent cemetery near her home. It was a profoundly sad end to a tumultuous life and a love affair which

had ricocheted from wild joy to bitter distress. But at the end, Harriet died peacefully and without pain.

I'm imagining her lying in her bed, which is positioned so she can see her pretty garden through the window. There's a distant view of the misty profile of the Paris skyline, but she prefers to look out at the garden full of flowers and to watch birds flitting in and out of trees, busy with springtime activity. The daffodils and crocuses are now in the full glory of their rich awakening; she has watched them every day from the very first appearance of those new green shoots pushing up through the brown winter earth. The display that has emerged in the last few days is a delight.

On the wall beside the window hangs the portrait of her which Hector brought last year. She remembers how distressed she was at first, not wanting to look at herself as she used to be. Unable to articulate her feelings in words, she wept inconsolably. But he sat with her; holding her hand and stroking her hair he told her with tears in his eyes how much she meant to him, and what an inspiration she had been to his music. Gradually since then she has become proud of the portrait. When visitors and the nurses who care for her look at it, she is glad now that they can see that she was once that radiant young woman in the magnificent heyday of her theatrical triumphs.

She's too tired now to be resentful and angry any more. And since the visit a few days ago of her beloved son Louis she has felt calm and peaceful. It was such a joy to see him as he came through the door into her room, vivid and handsome in his naval uniform. Harriet knows now that the end is very near. When Hector arrives to see her, as he often does, she tries to greet him, but her face can't make the proper movement. But he understands, and smiles down at her before sitting beside her and gently taking her hand.

He stays quietly with her as she falls asleep, and when she is breathing softly and tranquilly he leaves the room. But two hours later he is called back. She has gone.

FIFTH MOVEMENT: ESTELLE FOURNIER NÉE ESTELLE DU BOEUF

By the end of the 1850's Hector Berlioz was worn out, physically and emotionally. His successful foreign tours had had seemingly little effect on his reputation with the Paris musical establishment. As he himself knew, his musical values and his freethinking attitude to established forms of rhythm, harmony and melody had from the very beginning led to his work being eyed with suspicion. Never one

to keep things to himself, his forthright manner and emotional temperament led to frequent clashes with those who were in control of the musical institutions in Paris. As an accomplished writer, his journalistic work - frank, brilliant, funny and sometimes merciless - didn't make any concessions either, which annoyed a lot of the people who had been the subjects of some of his more acerbic comments

I think he was finally almost broken by what happened with his grand opera 'Les Troyens' (The Trojans'), which he had been working on for the past four years. He had loved Virgil's Aeneid since boyhood and had long pondered creating a grand five-act opera based on the epic, planning to write both libretto and score. He tried to resist this temptation, knowing that the subject - which seemed to him a moving and magnificent one - would probably be found dreary and tedious by the Parisian opera-going public. But he couldn't get it out of his mind and he knew it would continue to haunt him until he'd written it. This he did, producing an immense and spectacular dramatic creation.

But attempts to get it performed proved to be well-nigh impossible. Its length and the amount of labour which such an undertaking would demand put several impressarios off at the outset. Despite Berlioz arranging public readings of his poetry to hand-picked audiences, and even writing to

Napoleon III in the hope that he would support such a glorious piece of operatic theatre, there were no takers. In the end he had to agree to its being divided in half. The second part '*The Trojans at Carthage*' was successfully performed at the Théâtre-Lyrique in November 1863. It aroused praise and admiration, the positive reviews far outweighing the negative ones. Sadly for Berlioz, he was never to experience this magnum opus being performed in its entirety in his lifetime. When the first complete performance of 'The Trojans' took place its creator had been dead for over twenty years.

It was a weary and disillusioned man who wrote these words in his Memoirs in 1864: '*I am in my sixty-first year; past hopes, past illusions, past high thoughts and lofty conceptions. My son is almost always far away from me. I am alone. My contempt for the folly and baseness of mankind, my hatred of its atrocious cruelty, have never been so intense. And I say hourly to Death; 'When you will'. Why does he delay?* '

But into those last few unhappy years of the life of this extraordinary, rebellious, unconventional and brilliant man there was to be a surprising twist which would bring him some unexpected joy. Feeling desolate and lonely after a visit from his son, he decided to go back to his childhood home, to see his nieces, to think about the past, and to revisit old haunts. Both his much loved sisters were dead, as

were his parents, so it was a melancholy as well as a nostalgic pilgrimage. After spending a peaceful fortnight with his brother-in-law and the two girls, he made his way to Meylan.

The walk up the mountainside was full of memories of Estelle, his boyhood love, and when he reached the rock where he had first seen her he broke down completely. He hugged the flowering cherry tree nearby and, weeping, took a bit of its bark as a keepsake, then moved down to the house where Estelle had stayed. The mother and daughter now living there let him wander round the garden then invited him in so he could look at the view from the window. Overcome by his emotions, he thanked them, apologised for his tears, and left.

His brother-in-law had found out that Estelle was still alive, and now living in Lyon. So that same evening, he headed there. As nervous as the ardent child he had been all those years ago, he hardly slept that night. The next morning, holding a letter asking if she would see him, he made his way to where she was living, and, sick and literally trembling with apprehension, knocked on her door.

Estelle, now Madame Fournier, was a widow. Her life had been quiet and, compared to his, uneventful. Her husband had died when their children were young and their two daughters had also died in childhood. When Berlioz arrived he found her calm,

kind and dignified. But he saw in this grey haired elderly woman his '*Stella montis*,' the idol he had adored as a child, and was almost overcome by his feelings. They talked together about the past, and when he left she had agreed to let him keep in touch with her, but also told him she was shortly moving to Geneva where one of her sons was living.

He writes movingly in his Memoirs about his feelings for this '*aged, saddened, obscure woman, who knows nothing of art - my soul is hers, as it was once, as it will be to my dying day*'. They corresponded over the next few years, her letters were composed and temperate, his - despite his efforts to keep his fervent entreaties in check - full of the impassioned emotion which was part of his soul. As the years passed, he became calmer and a little more rational. Her son and daughter-in-law visited him in Paris, to his great joy. For three years he made an annual trip to visit her in Geneva and when he died he left her a life annuity.

The tolerant generosity of spirit which Estelle Fournier showed to Hector Berlioz when he re-entered her life was, I think, remarkable. She could have been so alarmed by his ardent and uncontrolled manner as he erupted into her quiet house that day in Lyon, that she might have felt quite understandably that she couldn't cope with letting him keep in touch with her.

I'm trying to imagine her own feelings as she looks back into the past, remembering the red-haired boy whose adoration of her seemed at the time to be both funny and embarrassing - but also secretly quite flattering! With a pang of shame she recalls how she teased him, cruelly aware of his infatuation and at times using her power over his emotions. On one occasion she humiliated him by demanding him as her partner in a game of Prisoner's Base. In this game the men were supposed to choose their female partners, but poor Hector was far too embarrassed to do so. *'Well then,* she'd cried blithely, *'I'll choose. I pick Monsieur Hector'.* He was overcome, refusing to meet her eyes and afterwards running away to hide. She had laughed with the others at his shamed mortification.

But there had also been times of companionship. Estelle suddenly remembers going blackberry picking with him one day, how he leapt and bounded down the steep slope like a mountain goat, and how she warned him not to go so near the steep edge of the escarpment. He had looked back at her, grinning and bright eyed, she realises now that not only was he trying to impress her with his agility, but was probably also elated by her mild expression of concern for his safety.

Simultaneously she recalls that sudden feeling of heady awareness that she was now a young lady - and the belle of the neighbourhood. Receiving the

admiration and attention of grown-up gentlemen was far more exciting than the tiresome adoration of a brooding adolescent. Then in due course she was married to Casimir Fournier. It had been a happy marriage. Casimir, much older than her, was a kind and caring husband, a great comfort to her as they mourned together the loss of their little girls. Some years later her grandmother told her that Hector, the love-struck boy of her girlhood, had grown up and was now studying medicine in Paris, following in the footsteps of his father. She didn't really give him another thought; the demands of home and family continued to be her prime concern, especially later when the health of her husband began to deteriorate.

Nevertheless from time to time more news of Hector's exploits did filter into her quiet life. The trainee medic seemed to have given up his planned career as a doctor to become the *enfant terrible* of contemporary music. Occasionally she read his *feuilletons* (critiques) in the *Journal des Débats*. She remembers her feelings of mingled surprise and dismay when she received a letter from him out of the blue, some sixteen years ago. It didn't touch her heart in the way it has been touched just now by his recent visit; it had all seemed a bit exaggeratedly sentimental, and she had other things on her mind. Her husband had then not been long dead and she was busy bringing up her boys alone, so she never

replied. But she did begin to take a bit more interest in the public figure Hector had become, and was further intrigued when she read a brief biography of him.

Now she finds herself moved by his fragility both in mind and body. If a friendly correspondence with him can restore a bit of hope to his troubled soul, she will agree, and do what she can to help him.

CODA

By the late 1860's Berlioz's health had broken down and he was in constant pain from an acute intestinal condition. But it was the death of his beloved son Louis of yellow fever in Havana in 1867 which finally deprived him of the will to live. After a lifetime of passion and toil, never compromising his unique musical vision and fighting tirelessly against the outdated mores of his time, Hector Berlioz died on 8th March 1869. He is buried in Montmartre with Harriet and Marie.

A startlingly original composer, a dramatic virtuoso conductor (the first such in France, setting the pattern for all subsequent conductors) an accomplished writer, and a skilled, forensic and witty

critic - to me Berlioz belongs right up there with the musical immortals.

Estelle lived another seven years after the death of Hector Berlioz, The annuity he left her would have made a great difference to the final few years of her life. She is buried at Saint Symphorien where she died in 1876.

Episode 8

Mary

FIRST MOVEMENT: BACKDROP

Charles Dickens was undoubtedly a sort of Victorian literary superstar, immensely popular in his lifetime and famous worldwide. His works were loved by people of all classes and from all walks of life; his gloriously funny characterisation coupled with the ingenuity of his plots made him a hit across the board. And both through his writing and in reality he was a radical and a philanthropist; a powerful and influential commentator on the plight of the poor, the greed of the rich, the exploitation of the weak, and the abuse of women and children. His celebrity status enabled him to highlight the terrible human cost exacted by social and economic change in those years of Victorian growth and prosperity

which had made Great Britain the richest country in the world. He seems to have embodied the spirit of the age, the conscience of the age - and even today one discovers his name associated with the origins of many charitable institutions still around.

It's fascinating, then, to remember that Dickens spent nearly half his life not as a subject of Queen Victoria at all. He was born in early 1812; into the world of Jane Austen and Lord Byron, of Wellington and Napoleon. On the throne, standing in for his mad father, was the Prince Regent - pleasure-seeking, paunchy, profligate Prinny. The nation was still dominated by the threat from across the Channel; Britain had been at war with France for the last twenty years. In 1812 the Navy was still on the front line, defending the country and resisting the Napoleonic trade blockade (the Continental System described in the previous Episode of this book). The country at large remained nervously aware of the Napoleonic juggernaut over the sea. Against the ongoing threat the Dickens family played its part in the defence of the nation, albeit in a minor capacity. Dickens's father, John Dickens, was a clerk in the Navy Pay Office. He had been employed first in Portsmouth (where Charles was born) and then London. But after Wellington's conclusive victory at Waterloo in 1815 the work of the Pay Office changed, and in 1816 John Dickens was sent out of London to

the naval town of Chatham in Kent, where he was again employed as an office worker in the backroom bureaucracy of the Royal Navy.

The final defeat of Napoleon in 1815 brought peace to Britain, but the expected benefits of peace were slow in coming. Twenty years of war had drained the nation's coffers, resulting in a huge economic slump. The total national debt had risen fourfold and the burden of this fell largely on industrialists and on the general public, who had already had to tighten their belts during the long years of war. The 1815 Corn Law, instigated by the landowning classes to protect their interests against the importation of cheap foreign grain, led to widespread privation and hunger. Industrialists, together with other representatives of the new middle classes, were frustrated by the aristocratic landowners' stranglehold on Parliament and were increasingly demanding representation there.

By the time Prinny succeeded to the throne as George IV after his father's death in 1820, the country was more divided than ever. Economic hardship caused by food shortages, industrial unemployment and poor harvests were all factors. For many people, an increasing sense of belonging to the new working class - in effect the force driving the engine of production in industry - but still being denied the vote, was an injustice which needed to

be righted. But the privileged élite, still fearful of violent Jacobin-style revolution, tightened their grip on power and made no concessions to these demands. All this led to riots in successive years from 1816, culminating in 1819, the year of the Peterloo Massacre.

This was a radical meeting at St Peter's Fields in Manchester, organised by the activist Henry Hunt. It was planned as a peaceful mass-gathering to demand Parliamentary reform, with no intention to cause any sort of insurrection - the aim was to get the voices of the people heard. A lot of women and children joined the 60,000 strong rally. But local magistrates, alarmed by the size of the crowd, ordered the Manchester Yeomanry to arrest the speakers as soon as the rally got going. The soldiers over-stepped the mark; they didn't just confine themselves to seizing the speakers, but, wielding sabres, attacked the crowd at large. With the help of the Cheshire Volunteers, the armed forces cleared the crowd, leaving only bodies on the ground.

There was widespread horror at this atrocity; intellectuals, journalists, writers and poets all contributing to the outpouring of anger. Shelley's incendiary and powerful poem '*The Mask of Anarchy*' was just one of many expressions of outrage. Charles Dickens, only seven years old at the time, was probably unaware of the event, but would in his

time become a vigorous and influential champion of working people, that unconsidered multitude which formed the majority of the population and which, even after the Reform Bills of the 1830's, was largely excluded from the franchise.

After Peterloo, the immediate result was the knee-jerk passing of the repressive Six Acts, aimed at quelling any organisation committed to radical change, but things did improve somewhat after the government began belatedly to realise that such suppression would only fuel more discontent. Luckily too, during the 1820's the economic situation improved. Parliament at last embarked on a programme of cautious reform. This decade saw the abolition of those notorious 'Combination Acts', dating from post French revolution neurosis, outlawing any group organisation dedicated to political reform. Trade Unions now became legal and had the right to regulate wages and hours of labour. Religious Emancipation Acts were also passed regarding Catholics and Nonconformists, who became eligible to stand for Parliament.

Things accelerated after the death of the unloved monarch, George IV, in 1830. The Times commented '*There never was an individual less regretted by his fellow creatures than this deceased king, What eye has wept for him? What heart has heaved one sigh of unmercenary sorrow?* William, the unremarkable brother who

succeeded him, was popular simply because he wasn't Prinny. Parliamentary reform was at last on its way to being established. One of the most avid and energetic chroniclers of the Reform movement was to be the 20 year-old Charles Dickens, working as a Parliamentary reporter and travelling all over the country to attend debates and hustings.

Today the 1832 Reform Act wouldn't be considered all that democratic. It did increase the number of male electors (still no votes for women) by more than a third - so now about one in five men had the right to vote. It also got rid of the patently corrupt system of Rotten Boroughs - wherein small sparsely populated rural settlements, often part of the estates of aristocratic landowners, could hold two or more parliamentary seats while the newer and much more densely populated industrial centres like Birmingham and Manchester had none. The bill was hailed with enthusiasm; what it achieved was modest, but it pushed open a previously firmly locked door and paved the way for further amendments in subsequent decades. Universal Manhood Suffrage didn't become law until 1918; unsurprisingly most women had to wait another ten years after that.

Nevertheless the 1830's, under a reforming Whig government, was a decade of important changes. Slavery in British colonies was abolished in 1833, and that same year the Government passed the Factory

Act, aimed at improving conditions for children working in factories. Child labour was commonplace as the Industrial Revolution advanced; conditions were often appalling - sometimes children barely out of infancy would be working up to sixteen hours a day. The Act laid down some basic conditions: There should be no child workers under nine years of age and all employers should hold an age certificate for their child workers. Working hours for children under 13 years old should be limited to nine and for those aged between 13 and 18 to twelve. Inhumane as these still seem today, they were an improvement.

Night working for children was also abolished, and there was a new rule establishing two hours schooling each day for working children. How they fitted these in with the long hours on the shop floor I have no idea. I imagine many of the poor little souls spent much of their educational sessions half asleep with exhaustion. Dickens provides a graphic and harrowing account of factory life in his grim tale 'Hard Times'. In a factory run by the brutal manager Josiah Bounderby, child and adult labourers alike are subject to harsh, cruel treatment and lead lives of unremitting toil and misery. This book was published in the early 1850's, abuse was not yet a thing of the past despite the decrees of the 1833 Act.

The new Poor Law in 1834 reorganised the system regarding the homeless poor and needy. Unions

of parishes were established under the control of elected Boards of Guardians. Each union had to provide a workhouse, where the most destitute would be housed; here families were split up and all inmates had to work for their subsistence. In Dickens's '*Oliver Twist*', little Oliver is sent from the workhouse to the local magistrate, who has to decide whether he should be apprenticed to a chimney sweep. In this case, the elderly magistrate notices how scared the child is and refuses to sign the agreement. Oliver is saved from the hellish fate of becoming a chimney boy and sent back to the workhouse - possibly marginally less hellish but a harsh and comfortless place nonetheless.

Actually this Act proved to be a controversial one, many philanthropists claiming that it made the situation worse. Dickens attacked the new law as being inhumane; as the underlying principle of it was that life in the workhouse should be the least palatable option, the intention presumably to encourage any destitute person to seek employment. The old system of outdoor 'Poor Relief' had been kinder, Dickens felt. He was not alone in coming to this conclusion.

The '*good old King*' as the Times reported, died in 1837, ushering in eighteen-year old Victoria. Her reign would last for more than 63 years, overseeing Great Britain through decades of change and

development, colonial expansion and increasing prosperity, which were to make it the world's richest and most powerful country. Through the writings of Charles Dickens we get varied insights into the unhappy underbelly of the increasing prosperity of the nation. We also glimpse how ordinary people managed the challenges of their lives in the complex, multi-faceted ambience of the ever-expanding cities. This was a period of unprecedented social upheaval; the effects of industrialisation and demographic change were affecting domestic life as never before.

Existing class boundaries became more fluid, but brought with them unforeseen new challenges. So, with humour and compassion, Dickens portrays the expanding middle class. It ranges from people who are only just coping, trying to maintain a semblance of respectability while fending off poverty, to the aspirational and upwardly mobile newly prosperous, who themselves become pretentiously obsessed with upholding their class status by denigrating all those who haven't made it. Then, as the century progresses, we get the development of Victorian capitalism and the rise of the merchant classes. In the 1840's Dickens gives us Mr Dombey, who is so single-mindedly obsessed with business that he doesn't heed the domestic tragedy which is unfolding in his own household. Another such, Scrooge, becomes so

corrupted by the narrow miserly path of his life that he has to be rescued by spiritual intervention.

Through his writings, then, Dickens opens windows into a vast panorama of Victorian life. It ranges over poverty and prosperity, entertainment and recreation, living and dying, and the lawful and the lawless. There is education good and bad, there are mansions and slums, there are stagecoaches, and there are railways. Like the breakneck progress of the railway age, Dickens presents energetic and vibrant impressions of the living maelstrom of his times, conjuring up a period which has pushed long fingers into our own age and has greatly shaped the world we live in today. And by now women as well as men were playing a key rôle in some of these developments.

I will therefore now turn to this significant half of the population, to see some of the ways in which women's lives were becoming less marginalised. The idea of the *'Angel in the Home'* remained a potent one, but several strongminded women refused to accept this stereotype and initiated lasting change.

SECOND MOVEMENT: WOMEN

When I was eleven I started at secondary school. I dressed for the first time in my brand new school

uniform - a bottle-green tunic over a white blouse, a blue and green striped tie, and a green beret adorned with a green and blue cockade. The whole (rather too large) ensemble was completed by a decidedly commodious bottle-green blazer sporting a badge depicting a stylised sailing boat and the school motto: *'Onwards and Upwards'*. My new school was in the London borough of Camden, a few tube-stops from my home in Hampstead. It was called Camden School for Girls, and was a voluntary-aided girls grammar school.

We all learnt early on about our founder, the women's education pioneer Frances Mary Buss. Every spring we celebrated her memory on Founders Day, a day which began with us all creating posies of yellow, purple and white flowers and green foliage; the tradition being that these were Miss Buss's favourite colours. Our sister school, the North London Collegiate School, had been established by Miss Buss before ours, but they wore daffodils not posies on their Foundation Day. I remember wondering whether daffodils were more important to her than our mixed creations. We were, after all, I naively thought, the less important school, originally founded for girls from humbler backgrounds than the North London Collegiate.

Frances Mary Buss was the only surviving daughter of Robert William Buss and his wife

Frances. She was born in Camden Town, London, in 1827. Her father, a painter and etcher, is mainly remembered today for his evocative unfinished painting entitled 'Dickens's Dream'. He also submitted some other illustrations for Dickens's work including two sketches for the Pickwick papers, but that commission eventually went to Hablot Knight Brown, who was to become '*Phiz*' to Dickens's '*Boz*'. For Buss, despite being a reasonably successful artist, supporting a family of five surviving children was something of a struggle. All the children had to get work to supplement the family finances. Buss himself boosted his income by teaching, as did his wife, who opened a school for boys and girls nearby in Kentish Town. As soon as their daughter Frances Mary was fourteen, she became a teacher at her mother's school.

A clever, strong minded young woman, Frances Mary found the current attitude to the education of girls unacceptable. Why, she asked, were girls not considered capable of receiving the same education as their brothers? Although things had moved on considerably from the days of Mary Wollstonecraft, with plenty of schools for girls now available, the prevailing belief remained that a girl's education should comprise only as much learning and knowledge as she needed to achieve the standard of moral excellence which would make her a good wife

and mother. Domestic skills for middle and upper-class girls were still the key precept. Interestingly, children of the working poor in some cases may have benefited from a more liberal education than their posher contemporaries; because both girls and boys could attend charity schools where they would acquire the basic skills of the three R's, some historical knowledge, plus moral and religious instruction as well as practical skills.

The rise of the Governess - probably a reasonably well-educated young woman who might have attended such a school, and who now needed to earn her living - was a result of newly wealthy middle-class families wanting appropriate tuition for their daughters. In 1843 the Governess's Benevolent Society was established to support the growing number of young women taking up this career. It was soon apparent though that many of them lacked much of the necessary breadth of knowledge which they needed to become competent teachers. The Society therefore established a training college in London for young women over the age of twelve, to enable these potential teachers and governesses to acquire the skills and understanding they needed. It was called Queen's College and was located in Harley Street.

The college was run by a reforming educationalist, Frederick Denison Maurice, who also instigated a

programme of free evening lectures at the college. Frances Mary heard about these lectures from a family friend, so for the next two years, several times a week, after her day's teaching she would walk across London to Harley Street and back so she could partake of the varied lectures which were delivered there by eminent academics. It was, in effect, her own private access to a university-standard education at a time when there was no higher education for women. She loved it, achieving several certificates and beginning to develop her own ideas about education for girls.

In April 1850, aged 23, Frances Mary Buss established her first school in the family home in Camden Town - The North London Collegiate School for Young Ladies. Fees were modest, because for most families the education of their sons was the first priority; indeed in the early days Miss Buss sometimes didn't take her salary as headmistress so the school could stay afloat. She achieved some sponsorship from two City companies, the Brewers and the Clothworkers Guilds, but very little came in the way of public donations. Boys' schools had no difficulty in attracting such support.

The North London Collegiate School curriculum was planned to provide a wide-ranging liberal education, including literature, art, music, the sciences, maths and Latin. There was also outdoor

exercise, and swimming sessions which were arranged at the nearby St Pancras Baths. As Miss Buss said, the school was aimed at *'preparation for life, not the drawing room'*. Most unusually for its time, regarding matters of faith the school operated a policy of religious tolerance; welcoming Anglican, Catholic and Jewish girls alike. Despite financial struggles in the early days, the school flourished and grew. The staff, hand-picked by Miss Buss for their talents and aptitudes, and the governors, a judicial mix of men and women, ensured a well-run institution with a record of academic achievement which gained the school a reputation both for quality and the breadth of its syllabus.

As the school expanded, so did its reputation and so did the curriculum. It moved to more spacious premises in nearby Sandall Road and eventually out to Edgware, where it still is today. Sandall Road is now the home of Miss Buss's second school, the Camden School for Girls which she established in 1871, just over 150 years ago. It was aimed at educating girls from poorer backgrounds, had very low fees, and initially took younger children than the North London Collegiate. And this is the school at which I received my excellent grammar school education. Now a state comprehensive, it continues to rank in the forefront of London state schools.

While Frances Mary Buss was attending those lectures in Harley Street, she became friendly with another attendee, Dorothea Beale, who was also to play a key part in the campaign for good academic education for girls. Miss Beale became the first Principal of the newly established Cheltenham Ladies College in Gloucestershire. Realising that the lack of teacher training in much of the country was a real impediment to the improvement of schools, Miss Beale started a residential training college in Cheltenham. She was later the founder of St Hilda's Hall in Oxford, now St Hilda's College. Another key pioneer at the time was Emily Davis (founder of Girton College, Cambridge). Courageous and enterprising women were at last raising their heads above the parapet, claiming educational rights for girls denied to them for centuries.

Neither Miss Buss nor Miss Beale married. They were both idealists who devoted their lives and talents to the cause of high quality education for girls and young women. In the generations since they lived, many thousands of women, like myself, have benefited from their dedication and vision. They were incidentally also both suffragists, another of the causes for which such women were campaigning. It's women like Miss Buss and Miss Beale who have made the lives of people like myself immeasurably richer by providing us with educational opportunity, by

empowering us to explore the riches of scholarship and culture, and by enabling us to think and to question. At the beginning of the c19[th] Napoleon had said '*What we ask of education is not that girls should think, but that they should believe*'. Thanks to Miss Buss and Miss Beale and their co-campaigners, that archaic idea that a woman's brain was less capable than a man's had been soundly invalidated.

As adolescents we laughed at this little rhyme about them:

> Miss Buss and Miss Beale,
> Cupid's darts do not feel.
> How different from us,
> Miss Beale and Miss Buss.

But thank goodness for them!

THIRD MOVEMENT:
CHARLES JOHN HUFFAM DICKENS

An astonishing revelation greeted the readers of the first volume of John Forster's biography of Charles Dickens. This hit the bookshops in 1872 - a couple of years after the death of the great man - and included a quotation from an autobiographical fragment written by Dickens in the 1840's when he was

planning his memoirs. Those memoirs never came to fruition, but he passed what he'd written over to Forster, asking him to become his biographer, and to whom he then confided his memories in a long series of conversations. These included describing those events in his childhood which had caused him such acute suffering that they had until then remained a secret. During his lifetime Dickens never divulged this secret except to Forster and possibly to his wife Catherine.

The years of Charles Dickens's childhood between the ages of five and ten, when his family lived in Chatham, were very happy ones. With his much-loved elder sister Fanny he enjoyed playing in the fields outside, building dens and forts among the haystacks, or dreamily watching the tall masts of ships as they moved slowly into the harbour. He was an imaginative child who would fantasise about the giants and dwarves and fairies in his picture books, fascinated too by the stories of the Arabian Nights and the Tales of the Genii. When a bit older he cut his literary teeth on the picaresque novels of the C18th; Tom Jones, Roderick Random, Peregrine Pickle – rollicking tales of loveable rogues - black sheep with hearts of gold.

Both Fanny and Charles attended the local dame school. They then progressed on to William Giles's School, an excellent establishment run by an

admirable and enlightened Nonconformist teacher. Giles recognised Charles's abilities and encouraged him to read widely, lending him books, and after the Dickens family moved back to London and Charles had to leave the school, presenting him with a bound copy of a collection of essays by Oliver Goldsmith.

The move to London put an abrupt end to that joyful carefree childhood. John Dickens had been recalled by the Admiralty to work at Somerset House. But his debts were mounting, the family was growing, creditors were pressing, and young Charles entered what was to be the most dismal and hopeless period of his youth. At first he wondered when he would start school again, while in the meantime running errands for his family (mainly taking books and other stuff to sell and bring back money to pay debts and expenses). It seemed that there was to be no more schooling for this precocious and gifted child; instead at the age of twelve he was sent out to work at Warren's Boot Blacking Factory at Hungerford Steps, where their relative by marriage, James Lamert, was the manager. Lamert thought he was doing the family a good turn by giving young Charles this opportunity to contribute to the family income.

For twelve-year-old Charles, however, it was a devastating and humiliating experience. Much later, as a successful writer, he wrote describing the '*poor little drudge*' he had become: '*No words can express the*

secret agony of my soul...... I felt my early hopes of growing up to be a learned and distinguished man crushed in my breast. The deep remembrance of the sense I had of being utterly neglected and hopeless,...the shame I felt in my position, the misery it was to my young heart.....cannot be written. That I suffered in secret, and that I suffered exquisitely, no-one ever knew but I'.

It got worse before it got better, when soon after he'd started working there his father was arrested for debt and sent to the Marshalsea debtor's prison in Southwark. Charles was so traumatised by this entire episode that he kept it a close secret until the world learnt of it from that revelation in the Forster biography. But there is a ghostly echo of it in many of his books - passing references to Warrens, to boot blacking and drudgery. And of course, it was these miseries which profoundly shaped him as a writer; from them came a host of fictional children, suffering or dying young, undergoing injustice, exploitation, cruelty and pain.

Things did begin to pick up again in due course, after John Dickens received a legacy from a recently deceased relative which enabled him to pay his debts. He was released from the Marshalsea and was eventually granted a pension by the Navy Pay Office. So young Charles was able to return to school, seeming to cast off the privations of the last year and throwing himself wholeheartedly into schoolboy

life - reading penny magazines, playing cricket and quoits, talking slang, acting in charades and other such activities. But the shadow of the blacking factory experience left an emotional wound which stayed with him for the rest of his life.

Leaving school two years later at fifteen, he was employed first as a lawyer's clerk and then as a court reporter. He became a bit of a dandy, sporting coloured waistcoats, a black neckerchief and a smart blue jacket, his wavy hair fashionably long and carefully combed. He also now started seriously to consider a career on the stage. Young Charles was a brilliant mimic; he had his fellow clerks in fits of laughter with his wicked impersonations of the characters around – a snuff-taking old laundress, a selection of street vendors, and of course lawyers and their clients.

With his sister Fanny - a talented musician who'd studied at the Royal Academy of Music - he organised musical evenings, giving recitations and singing comic songs. He also set up and acted in private theatricals at home, using Fanny and other siblings together with friends in the cast. Almost every night he went to the theatre, sometimes to the little private theatres in the side streets around the Strand, where, for a small sum paid to the manager, he could himself take a part on stage. He would rehearse privately at home in front of the mirror, inspired by one-man

performances by the actor Charles Matthews which he'd seen at the Adelphi Theatre. When he felt ready, he wrote to the manager at Covent Garden asking for an audition.

This never happened. On the day of the audition he had a heavy cold, so he wrote to cancel it and planned to reapply the next season. But by the next season he had moved on - he was working as a reporter for Parliament, and, in his spare time, writing the sketches and short stories which were to herald his entry into the world of authorship as *Sketches by Boz*. Even so, Dickens never lost his fascination with the world of the stage.

In his writing his sense of the theatrical is never far away. The massive cast of characters he created are often formed through their voices and appearances. His plots tend to be melodramatic and sensational, interwoven with scenes of tragedy and comedy, making the reader cry one minute and laugh the next. In his real life, when he was middle-aged he fell passionately in love with a young actress - she was 18, he was 45. This was another of those secrets which only came out after his death; even Forster left it out of his biography. The theatre had done more than colour Dickens's fiction, it had taken over his life. In his last decade he travelled all over Britain and America giving dramatised public readings from his works. This became an addiction and seriously

affected his health, raising his blood pressure and giving him internal haemorrhages. He died before his time, burnt out, aged 58

Back now, however, to the young Dickens, on the cusp of glory. Within a couple years of years after *Sketches by Boz* he had become the hugely popular creator of the comic sketches collected together as 'The Pickwick Papers'. These made Mr Pickwick and his club members into cult figures - larger than life characters whose adventures and misadventures seemed to tap into the national consciousness. Those doses of laughter, pathos and melodrama launched Charles Dickens into his dramatic literary journey to superstardom. He was 24 years old.

As an impecunious and very young man he had embarked on a fervent but unsuccessful courtship of a banker's daughter, who flirted with him but never really took him seriously. Now he was financially more secure he felt ready to commit himself to marriage. His choice of wife was Catherine Hogarth, daughter of a Scottish publisher and journalist. Catherine's background was undoubtedly a social cut above his, but his successful and accomplished literary achievements ensured a very cordial relationship with the Hogarth circle. Charles Dickens and Catherine Hogarth were married in 1836.

The early years of the marriage were happy ones. Dickens's meteoric literary success provided

for a comfortable lifestyle. The birth of their son Charley in 1837 was a joyful event, celebrated with characteristic exuberance by the baby's proud young father. For the exhausted young mother, it was a more stressful time. After a difficult delivery she found herself unable to breastfeed the baby so a wet nurse had to be hired. Catherine was tearful and anxious, feeling that she had failed her child - actually she was suffering from post-natal depression. This would be a repeating pattern through her many subsequent pregnancies, and was to be one of the factors in the deteriorating relationship between Dickens and his wife in years to come.

Worn out by repeated childbearing and post-natal depression, unable to keep up with the frenetic pace and demanding regime of the Dickens lifestyle, by 1855 poor Catherine was a long way from the [8]*'pretty, fresh-coloured little woman... much admired...'* whom he had married. Dickens turned away from her; perhaps one reason for his feverish hyperactivity and involvement in so many projects was because he was feeling trapped by this marriage and didn't want to be at home. It's a sad story, and this rejection of his wife seems to be both cruel and indefensible from the man who, through his novels and philanthropic

8. *Abridged from description of Catherine Hogarth in Michael Slater's biography of Dickens*

works, seemed to embody the spirit of loving kindness and family values.

But all this was in the future. After young Charley's birth, the loving and concerned Dickens was making every effort to support his wife, inviting her younger sister Mary to stay to help with the baby through this difficult period. To cheer Catherine up and to give everyone a change of scene he organised a five-week break in Kent, the countryside of his childhood, for them all. He had to commute up to London during the week, but spent each weekend with them and saw with satisfaction that his plan was working, as Catherine recovered her good spirits and health.

The intense warmth and affection Charles Dickens developed for Mary Hogarth was to become one of the enduring features of his life. He never forgot her, and his memory of this bright, kind, clever young woman was to generate a string of idealised images of pure, beautiful, suffering young girls in his fiction. Dying young, Mary became for him a sort of literary Muse.

FOURTH MOVEMENT:
MARY SCOTT HOGARTH

Mary Hogarth was only fourteen when she first met Chares Dickens, while he was courting her sister Catherine. Mary was lively, attractive and intelligent, full of admiration for her famous brother-in-law to be - so very soon she and Dickens were on terms of easy-going familiarity. She was clearly excited at the prospect of becoming a relation of this interesting and successful young author, writing proudly to a friend of the family that Dickens was being *'courted and made up to by all the literary gentlemen…'*

After the wedding she came to stay with the newly married couple, becoming a much-loved member of the household. She had enjoyed, as she wrote in a letter to her cousin, a *'most delightfully happy month'*. Thereafter she was a frequent and welcome visitor. Cheerful and sensible, she provided kind, practical support to Catherine during and after her pregnancies, as well as enjoyable companionship to Dickens.

A few months later, Dickens, Catherine and Mary had an evening out at the theatre, where the programme included a farce by Dickens. It was a lighthearted and delightful evening, but was to end in tragedy. They arrived home at 1am and enjoyed a

cheerful late supper together, after which Mary '*in the best health and spirits*', as Dickens related, went to bed. But moments later she seems to have suffered some sort of collapse and the next day she was dead. The doctors diagnosed heart failure and concluded that her heart had been faulty well before this.

Dickens was distraught, overtaken by anguish so intense that he had to cancel forthcoming episodes of Pickwick Papers and Oliver Twist. Removing a ring from her finger and putting it on his own, he said that when he died he wished to be buried in the same grave with her. He also had a mourning locket made containing a lock of her hair. He even kept her clothes, and from time to time over the following weeks would take them out to hold and caress them. So emotionally disturbed was he that he dreamed about her constantly for months afterwards

In letters to friends he described this beloved girl, as '*the grace and life of our home ...I solemnly believe that so perfect a creature never breathed....she had not a fault..* Mary's gravestone in Kensal Green Cemetery bears this inscription composed by Dickens: '*Young, beautiful and good, God in his Mercy numbered her with his Angels at the early age of Seventeen*'

As he gradually calmed down and returned to his writing, Dickens was repeatedly to create idealised images of Mary. Rose Maylie in Oliver Twist is the first of them – '*She was not past seventeen. Cast in so*

slight and exquisite a mould, so mild and gentle, so pure and beautiful, that earth seemed not her element…'. Like Mary, Rose becomes desperately ill, but perhaps responding to a private fantasy, Dickens saves her from the jaws of death.

Little Nell in The Old Curiosity Shop isn't so lucky. This angelic child, after travelling the country with her wayward old grandfather to escape from the malevolent dwarf, their landlord Quilp, at last reaches the safe haven of a kind schoolmaster's house. But as the months pass she begins to decline. Her grave becomes a sort of pilgrimage spot for those who loved her, *'so young, so beautiful, so good'* as she is remembered, in an echo of the words on Mary Hogarth's grave. The death of Little Nell, drawn out over several episodes of the serialised book, caused genuine anger and heartache to many of Dickens's readers. *'He should not have killed her'* cried the MP Daniel O'Connell, famously flinging the story out of a railway carriage window. Nowadays the tragedy of Nell's life and death is seen as over-sentimental, even maudlin. But in fairness, Dickens was writing at a time when the death of one or more children was a common occurrence in families right across the social spectrum. He himself lost two siblings in childhood and a decade or so later was to lose his infant daughter Dora at just a few months old.

Another innocent suffering young girl appears as a central character in Dickens's novel Dombey and Son. The son of the title is Paul Dombey, precocious and sickly, whose mother died when he was born.. Poor little Paul, the focus of his business-obsessed father's plans for the future, doesn't survive beyond episode five of the story, which was first issued in twenty episodes. Considered worthy of no attention, disregarded and ignored by her father, is Paul's elder sister Florence. In the stern, emotionally barren Dombey household, the only manifestation of love is between Paul and Florence. Paul adores her, describing her as *'so young, so good, so beautiful'* – (that descriptive phrase again).

Florence Dombey, gentle and kind but also quite resilient and practical, is the true hero of this book. Dickens gives her some of Mary's levelheadedness but also wraps her, like his visions of Mary, in a semi-mystical aura: '*So Florence bloomed there like the king's fair daughter ...*' he says. When she reaches the fateful age of seventeen – '*a child in innocent simplicity, a woman in her honest self-reliance*' he surely had the image of Mary in his mind. But he gives Florence a future and the book a happy ending. She wins over her emotionally desiccated father, marries kind Walter Gay, and provides the now doting old man with a pair of grandchildren.

Then there's Agnes Wickfield, the gentle faithful girl who becomes, for David Copperfield '*the better angel of my life*'. In 1842, Dickens, still obsessed, wrote of Mary as '*the spirit which directs my life, and…..has pointed upward with unchanging finger….*' The book *David Copperfield* ends with this plea to Agnes: '*….. may I, when realities are melting from me like the shadows which I now dismiss, still find thee near me, pointing upward*'

What then, of the real Mary? Was she really the angelic being of Dickens's imagination, the '*perfect creature…*who had '*not a single fault*? I think she must undoubtedly have been a delightful young person with many sterling qualities - quick-witted, helpful and kind-hearted. At seventeen she was also obviously a comely and attractive girl. Few men in their twenties, as Dickens was when she came to stay, would be impervious to these youthful charms. On her part, she probably had something of a crush on her sister's clever, witty, charismatic husband.

I'm imagining her setting out on a shopping expedition with Charles Dickens one afternoon in early January 1837. She is visiting Charles and Catherine in their rooms at Furnival's Inn in Holborn. Mary loves spending time with the Dickenses. She recently spent a month with them, wherein an easy rapport quickly developed between her and her brother-in-law Charles. The purpose

of this particular trip is to find a bedside table for Catherine, who is in bed at home, in labour with her first child. This has been going on since last night, and Mary and Charles confess to one another that it's a bit of a relief to be away from the atmosphere of pain and bustle while both their mothers briskly attend to the mother-to-be. They are in high spirits, popping in and out of all sorts of little shops around High Holborn, enjoying a shared feeling of escape and adventure.

Charles has fabricated an excuse to opt out of a planned meeting with a colleague this morning in order to snatch himself these few hours of freedom. Mary listens, spellbound, as he entertains her during their explorations with stories about some of the places they are passing. She doesn't know if they are real history or products of his imagination, but she is pleasurably thrilled when he points out the steps leading to Bleeding Heart Yard. He tells her, with dramatic panache, a gory tale about a murder which took place there 200 years ago, but then adds that it's probably named after a nearby pub, the Bleeding Heart, which has a sign showing the bleeding heart of the Virgin Mary. They also visit Ely Place nearby; Mary is fascinated to learn that this little street is not officially part of London at all but owned by the diocese of Ely in Cambridgeshire. Charles gives her a rendering of John of Gaunt's speech from

Shakespeare's Richard II, stirring and dramatic. Here, he tells her, was where John of Gaunt lived six hundred years ago.

Their wanderings eventually take them down Fetter Lane towards the Strand, ending up by the river. Mary is keen to see the new Hungerford Market; she has heard about its magnificent Italian-style colonnades and galleries, and the extraordinary variety of produce available there. But Charles seems reluctant to go any further. She doesn't know that this area brings back painful memories of his childhood and the lonely daily trek he made each day to work at the blacking factory nearby.

By now Mary's feet are beginning to ache a bit, so they stop by Westminster Bridge and stand together watching steam paddle-boats chugging up and down, zig-zagging between the arches. Then Charles turns her round to look at the views on either side. To the right they can see the ruins of the palace of Westminster. Both remember the huge fire a few years ago which destroyed most the Parliamentary buildings. Charles describes how he had worked there as a parliamentary reporter some years earlier, and how he had joined the huge crowd of onlookers gazing in awe and horror as the building went up in flames. Turning to the east he then points out the majestic dome of St Paul's Cathedral, and tells her about the whispering gallery inside the church

around the base of the dome. Here, he says, the ghost of a murdered woman can be heard running round the dome, her cries and her footsteps echoing as the sound reverberates around the gallery. It's an enjoyably spine-chilling story, but Mary thinks it might be a figment of his ever fertile imagination.

They arrive back at Furnival's Inn about 6 o'clock, having bought the little table they saw in the very first shop they visited. Meanwhile Catherine, exhausted, is in the final stages of labour. When at last she gives birth to a healthy son, everyone is relieved and delighted. Mary and Charles lead the rejoicing - already in high spirits after their happy afternoon together.

There isn't room at Furnival's Inn for Mary to stay the night, as both new grandmothers are occupying the other bedchambers while caring for mother and baby. Charles eagerly offers to see Mary home and calls for a hackney cab, giving the two of them another happy hour of one another's company. He is effervescent with excitement at the birth of his son and heir. Mary feels proud and privileged to have been part of this domestic drama. When they arrive at her home he sees her in, kisses her cheek and promised he will be back the next morning to collect her. She will then be staying with them for the next few weeks to help Catherine with the baby.

CODA

Charles Dickens died, aged beyond his years, at Gads Hill Place, his home in Kent, on 9th June 1870. He was only 58 years old, but was suffering with heart trouble, a bloodshot eye, a tremor in one hand, and frequent internal haemorrhages. A decade of dramatic public readings had thrilled his public and netted him a small fortune, but it had also destroyed his health

He was not buried next to Mary in Kensal Green Cemetery as he had desired, in the traumatic aftermath of her untimely death. She lies there with her parents and her brother. Catherine Dickens is in Highgate Cemetery, and Charles himself is buried with the great literary figures of his nation, in Poets Corner in Westminster Abbey

THE END (© Eliza Merry 2022)

Postlude

SOURCES AND REFERENCES

- The Twelve Caesars - Suetonius (Penguin Classics translated. by Robert Graves 1957)
- The Greek Myths vols. 1 and 2 – Robert Graves ((Penguin 1960)
- The Aeneid - Virgil; (Penguin Classics transl. W F Jackson Knight 1969)
- A Book of Latin Verse (Oxford Clarendon Press collected by HW Garrod 1915)
- Cicero - Selected Letters (Penguin Classics transl. D R Shackleton Bailey 1982)
- Life in Rome in Ancient Times (Liber Fribourg Paul Werner transl. David Macrae 1977)
- Roman Women, Their History and Habits - Dacre Balsdon (Bodley Head; 1962)
- Women in Antiquity - Charles Seltman (Pan; 1956)
- Catullus - ET Merrill (Harvard University Press; 1893)
- Landmarks in Classical Literature - Philip Gaskell (Edinburgh UP; 1999)
- Reading Dante - From Here to Eternity - Prue Shaw (Liveright; 2014)
- Why Dante Matters - John Took (Bloomsbury; 2020)

- Dante - The Divine Comedy (Penguin Classics transl. Robin Kirkpatrick 2012)

- Penguin Book of Italian Verse (edited by George Kay 1960)

- Petrarch – Everywhere a Wanderer - Christopher Celenza (Reaktion Books 2017)

- The Book of the City of Ladies - Christine de Pizan (Penguin Classics transl.Sarah Lawson)

- Shakespeare: the Evidence - Ian Wilson (Hodder Headline1994)

- Contested Will: Who Wrote Shakespeare - James Shapiro (Faber & Faber; 2010)

- 1599 - a Year in the Life of William Shakespeare - James Shapiro (Faber & Faber; 2005)

- In Search of Shakespeare - Michael Wood (BBC publications, 2003)

- Shakespeare's Wife - Germaine Greer (Bloomsbury; 2007)

- All the Sonnets of Shakespeare - Ed.: P. Edmundson & S. Wells (Cambridge U.P: 2020)

- The Poems of Aemilia Lanier – Susanne Woods (Oxford UP 1993)

- The England of Elizabeth - A L Rowse (Macmillan & Co 1950)

- Queen Elizabeth I - J .E. Neale (Penguin /Pelican 1960)

- Vermeer and his Milieu - John Michael Montias (Princeton U.P; 1989)

- Enchanting the Eye - Christopher Lloyd (Royal Collection Enterprises 2004)
- The Story of Art - E H Gombrich (16th edition; Phaidon Press 2006)
- The Romantic Age in Britain - ed. Boris Ford (Cambridge Cultural History CUP 1992)
- John Keats - Robert Gittings (Penguin Books 1979)
- John Keats ; A Life - Stephen Coote (Hodder and Stoughton 1995)
- Keats - Andrew Motion (Faber & Faber 1997)
- Mary Shelley - Miranda Seymour (John Murray 2000)
- The Romantics: Their Lives, Works & Inspiration (Ed. Nat. Harris; Marshal Cavendish 1991)
- Europe Since Napoleon - David Thompson (Penguin 1963)
- London The Biography - Peter Ackroyd (Chatto & Windus 2000)
- Life in Victorian Britain - Michael Paterson (Constable and Robinson 2008)
- The Memoirs of Hector Berlioz transl. David Cairns (Victor Gollancz 1969)
- Les Misérables - Victor Hugo transl. Norman Denny (Penguin Classics 1976)
- The New Oxford Companion to Music (OUP revised 1995)
- A Social History of Nineteenth Century France - Roger Price (Holmes & Meier 1994)

- The Oxford Illustrated History of the Theatre - John Russell Brown (OUP 2001)
- Life of Charles Dickens (abridged) John Forster (Cassell & Co Ltd; orig., publ.1872)
- The World of Charles Dickens – Angus Wilson (Penguin 1972)
- Dickens of London - Wolf Mankowitz (Weidenfeld and Nicholson 1976)
- Dickens - Peter Ackroyd (Vintage Random House 2002)
- Charles Dickens – Michael Slater (Yale UP 2009)
- Charles Dickens – A Life - Claire Tomalin (Penguin 2011)
- Becoming Dickens - Robert Douglas-Fairhurst (Harvard UP 2011)
- Oxford Reader's Companion to Dickens - Ed. Paul Schlicke (OUP 2000)
- Miss Buss's Second School - Doris Burchell (Frances Mary Buss Foundation 1971)
- Encyclopaedia Britannica (numerous articles - Fifteenth Edition 1987)
- Wikipedia (Numerous articles)

Podcasts:

- BBC In Our Time:
- The Muses (19th May 2016)
- Catullus (9th January 2021)
- Christine de Pizan (8th June 2017)

- The Bluestockings (5th June 2014)
- Mary Wollstonecraft (31st December 2009)
- George Sand (6th February 2020)
- Delacroix - Liberty leading the People (20th October 2011)
- 1848 – Year of Revolution (19th January 2012).

Lectures:

- Yale Dante Lecture series recorded Autumn 2008 – lecturer: Professor Giuseppe Mazzotta;
- 2021 Shakespeare lecture series -'What was Shakespeare really like?' – lecturer Professor Sir Stanley Wells

Websites:

- Irish Biography website
- The Hector Berlioz Website
- Essential Vermeer website

I am indebted to all the scholars, writers and experts whose works I have consulted when writing this book. Quotations from the Memoirs of Hector Berlioz are from David Cairns's excellent translation. I apologise in advance to anyone who I may have inadvertently omitted from the above list.

Printed in Great Britain
by Amazon